D0970176

McCARTHYISM
The Great American Red Scare

A DOCUMENTARY HISTORY

Edited by
ALBERT FRIED

New York Oxford
OXFORD UNIVERSITY PRESS
1997

I want to thank those who helped bring the book to fruition: Oxford University Press, and in particular my editors, Nancy Lane and Thomas LeBien, for their splendid support from start to finish; the great New York Public Library and Columbia University Library, so notable for their generosity and wonderful courtesies; all the friends, too many to mention, who heard me out and offered advice, some of which I accepted; the students of SUNY Purchase who took my classes on McCarthyism over the years; and above all Edith Firoozi Fried, most demanding, trenchant, and loving of critics.

Oxford University Press

Oxford New York
Athens Auckland Bangkok
Bogota Bombay Buenos Aires Calcutta
Cape Town Dar es Salaam Delhi
Florence Hong Kong Istanbul Karachi
Kuala Lumpur Madras Madrid Melbourne
Mexico City Nairobi Paris Singapore
Taipei Tokyo Toronto

and associated companies in
Berlin Ibadan

Library of Congress Cataloging-in-Publication Data
Fried, Albert. McCarthyism : the great American Red scare :
a documentary history / Albert Fried.
p. cm. Includes bibliographical references. ISBN 0–19–509701–7
1. Anti-communist movements—United States—History.
2. McCarthy, Joseph, 1908–1957.
3. Internal security—United States—History—20th century.
4. Radicalism—United States—History—20th century.
I. Title. E743.5.F668 1997 973.9—dc20 96–7280

2 4 6 8 9 7 5 3 1

Printed in the United States of America
on acid-free paper

Contents

1

Introduction: Definitions, A Précis

1

The word "McCarthyism" became a public epithet—exactly who invented it is unknown—soon after February 9, 1950, the day U.S. Republican Senator Joseph R. McCarthy, scarcely a household name outside his own state of Wisconsin, delivered a speech to a small Republican gathering in Wheeling, West Virginia. According to the paragraph-long summary carried by newswires—it was unrecorded and those who heard it later gave confused or conflicting versions—he accused the State Department of harboring precisely 205 Communists, i.e., traitors. The rest of his remarks were evidently unexceptional: the customary Lincoln Day Republican attacks on the Truman administration. But instead of disappearing into the void, where such dispatches usually end up, McCarthy's accusation began making headlines, especially when it provoked angry cries of foul from the administration and Democrats in general.

He now had to prove his case, behind which lay the ugly inference that State Department functionaries, perhaps high-ranking ones, were responsible for handing China over to Communism the year before and Eastern Europe to the Soviet Union before that, and were obviously plotting more betrayals. With breathtaking audacity, however, McCarthy offered not proof but fresh accusations, accompanied this time by names. He was thus destroying the reputations of specific individuals, who, in self-defense, could never get the media attention he did; the charges stuck. McCarthy's growing legion of critics, from the president down, responded with savage

denunciations of the man and his methods. How savage is exemplified in master satirist Herblock's remarkable cartoons in the *Washington Post*.* They invariably showed McCarthy climbing out of a sewer, a five o'clock shadow giving his face a sinister mien, and carrying a can of mud or pitch and a brush to smear innocent people with. The savagery is further brought out in a long screed, *McCarthy, the Man, the Senator, the "Ism,"* by investigative reporters Jack Anderson and Ronald W. May (Boston: Beacon Press, 1952). They attributed his success as a demagogue to his shameless opportunism, which, they revealed in endless detail, he displayed throughout his political and personal life. For Anderson and May and Herblock and most of McCarthy's early critics, the ism they now routinely invoked was merely the man writ large, broadened to include all such bullies and miscreants who used the Communist issue to tarnish those they disliked or disagreed with, no matter how hostile to Communism the falsely accused might be.

And yet the more savagely his enemies denounced him the more popular he seemed to be. He was riding so high that he adopted their epithet as his own. *McCarthyism, the Fight for America* was the title of his 1952 campaign book. He (and his supporters) proudly conceded that he and the lesser paladins of anti-Communism did not play by the Marquis of Queensberry rules, but that was because the satanic foe manipulated those rules to its advantage. At stake, he held—and so, apparently, did a sizable share of the electorate, maybe even the majority—was the survival of the United States and Christendom itself.

McCarthy's spectacular fall settled the debate over definition. By the end of 1954 he was disgraced, and by 1957, when he died, all but fogotten. It is as though Americans had become ashamed of themselves for having permitted such a man to speak for them, to exploit their credulity in their moment of vulnerability. By 1957 the word McCarthyism signified nothing of the virtues he and his apologists imputed to it, only the vices associated with the man and his career. The official verdict, as it were, can be found in the standard dictionaries, the most influential of them being *Webster's Third International,* which came out in 1961. "McCarthyism," it states, is a

> political attitude of the mid-twentieth century closely allied to know-nothingism and characterized chiefly by the opposition to elements held to be subversive and by the use of tactics involving personal attacks on individuals by means of widely publicized indiscriminate allegations, esp. on the basis of unsubstantiated charges.

This labored definition, it should be noted, pretty much reflects the way McCarthy's earliest critics, Herblock and others, understood the term, which, after all, they invented and popularized. And it is how the term is still used in everyday parlance. Regardless of who we are and where we

* See some of them in Herbert Block, *Herblock's Special for Today* (New York: Simon and Schuster, 1958).

stand politically, it springs immediately to our lips when those who accuse us of a wrong do not provide the evidence—and even if they do provide it—entitling us to accuse them of incivility and unfairness at the very least and to demand that they receive the comeuppance McCarthy himself did.

<div align="center">

2

</div>

In the years since his fall the ism has taken on new meanings. No longer can it be defined only, or even primarily, as the misconduct of demagogues who blacken reputations, destroy livelihoods, etc. It has also come to embrace affairs of state, large areas of domestic and foreign policy, and an entire historical period. How this transformation came about can be briefly told.

Until the 1960s a tight national consensus of opinion held sway. Americans overwhelmingly approved of their government's tough-minded opposition to the Soviet Union and Communism (though some or most of them might have disagreed with this or that facet of it), and they celebrated with scant demur the social order under which they enjoyed such freedom and abundance and security. That consensus, however, suddenly, catastrophically, fell apart in the wake of the civil rights revolution, the anti-Vietnam War insurgency, the massive campus unrest, and the flowering of a quite fantastic counterculture.

Meanwhile, young historians, social scientists, and liberal artists rebelled against the consensus that had dominated their disciplines. They challenged the dogma according to which America fought the Cold War, namely that it was a struggle to the death between good and evil and that the good would prevail only if the evil was suppressed at home and contained or rolled back abroad, whatever the cost. The challenge to that dogma has been vindicated by the test of time in the sense that they, the radical scholars who emerged in the 1960s, have made their revised views the prevailing orthodoxy, thanks to their prolific output and the status they have achieved in their professions.

Nowhere has their effect been more striking than in their work on McCarthyism. In their hands, the dictionary definition, so quaint and moralistic, so redolent of the man and his adversaries, has given way to the open-ended conception of the subject described above. What they have done with McCarthyism may be summed up in the following definitions.

1. *McCarthyism can be defined as the great American red scare.* Previous red scares were fierce and punitive, but they were mercifully brief. The Alien and Sedition Acts of 1798 proved extremely unpopular and withered away even before Thomas Jefferson, their chief opponent, became president three years later. Hostility toward radicals from the 1870s through the early twentieth century, an age of violent industrial warfare across the country, was episodic and confined to localities. And the most famous of pre-McCarthyism red scares, the one that jailed or deported or otherwise persecuted thousands of suspected "Bolsheviki," lasted less than two years,

dying out in 1921. But the McCarthyism red scare went on and on for decades, and became a whole way of life. It was indeed the great American red scare.

There is a grim irony in this to which revisionist scholars like to call attention.

No sooner did World War II end than the far right, frustrated by America's four years of friendship with the Soviet Union and (relative) solicitude toward Communism, began testing anti-Communist waters. Republicans denounced the late President Roosevelt and the liberal Democrats who served in his administration for kowtowing to Stalin, sanctioning his conquests. The Republican sweep in the 1946 Congressional election, the first since 1928, convinced President Truman, if he still needed convincing, that he had to be conspicuously tough on Communism, lest the Republicans further exploit the issue to their benefit and his detriment. His bold move to provide economic and military support for the Greek and Turkish governments—the Truman Doctrine—may have been justified from a narrowly strategic point of view; certainly the Greek government would have fallen to Communist-led insurgents. How *Truman* justified the move bears directly on any inquiry into the genesis and development of McCarthyism. He presented his doctrine to the American people in ideological terms, as the necessary defense against a totalitarianism whose aim, like Hitler's, was nothing less than the enslavement of mankind. And while Truman did not deliberately time the doctrine to coincide with his promulgation of a "loyalty review" program to root out Communists from among the millions of federal employees—he announced them within days of each other in March 1947—the linkage was no coincidence. Could he be tough on enemies abroad and indifferent to them and their sympathizers at home—especially in the face of burgeoning criticisms of him and the Democrats?

Thus was launched America's red scare nonpareil. Loyalty review boards on the Truman administration model sprung up across the nation, scrutinizing the personal lives and political beliefs not only of government workers, but many private ones as well. Subject to such scrutiny were those who at any time in their lives belonged to any of the organizations that the attorney general deemed subversive, or who knew or were related to anyone who ever belonged to any of them. Numerous legislative and administrative committees held highly publicized inquisitorial hearings, the object being to defame and humiliate their victims. Prestigious liberal organizations hastily purged themselves of alleged Communists. After a year-long trial, a New York jury convicted eleven Communist party leaders of advocating the violent overthrow of the government, the prelude, once they exhausted their appeals, to wholesale arrests of other party officials. The point is that this orgy of repression occurred during Truman's watch, and to a measurable extent by his initiative. McCarthy had not yet made his appearance.

It can be argued on Truman's behalf that he, the Democratic party,

and the liberal community at large went along with the red scare to prevent a worse, or Republican, one from afflicting the nation. The 1948 presidential election seemed to support this view. To everyone's amazement, Truman and the Democrats won the election, foiling Republican efforts to win on the soft-on-Communism issue. The election also left no doubt that "popular front" liberalism—the liberalism that blamed Truman for starting the Cold War and harked back to late 1930s when progressives of every coloration, from scarlet to mildest pink, worked together to stop Fascism and advance the New Deal agenda—was marginalized, discredited, and irrelevant. That was evident from the fact that the liberal popular front candidate for president, former secretary of agriculture and vice president Henry A. Wallace, went down to crushing defeat. Many popular front liberals themselves were soon caught in the toils of the red scare.

But then Providence turned its baleful irony on Truman and the Democrats. Events between September 1949 and June 1950 shattered American equanimity: the Soviets exploded an atomic bomb, thus breaking America's monopoly/control of that immense advantage; China fell to Mao Zedong's Communist armies, America having spared no expense in backing the hopelessly corrupt government there; and American soldiers began fighting in South Korea against a powerful invading army from the Communist North, the Cold War having thus become a hot one, on the Asian mainland at least. In the midst of these American defeats abroad a cognate event of some significance was taking place at home. In January 1950 Alger Hiss, a highly placed and respected State Department official from the mid-1930s until he became director of the Carnegie Foundation for Peace in 1947, went to jail for perjury, because a confessed communist spy proved to the jury's satisfaction that Hiss had once given him secret State Department documents. (Hiss eluded espionage charges because the statute of limitations had run out and he served only five years.) It was while this concatenation of events unfolded that McCarthy came out of nowhere and announced his presence. Not Communists but the Truman administration and liberal Democrats or Cold War liberals—to be distinguished again from popular front liberals who no longer mattered—were the main targets of his animadversions. The Truman Administration, which had set the red scare in motion, defensively perhaps, now was enveloped by it. "Twenty years of treason" was McCarthy's refrain, as it was the radical right's, and much of America agreed. The Truman, or Cold War, liberals, were promptly removed from office and cast into the wilderness. The red scare victimized not just a few of them. It hardly consoled the others that the irony of their fate could have been crueler than it was; at least none of them went to jail.

2. *McCarthyism may also be defined as the Cold War's revenge on liberal Democrats.* This definition picks up where the previous one leaves off, adding to the irony that held them in thrall.

Desperate to win back the electorate, Democratic Party leaders in the 1950s concluded that they must go beyond negative or defensive anti-

Communist strategies. They must take hard-line Cold War positions and demand a much-expanded military buildup and weapons program. And above all they must never allow any country to fall to Communism. How completely McCarthyism thus triumphed in foreign policy became evident when liberal and Cold War Democrats returned to national power in 1961 (by the skin of their teeth) under John F. Kennedy and consolidated it for most of the decade under Lyndon B. Johnson. Whatever they accomplished domestically was eclipsed by the Vietnam War, more exactly by the assumption that guided their involvement in it—that the public would no more forgive them for losing South Vietnam to the Communists than it forgave the Truman administration for losing China and failing to defeat North Korea. Johnson committed half a million soldiers to the war even though policy-makers knew all along that the enemy could not be defeated. This we know from the government's own account in the secret Pentagon Papers that came out in 1971 and the public apology that Robert S. McNamara, then Secretary of Defense and one of the chief architects of the war, has recently made.* Fear of a backlash, fear of another dark reaction, in a word, fear of McCarthyism redivivus, proved disastrous to liberal Democrats, the consequences of which dog them, and the country, to this day.

3. *McCarthyism, finally, may be defined as the errant behavior of powerful institutions, public and private.* Regarding public ones, that the FBI and its ineffable director, J. Edgar Hoover, were enthusiastic participants in the red scare is a well-established fact that is continually reinforced by new revelations. Americans in the 1940s and 1950s listened obediently to his warnings against any group that questioned, much less disturbed, the status quo, Communists in particular, because they respected his authority and integrity and professionalism so much. (He was ruthlessly adept at press agentry.) But little did Americans know that Hoover and his assistants routinely fed slanderous data to favored outlets: newspaper columnists, ideological yokemates in various walks of life, and grand inquisitors, McCarthy among them. Hoover's FBI, as we will see, went on to commit flagrant illegalities.

Hoover theoretically answered to a Justice Department (actually, he answered to no one) which, especially during the Truman and Eisenhower administrations, shared his outlook and did what it could to prosecute red scare victims. Indeed, every other federal agency contributed its mite to the same end when called on to do so: the State Department's Passport Division, which arrogated to itself the absolute authority to keep in or keep out whomever it wished; the Post Office, which decided whose mail from abroad it should hold or register; the Internal Revenue Service, which, contrary to explicit regulations, hounded and penalized "subversive" individuals and organizations; the Immigration and Naturalization Service, to

*The apology appears in his 1995 memoir, *In Retrospect* (New York: Times Books, 1995), much of which deals with the "mistakes" he and President Johnson and others were guilty of in Vietnam. See especially pp. 319–322.

which anti-Communist legislation gave far-reaching police powers; and the national security institutions, the Central Intelligence Agency and the National Security Agency, which were supposed to confine their activities to foreign enemies, but overstepped their bounds with alacrity when ordered; and the same held true for military intelligence, specifically the Army's.

The multitude of state and local bureaucracies, limited in scope as they were, played a notable part of their own in the red scare. Their power to license, incorporate, inspect, and tax enabled them to freely persecute those they anathematized as politically undesirable. One example illustrates the effect of that power. In 1952 the New York state insurance commissioner withdrew the license from a remarkably successful Communist-run corporation, the International Worker's Order, which, among other things, provided fairly comprehensive, low-cost health and life insurance for its members. Having flourished for decades, the IWO was dissolved on the commissioner's order and that was that.

Then there were the private institutions, those especially vulnerable to public opinion and policy, those, in other words, that tended most readily to succumb to the red scare—defense contractors, producers, and sellers of consumer goods, the media, the advertisement and entertainment industries, and the trade unions. Occasionally, even churches succumbed, as when the Brooklyn–Long Island Episcopal diocese fired a fellow traveling priest (John Howard Melish) over the strenuous objection of his congregation. And so did schools of higher education, including Ivy League ones, increasingly integrated as they were into America's military-industrial nexus.

After a slow and fitful start, the Supreme Court to its credit had, by the 1960s, circumscribed the arbitrary behavior of public institutions; private ones yielded to civil lawsuits for damages. The Supreme Court's decisions, scores of them, amounted to a bracing reaffirmation of the Bill of Rights and due process of law.

But McCarthyism rose to the occasion, demonstrating how skillfully it adapted itself to such legal circumscriptions. So long as they did not disobey court rulings the institutions could surreptitiously do as they pleased. During the wrathful sixties the CIA and NSA and Army intelligence, along with the usual "red squads," conducted massive campaigns of illegal surveillance and dossier-collecting of antiwar activists. Someday we may learn exactly what these institutions were planning to do with the information they gathered. As one might expect, the FBI was the worst offender, relying as it did on "blackbag" (breaking and entering) and notably wicked counterintelligence (COINTEL) programs; the bureau had clearly reached its nadir. To J. Edgar Hoover, the insurgent movements, with their contempt for authority, their assault on cherished distinctions of class, race, gender, sexual orientation, etc., meant that America's resolve was weakening and that the reds might win after all—a terrifying prospect for the anti-Communist crusader to behold in his declining years. And as late as the

1970s, President Richard Nixon, who owed his rise to the red scare, used federal agencies to harass and discommode his enemies, in his mind numerous beyond reckoning, and then to cover up his crimes. (He also had his own extra-legal operatives: the "plumbers"). To the end Nixon had stayed true to his McCarthyite heritage.

In the immediate aftermath of Watergate, Nixon's resignation, and the Vietnam debacle (1973–75), an outraged Congress imposed strict prohibitions on government bureaucracies to prevent them from violating citizens' rights. But such prohibitions, however earnest their intent, carry no guarantees. How durable they are depends on how the nation responds to fresh crises. The latest crisis concerns fear of terrorism. Congress in 1996 has overwhelmingly passed a law that significantly increases the government's power of surveillance and diminishes legal protections for suspected wrongdoers. Should there be more World Trade Center and Oklahoma City bombings, a full-throated scare may overwhelm the constraints of due process.

But no longer will it bear the color red. The Cold War is gone. So is Communism as a fighting ideology. (The few remaining Communist countries are rather benign.) And therefore so is McCarthyism, except as an historical phenomenon, as a flourishing and ever-expanding subject of study—and, of course, as a term of reproach, a personal insult, a dirty word.

3

As a subject of study, then, there is no telling in what new directions scholars will take McCarthyism, what new definitions they will come up with. A good case can be made for writing a history that will treat McCarthyism in all its multifariousness, that will do justice to its widely ramifying effects on society, that will even place it at the very center, as the leitmotif, of the Cold War period. Conceivably, that history can also be an anthology of documents. Only the amount of space that would be required for such an omnium gatherum is too daunting to contemplate; several volumes at a minimum, for it would have to include most of the important events of that extraordinary half-century. It would be, to say the least, an impracticable anthology.

The title of this anthology suggests the kind of practicable one I have done. It concentrates on what I would regard as the primary definition of McCarthyism—the great red scare it unloosed on America, or, if one prefers, that America unloosed on itself. I say primary definition because without it McCarthyism as a subject of study in its broad and comprehensive sense would not have been possible, and the American experience would have been entirely different than it was. For the end result of the red scare was the suppression of both organized radical dissent and such adversarial opinion as veered too far from the norm. The red scare served to legitimate and enforce the national consensus.

The purpose of this book is also its limiting principle, namely to make *McCarthyism: The Great American Red Scare* accessible to students, teachers, and readers at large. That purpose, that principle, governed my decisions as to which documents to include and which to omit—which are significant, illuminate the points at issue, and are interesting in themselves—and as to how I should best arrange them topically and chronologically.

2

Intimations of Things to Come

By the summer of 1939 the Communist Party of the United States had reason to be pleased with itself. Only ten years earlier it lay in the slough of despond. It then admitted to a membership of only 10,000 or so and was making little headway among the dispossessed whom it championed— workers, blacks, the poor in general. Why was obvious. American capitalism was simply too successful. And so, the Great Depression, when it struck, caught the party off guard as much as it did the capitalists and the politicians and everyone else, but the party quickly recovered and engaged in widespread protests that brought it a good deal of notoriety. But the gains it made, impressive only if compared to pre-Depression days, were disappointing under the circumstances: for example, as of 1935 it could claim no more than a three-fold increase in members and did no better among industrial workers, small farmers, and minorities, despite the quite heroic struggles it had been conducting in their behalf. Why then did the Communist Party suddenly prosper, becoming the supreme force on the far left, with its membership rolls, its army of fellow travelers, well-wishers and hangers-on, its trade unions, its front organizations and auxiliaries, its influence on culture and the arts, having swelled beyond its most sanguine anticipations? Why this suddenly occurred in the latter half of the decade helps explain its peculiar vulnerability to McCarthyism and so requires further discussion.

1

Communists made no bones about the fact that they identified totally with the Soviet Union as the workers' fatherland, more exactly with the Communist International, or Comintern. Indeed, the party and its institutions happily affirmed their organic inseparability from the Comintern, its policies being theirs without demur or conditions. Now this relationship gave American Communists a certain advantage. Not a few Americans saw in the Soviet experiment a healthy alternative to the capitalist system that was bringing them such misery. And yet, as noted, that advantage, along with the tremendous activism, did not do all that much for the party and movement.

It was the vagaries of international politics that came to the rescue. The details of what was happening in the world would of course take us too far afield. Suffice it to say that the Comintern announced a fundamental policy shift in August 1935. Instead of Communists everywhere standing alone, bitterly hostile to every other group on the left, this in the belief that the imminent collapse of capitalism would redound solely to their benefit, now they would cooperate with those very groups in a "popular front" (mentioned in the introduction) against the paramount danger, Fascism, more specifically Nazism, its German variant. Hitler's mighty achievements since taking power in January 1933—an inspiration to Fascists and pro-Fascists in Europe and America—posed a mortal threat to the Soviet Union and Communism. Communists now presented themselves as the vanguard of popular resistance to Fascism and downplayed their role as the vanguard of proletarian revolution.

The value of the Soviet Union to American Communism over the next four years was incalculable. That was because the Soviet Union alone among the major powers stood up to advancing Fascism. Western democracies, the United States included, passively stood by as Germany, Italy, and Japan swallowed up or conquered or invaded one country or portion of a country after another—in succession: Ethiopia, the Rhineland, China, Austria, Czechoslovakia, and Albania—or, in the case of Spain, openly assisted the army to overthrow a democratically elected government and install a quasi-Fascist (Falangist) one. While all this was going on, Americans by the droves rallied to the Communist standard, and not necessarily because they discovered the virtues of Marxism-Leninism. They embraced the popular front with Communists out of solidarity with the Soviet Union in its lonely resistance to Fascist expansion, Hitler's in particular.

2

The Communist rise inevitably called forth a reaction. Conservative members of the House of Representatives got authorization to establish an "Un-American Activities" committee, headed by one Martin Dies of

Texas. The Dies Committee hearings of 1938–40 on alleged Communist power and influence created something of a sensation, exaggerated as they were by a press eager to advertise the issue, at the root of which was the assumption that the Roosevelt administration, that New Deal liberalism, was nothing more than a respectable front for the reds. A goodly number of Americans shared that assumption. A smaller number, consisting of those sympathetic to the emerging Fascist world order—there were scores of far right organizations, including zealots of the popular radio priest, Father Charles E. Coughlin, and his "Christian Front"—went a giant step further and looked to that world order for leadership. Not to be omitted from the equation was the law enforcement community, chiefly J. Edgar Hoover and his FBI. From the instant Hoover entered the Justice Department in 1917 as a lad fresh out of law school he targeted the reds, loosely defined to mean any rebel who defied the status quo, as public villains number one. Thanks to his competence he soon became bureau director. But in 1924 a liberal attorney general forbade the bureau from undertaking any further political investigations. In 1936 President Roosevelt officially lifted the ban to monitor the proliferating extremists of the left and right. That enabled Hoover to pursue his most hated enemies, the extremists of the left.

Nor were conservatives and rightists the only, or even the most violently hostile, anti-Communists by the late 1930s. American Federation of Labor Leaders, most of whom strongly supported Roosevelt and the New Deal, would have supped with the devil if doing so could have helped them bring down the rival Congress of Industrial Organizations, whose startling rise owed much, perhaps most, to Communists. These American Federation of Labor leaders cooperated with any public agency, the FBI, the Dies Committee, etc., that exposed the common foe as stooges of the Soviet Union, which was exactly what the right and the Fascists were claiming.

Critics of the popular front did not get very far, however. The Roosevelt administration fended them off with minor concessions, and the Communists, strongly entrenched and full of brio, defied them with impunity. But the right failed mainly because the public in general remained unpersuaded that the Soviets, regardless of what one thought of Communism, represented a greater danger to America than the Axis alliance, consisting of Nazi Germany, Fascist Italy, and Imperial Japan, which was striding across the earth in seven league boots.

The point here deserves re-emphasis: Communist Party fortunes depended on the Soviet Union's role in world affairs. This constituted the party's singular advantage, and, as it quickly discovered, its singular vulnerability. Nations at risk will always sacrifice ideological consistency and good faith promises when their interests require it. In the late summer of 1939, with war looming on the horizon, Stalin decided that Soviet interests required such a sacrifice. He and Hitler signed a nonaggression pact just before Hitler attacked Poland, setting off the war. The Soviets now proclaimed their neutrality and the dissolution of the popular front. More-

over, they appeared to have an expansionist agenda coordinated with Hitler's. The pact allowed them to seize a third of Poland; shortly after, they took a section of Finland, the three Baltic countries, and a piece of Romania. Months later the *Wehrmacht* overran all of Western Europe (except for Sweden and Switzerland) and stood poised to invade England. The Fascist world order was at hand—and, it seemed, with Soviet complicity.

To say that American public opinion turned against the Communists would be an egregious understatement. Liberals now joined conservatives in another kind of popular front, this one directed against them, the Communists. It resulted in the passage of the Smith Act, authorizing the government to try anyone who advocated its violent overthrow. The FBI turned its agents loose on Communists with a vengeance. Red squads in various localities picked up where they had left off in 1921. Fearing heavier blows to come, Communists prepared to go underground—to formally disband the party, liquidate its far-flung properties, and resort to clandestinity.

But fate came to their rescue in the nick of time. Hitler invaded the Soviet Union on June 22, 1941, and five and a half months later Japan bombed Pearl Harbor. So it was that the popular front revived, only now it embraced not only progressives, but nearly all of America. Who did not admire the Soviet Union, America's comrade-in-arms, for its heroism, for the incalculable suffering it endured, in throwing back the monstrous evil of Nazism? It was a popular front war, fought by popular front allies for the popular front principles set forth in such popular front documents as the Atlantic Charter and the United Nations Charter.

3

When the war ended in September 1945 the American Communist movement was about as large and influential as it had ever been. And it enjoyed a legitimacy it had never possessed. Its farrago of trade unions, cultural and fraternal organizations, newspapers and magazines and book publishers, and its multitudes of friends and sympathizers, gave it a stake in the society that it sought to transform. Communists spoke the language of radical change, but success had made them cautious. They of course sided with the workers who struck en masse in 1945–46 with a ferocity not seen since post-World War I days, but they did so pragmatically, not apocalyptically, as their forbears had done in 1919. They knew that American capitalism would survive this crisis, weakened to be sure.

Meanwhile, they assumed, the party would continue to gather strength for the same reason that Communism at large was continuing to gather strength, Communism being the wave of mankind's future. No longer was the Soviet Union a beleaguered outpost of socialism; it had defeated Hitler and controlled six nations in its vicinity along with a third of Germany and Austria; despite the devastation it suffered, it was the only

other superpower, respected and feared by the rest of the world. Communists were proud to be identified with it.

Memories of the recent past might have tempered the euphoria. Communists might have asked themselves the question—it demanded little imagination and the shortest of memories—what would happen should tensions arise between the United States and the Soviet Union? They knew full well that their traditional enemies were out there straining for the chance to settle old scores.

1

The Sin of Advocacy
June 28, 1940

Not since the Alien and Sedition Acts of 1798 has such a law been passed in peacetime, giving the federal government as it did sweeping and undefined authority to go after groups it deemed subversive. The Alien Registration Act was its formal title, but it came to be known by the name of its author, Virginia Representative Howard Smith. At first it was used fitfully. In 1941, it enabled the government to jail eighteen Trotskyists for the high crime of being Trotskyists, and during World War II scores of Fascists—so the government styled them—were unsuccessfully tried under its provisions. The Smith Act would go into full effect during the McCarthy era, which is why it, that is, its main part, is included here.

TITLE I

. . . SEC. 2. (a) It shall be unlawful for any person—

(1) to knowingly or willfully advocate, abet, advise, or teach the duty, necessity, desirability, or propriety of overthrowing or destroying any government in the United States by force or violence, or by the assassination of any officer of any such government;

(2) with the intent to cause the overthrow or destruction of any government in the United States, to print, publish, edit, issue, circulate, sell, distribute, or publicly display any written or printed matter advocating, advising, or teaching the duty, necessity, desirability, or propriety of overthrowing or destroying any government in the United States by force or violence;

(3) to organize or help to organize any society, group, or assembly of persons who teach, advocate, or encourage the overthrow or destruction of any government in the United States by force or violence; or to be or become a member of, or affiliate with, any such society, group, or assembly of persons, knowing the purposes thereof.

76th Congress, 1st Session, Public Law 670.

2
HUAC Gets Under Way
January 1945

In 1938 the House of Representatives created a Special Committee on Un-American Activities under arch-conservative Martin Dies of Texas. It got a good deal of attention that year and the next for exposing alleged Communists in government, trade unions, Hollywood, etc. It fell into desuetude during the war, but in January 1945, with peace on the horizon, it came back to life. Its chief sponsor was Mississippi's notorious racist and anti-Semite, John E. Rankin. The House authorized it to investigate the following:

(1) the extent, character and objects of un-American propaganda activities in the United States (2) the diffusion within the United States of subversive and un-American propaganda that is instigated from foreign countries or of domestic origin and attacks the principles of the form of government as guaranteed by our Constitution. . . .

79th Congress, 1st Session, Public Law 601.

3

J. Edgar Hoover Alerts the Nation
October 28, 1945

> World War II had ended less than two months ago, yet the director of the FBI was already sounding the tocsin against domestic Communists. Here he did so in a speech before the International Association of Police Chiefs. Interesting to note is the distinction he drew between the low character of American Communists and the heroism of the Soviet Union.

. . . The responsibilities of law enforcement are ever broadening. Not only must we marshal our forces on the front of crime detection and apprehension, but there is an ever broadening front dominated by the subverter and purveyor of alien isms who seek to transform the America we know and love to a land of class struggle. The fight against fascism continues. The shooting war has stopped, but these espousers of dictatorships still exist, and they have been too well entrenched to become coverts of democracy overnight. The evidences of Fascist survival are too plain to ignore.

To the Fascist foe must be added another, the American Communist. These panderers of diabolic distrust already are concentrating their efforts to confuse and divide by applying the Fascist smear to progressive police departments, the FBI, and other American institutions to conceal their own sinister purposes.

The godless, truthless way of life that American Communists would force on America can mean only tyranny and oppression if they succeed. They are against the liberty which is America; they are for the license of their own. When they raise their false cry of unity, remember there can be no unity with the enemies of our way of life, who are attempting to undermine our democratic institutions. The Fascist-minded tyrant who we conquered on the battlefields is no different from the American communist corruptionist who now uses the tricks of the confidence man until his forces are sufficiently strong to rise with arms in revolt.

America cannot exist half democratic and half communist or Fascist. If we want to improve upon our American form of government we will do it in our own way, in our own time, and with our own blueprint. Therefore, it behooves us to be on guard for an enemy that brazenly and openly has advocated the corruption of America, that spends sleepless nights working one propaganda line after another, that poses behind a dozen fronts, that squirms and twists his way into those great American forces such as the church, schools, and the ranks of labor.

As I speak to you today, the big guns of the Communist Party in the United States are aimed at returning veterans, openly boasting that here is

United States Congress, 79th Congress, 1st Session, *Congressional Record*, 5410.

a new front behind which they can hide. They have selected a worthy foe, for the American Legion and the Veterans of Foreign Wars are too experienced in fighting America's enemies to be hoodwinked by these Communist swindlers.

Lest I be misunderstood, I do not for one minute detract from the heroic fight Russia waged against the invading Nazi hordes, to emerge as one of the great powers of the world. We must not let the antics of the American Communist prejudice us against this great nation which has the right to any form of government she desires, nor must we judge the great Russian people by the lunatic fringe which represents the great majority of American Communists.

Yes; we have a right and a duty to know what is going on in America. Law-enforcement in the peacetime era must determine to do its best to prevent home-grown or imported Fascists and Nazis from reorganizing or regrouping under some other high-sounding, misleading name. . . .

4

The Right to Wiretap
July 17, 1946

President Roosevelt originally authorized the FBI to conduct wiretaps with this proviso: They must be for reasons of "national defense" and have the attorney general's approval. But when in 1946 J. Edgar Hoover asked for that approval from Attorney General Tom Clark he omitted any mention of national defense. Unaware himself of the proviso, President Truman signed Clark's letter below. It gave the FBI virtual carte blanche to wiretap anyone it considered subversive.

Under date of May 21, 1940, President Franklin D. Roosevelt, in a memorandum addressed to Attorney General Jackson, stated: "You are therefore authorized and directed in such cases as you may approve, after investigation of the need in each case, to authorize the necessary investigating agents that they are at liberty to secure information by listening devices directed to the conversation or other communications of persons suspected of subversive activities against the Government of the United States, including suspected spies."

This directive was followed by Attorneys General Jackson and Biddle, and is being followed currently in this Department. I consider it appropriate, however, to bring the subject to your attention at this time.

It seems to me that in the present troubled period in international affairs, accompanied as it is by an increase in subversive activity here at home, it is as necessary as it was in 1940 to take the investigative measures referred to in President Roosevelt's memorandum. At the same time, the country is threatened by a very substantial increase in crime. While I am reluctant to suggest any use whatever of these special investigative measures in domestic cases, it seems to me imperative to use them in cases vitally affecting the domestic security, or where human life is in jeopardy.

As so modified, I believe the outstanding directive should be continued in force. If you concur in this policy, I should appreciate it if you would so indicate at the foot of this letter.

In my opinion, the measures proposed are within the authority of law, and I have in the files of the Department materials indicating to me that my two most recent predecessors as Attorney General would concur in this view.

Excerpted from *Spying on Americans,* Athan Theoharis (Philadelphia: Temple University Press, 1978), 99–100. Copyright 1978 by Temple University Press.

5

Un-Americanism in California
October 31, 1946

In 1943 Senator Jack B. Tenney, a Democrat, headed the California Fact-Finding Committee on American Activities. Like HUAC, its purpose was to expose and defame those in public life who were assumed to be pro-Communist. By 1946 the Tenney Committee had achieved considerable notoriety across California for its high-handedness. In October it held hearings in Oakland where a candidate was running for local office with Communist support. The person being interrogated worked for that candidate.

Q. Have you ever been a member of the Communist Party?
A. No.
Q. Are you sympathetic to Communism?
A. I believe in certain American principles.
Q. We're not talking about certain American principles. We are talking about Communist principles.
A. If the Communist party happens to believe in a program that I believe in that's O.K. with me.
Q. Well, do they?
A. In some instances, yes.
Q. You feel that the Communist Party is a good organization in America?
A. I feel that any attempt—I feel that the Communist Party—
Q. Will you answer the question, Mr. Seiger?
A. The Communist Party is a legal organization in this country.
Q. You think Communism is good?
A. I think that's a ridiculous question.
Q. I don't care what you think about it. Do you think it is good?
A. I think a program for America is good. If the Communist Party supports a program which to my mind is for the best interests of the American people that's O.K. with me.
Q. And do you believe they do represent such a program?
A. I believe that a program for a decent standard of living, a program for peace, a program for democracy that eliminates things of this nature is a good program for America. . . .
Q. You have no facts concerning this committee and its work?
A. On the contrary, I happen to read the paper.
Q. Do you subscribe to the People's Daily World?
A. That's right.
Q. And that is a Communist—

Excerpted from *The Tenney Committee*, Edward L. Barrett Jr. (Ithaca: Cornell University Press, 1951), 178–9. Copyright 1951 by Cornell University Press.

A. I also subscribe to the San Francisco Chronicle, a paper of big business.

Q. Let me tell you that you are not fooling everybody. Many Communists have lied about their connections. We know your purpose. We know why you have done this. That is perfectly all right with this committee, and we're glad to have you speak, but it is very obvious that you are a Communist.

A. That's your opinion, Mr. Tenney.

Q. That's my opinion.

A. O.K., you are privileged to believe it.

3

McCarthyism in Earnest

1

Franklin D. Roosevelt died on April 12, 1945. Rare was the person who thought Harry S. Truman could fill his shoes, and that included Truman himself. He was chosen to be Roosevelt's running mate the year before precisely because he lacked distinction, because he was acceptable to all Democratic Party factions—i.e., not unacceptable to any—unlike Henry A. Wallace, the vice president he replaced, who was dumped for his excessive liberalism. Roosevelt preferred Wallace but conceded the issue to avoid a nasty fight in the midst of the war.

Truman's acceptability meant that it was hard to pinpoint him ideologically. Having been raised in rural Missouri and having owed his political career to the notorious Prendergast machine of Kansas City, he was hardly expected to be a militant New Deal liberal, nor was he. But a faithful Roosevelt follower he was in his unobtrusive way. He came to the public's attention by the first-rate job he did as chairman of a U.S. Senate committee that investigated war profiteering; he came to the attention, that is, to the party bosses who were determined to remove Wallace from the ticket.

In his first year as President, Truman seemed to show his colors, convincing liberals that he emphatically was not one of them. Strikes began even before the war ended; soon they engulfed most of the mass production industries. Truman responded with threats of conscription among other punishments; that he lacked Roosevelt's finesse went without saying. Organized labor, Communists and non-Communist alike, certainly re-

garded him as no friend. And he especially displeased popular front liberals, who, it will be remembered, favored Soviet-American collaboration in the postwar era. But differences between the two countries kept cropping up, one of them—over Soviet reluctance to withdraw its troops from a province in Iran (their presence had been authorized during the war)—drawing them close to armed conflict. The term Cold War had not yet been invented, but their relations were very chilly indeed.

Conservatives, Democrats as well as Republicans, applauded Truman's show of toughness. Popular front liberals, not to mention those further to the left, were dismayed. In Henry Wallace, then serving as commerce secretary, these critics found their spokesman. A formidable spokesman he was, given the fact that so many Americans respected him for his accomplishments over the years. Wallace's argument, in brief, was that America could settle its economic problems and attain unheard of prosperity for itself and eventually the rest of the world if it resumed its friendly relations with the Soviet Union, the responsibility for their deterioration being President Truman's. Truman sought to smooth over his differences with Wallace to avoid a split with popular front liberals who, after all, constituted an important segment of the Democratic Party and whose support he needed against an increasingly rancorous Republican opposition.

But the split could no more be avoided than the split between the United States and the Soviet Union and the establishment of rival blocs in the world at large. It became official when Truman dismissed Wallace from his cabinet on September 20, 1946. Popular front liberals placed Truman squarely in the conservative camp. So far as Communists were concerned—and their movement had not lost its potency—he was an enemy bent on their destruction along with the Soviet Union's.

2

The rise of McCarthyism owed much to the smashing Republican victory of 1946. The election that year gave Republicans control of both houses of Congress for the first time since 1928. It was of major significance that they achieved their victory at the expense of Northern and Western liberals, many of them popular front sympathizers; Southern Democrats, who dominated the party's conservative wing, as usual suffered no losses. Congress was now very conservative. Moreover, the victors played up the Communist issue for all it was worth. (Especially adept at this was young Richard M. Nixon, running his first House race against a veteran California liberal.) This much was certain: anti-Communism had advanced to the front and center of American politics.

For Truman the election was not altogether bad. He despised Republicans to be sure, but he was also rid of some annoying critics on his left who agreed with Wallace's views. It would be easier now for him to put across the drastic policy change that his administration was contemplating,

one based on "containing" Communism throughout the world, and one that might demand sacrifices from Americans. Truman at the same time sought to mollify them on the Communist issue, which the Republicans were exploiting so well. Whether he himself believed a domestic Communist threat existed is questionable. That he believed no great principle was at stake in calling for measures that might harm civil liberties is indisputable. He may have called for them even without Republican pressure. Scholars are unclear on exactly where he stood in his heart of hearts, though his deeds speak for themselves.

And so weeks after the 1946 election Truman appointed a commission to produce recommendations on what he as chief executive should do about "employee loyalty." As expected the commission recommended that he institute procedures—review boards—to root out "disloyal" federal employees. Accordingly, on March 22, 1947, he issued Executive Order 9835, setting up those boards, the first time this had ever been done (except during World War II, and then only perfunctorily). The premise behind the order was that government workers possessed no right to their jobs, that if found disloyal—a term left to review boards alone to define on the basis of a list of organizations the attorney general had arbitrarily drawn up—they could be fired forthwith. How to reconcile that premise, the exercise of that power, with a sense of fairness and a reliance on due process was the abiding problem that confronted the review boards. It turned out to be an insoluble problem. Their task was to find and remove Communists. The trouble was that Communists were universally acknowledged to be devilishly clever at hiding their identities; they did not belong to "subversive" organizations; they could be anyone, indistinguishable from the neighbor next door. It was therefore necessary to seek information about suspects from any source, however dubious, and lay the burden of proof on them: they had to establish their innocence. They could bring lawyers and appeal verdicts to higher boards, but they could not face their accusers or get access to the information used against them. They enjoyed none of the rights of a court proceeding and had to be satisfied with such limited due process as the executive order granted them.

In the development of McCarthyism, historians for good reason assign great importance to the Truman loyalty reviews. Particularly so when the order is coupled with the foreign policy doctrine he promulgated a week and a half earlier. The Truman Doctrine, it will be remembered, condemned Communism everywhere because its adherents subverted their governments for the sake of Soviet expansion and conquest. Such being the internal danger, it logically followed, all public agencies, state and local, and private institutions too for that matter, must create their own loyalty review boards, with or without even the modicum of due process that the Truman one did, must acquire whatever material they could lay their hands on concerning people's lives, habits, beliefs, associations, relatives, etc., no one being above suspicion, least of all these "Masters of Deceit" (the title of one of J. Edgar Hoover's authoritative books on the Communist menace).

The Truman executive order sought to reassure Americans. Its effect was the opposite: It heightened anxieties and thus invited promises of greater security, which in turn, further heightened the anxiety. A large component of McCarthyism was this process of cause and effect, effect and cause, feeding on each other.

3

Congressional Republicans, meanwhile, were busy carrying out their own agenda. Topmost on their order of priorities was penalizing organized labor, especially its more militant or radical elements. In June 1947 Congress passed the Taft-Hartley Act by a large majority, so large it easily overrode Truman's eloquently phrased veto (which got him back into the union movement's good graces). Unmentioned in the veto message was one feature of the act, contained in a short paragraph, that had a profounder impact on labor than all the other pages combined. It specified that any union whose leaders failed to file an affidavit with the National Labor Relations Board stating that they were not Communists would be denied the board's services, tantamount to a death sentence. Communist party members naturally resigned. But then the same question or problem arose: How was the veracity of the affidavit to be determined? It was preposterous to think that a Communist who did not belong to the party would tell the truth. Inquiries had to be made, information gathered. The Natinal Labor Relations Board thus went into the business of conducting loyalty reviews, and a number of union officials ended up in jail because informers testified that they were closet Communists.

It was on another front that Congressional Republicans truly made their mark. The House Un-American Activities Committee was moribund before they took it over in 1947. Only occasionally had it gotten noticed, and then to its shame, thanks to its most egregious member, Mississippi's John Rankin. The new crop of staunch Republican anti-Communists, among them Richard M. Nixon, infused the Committee with energy and purpose. Their mission was to turn the klieg lights of publicity on the leftists who, in their view, had been influencing the administration for the last fourteen years. But first, as a sort of curtain-raiser, they decided to turn those lights on Hollywood, where, they claimed, Communists were producing propaganda films through a conspiratorial network of writers, directors, actors, and unions. This was precisely the argument that had long been advanced by the conservative part of the Hollywood community, by those who had personal scores to settle (i.e., the rival AFL union) and by studios that resented having to deal with unions at all (i.e., Walt Disney's). The House Un-American Activities Committee knew what it was doing when it jumped into the middle of the Hollywood fray.

Little did these staid Congressmen imagine what paydirt they would hit. Nineteen "unfriendly" witnesses—meaning those known to be or to have been Communist Party members—were called to testify when

HUAC hearings opened in Washington, D.C., on October 20th; one was an actor; the rest were writers and directors. They all decided to defy the committee by taking a principled stand, even if it resulted in martyrdom. They would assert their First Amendment rights to free speech and association rather than take the Fifth Amendment's protection against self-incriminating testimony. Had the ten who did testify—the hearings abruptly ended before the other nine could—taken the Fifth they would not have gone to jail, charged with contempt of Congress for refusing to answer questions about their political affiliations. Had they done so, some have maintained, the movie studios might not have fired and blacklisted them. This is inconceivable. The studios succumbed at once to the anti-Communist criticisms that descended on them after the hearings, and taking the Fifth was, at the time, considered to be a confession of guilt ("Fifth Amendment Communist" was the commonly accepted term) and punished accordingly. The "Hollywood Ten" would have been martyred whatever they did short of cooperating by naming names. They were pragmatically correct to affirm a great principle in the course of going down.

But if they expected their comrades and sympathizers in Hollywood and elsewhere to risk going down with them they were sorely disappointed. Some of their friends who did attempt a show of solidarity gave up the fight as soon as they saw what they were up against—the extent of the newspaper and political support for the committee and opposition to the unfriendly ten. The committee reveled in the extravagant publicity and applause it received. These, the nutrients of every politician, it would seek to elicit in subsequent hearings throughout the era of McCarthyism. Like the Truman loyalty review board, HUAC served as the model for comparable federal and state and even local legislative committees. If inquisitions to hunt down subversives were what the public wanted, inquisitions it would get.

4

The turnabout in President Truman's fortunes was astonishing. Practically until the mid-summer 1948 Democratic Party convention, it appeared that he might not get renominated, let alone win re-election. But within a year he was man of the hour at home while abroad his Communist containment policy was working to perfection. And for all of this he had none other than Josef Stalin to thank.

On June 24, 1948, Truman ordered the U.S. military to airlift the necessities of life to the 2 million people of West Berlin. Retaliating against American, British, and French moves to unite their German occupation zones into a single state linked to and allied with the West, Stalin had imposed a land and sea blockade of West Berlin, which lay well within the Soviet zone. In not challenging the airlift, which might have resulted in war, Stalin handed Truman a great victory. Of this fact Americans were

reminded daily by press accounts of heroic flights, of acts of mercy every few minutes around the clock. It was just the fillip Truman needed for his comeback. Whether he secretly thanked Stalin for providing it is a matter of speculation.

Meanwhile, in late July, just as the Democrats were convening to renominate him, his attorney general announced that America's twelve top Communist leaders would be prosecuted under the 1940 Smith Act. Conservatives had been demanding their prosecution for years, and it certainly was the popular thing to do. So detested were they that the liberal American Civil Liberties Union refused to help them. The Communists had their own lawyers to be sure, but it would have been very much in their interest to be seen objectively, through the presence of the ACLU, as a persecuted minority. And, in truth, a persecuted minority they were. Whatever one thought of their authoritarian style and modus operandi and their attachment to the Soviet Union, they had never behaved illegally until the government decided they did in 1948. By then, moreover, the number of party members was falling rapidly, and so was whatever prestige it still possessed. In any case, the American Communist Party was the smallest and most marginal of any among the world's democracies. Yet no other democracy prosecuted Communists for being Communists, much less imprisoned them for upwards of five years (some served longer), a miscarriage of justice if ever there was one.

5

Despite universal predictions of defeat, Truman was re-elected, having obviously persuaded the majority that he was on the right track in his approach to Communism (among other issues, of course). Nothing appeared to prove that more emphatically than the miserable performance of Henry Wallace and his Progressive Party. He received slightly more than a million votes, most of them concentrated in New York and California. It was the last gesture of popular front liberalism, its final humiliation. It had become irrelevant, and no one rejoiced more over that fact than Truman and the Democratic Party.

The election also humbled the Republicans, and they remained humbled so long as the international scene continued to favor Truman. In Greece, the insurgents were on the verge of defeat largely because Communist Yugoslavia, which was their major source of help, had defected from the Soviet camp. West Germany was unified under a reliably pro-American government. A treaty alliance (NATO) now bound together the nations of Western Europe and North America. Stalin lifted the Berlin blockade and got nothing in return. It was a fitting conclusion to Truman's miracle year, which made the bad news that soon arrived all the more damaging.

1

Defining Loyalty
March 22, 1947

Executive order 9835, which established federal loyalty review boards, more than anything else launched McCarthyism on its inexorable course. It legitimated subsequent "loyalty" investigations of employees across the land, local and state as well as federal, private as well as public. President Truman was responding to the recent Republican Congressional victory—something of a minirevolution—and with it the charge that he and the Democrats were soft on Communism.

PART I

Investigation of Applications

1. There shall be a loyalty investigation of every person entering civilian employment of any department or agency of the Executive Branch of the Federal Government.
 A. Investigations of persons entering the competitive service shall be conducted by the Civil Service Commission, except in such cases as are covered by a special agreement between the commission and any given department or agency.
 B. Investigations of persons other than those entering the competitive service shall be conducted by the employing department or agency. Departments and agencies without investigative organizations shall utilize the investigative facilities of the Civil Service Commission.

2. The investigations of persons entering the employ of the Executive Branch may be conducted after any such person enters upon actual employment therein, but in any such case the appointment of such persons shall be conditioned upon favorable determination with respect to his loyalty. . . .

3. An investigation shall be made of all applicants at all available pertinent sources of information and shall include reference to:
 A. Federal Bureau of Investigation files.
 B. Civil Service Commission files.
 C. Military and Naval Intelligence files.
 D. The files of any other appropriate government investigative or intelligence agency.
 E. House Committee of Un-American Activities files.

Federal Register, vol. 12, 1935–6.

F. Local law-enforcement files at the place of residence and employment of the applicant, including municipal, county and state law-enforcement files.
G. Schools and colleges attended by applicant.
H. Former employees of applicant.
I. References given by applicant.
J. Any other appropriate source.

4. Whenever derogatory information with respect to loyalty of an applicant is revealed, a full field investigation shall be conducted. A full field investigation shall also be conducted of those applicants, or of applicants for particular positions, as may be designated by the head of the employing department or agency, such designations to be based on the determination by any such head of the best interests of national security. . . .

PART III

Responsibilities of Civil Service Commission

C. The Loyalty Review Board shall also:
 (1) Advise all departments and agencies on all problems relating to employee loyalty.
 (2) Disseminate information pertinent to employee loyalty programs.
 (3) Coordinate the employee loyalty policies and procedures of the several departments and agencies.
 (4) Make reports and submit recommendations to the Civil Service Commission for transmission to the President from time to time as may be necessary to the maintenance of the employee loyalty program. . . .

2. There shall also be established and maintained in the Civil Service Commission a central master index covering all persons whom loyalty investigations have been made by any department or agency since Sept. 1, 1939. Such master index shall contain the name of each person investigated, adequate identifying information concerning each such person, and a reference to each department and agency which has conducted a loyalty investigation concerning the person involved. . . .
 B. The reports and other investigative material and information developed by the investigating department or agency shall be retained by such department or agency in each case.

3. The Loyalty Review Board shall currently be furnished by the Department of Justice the name of each foreign or domestic organization, association, movement, group or combination of persons which the

Attorney General, after appropriate investigation and determination, designates as totalitarian, Fascist, Communist or subversive, or as having adopted a policy of advocating or approving the commission of acts of force or violence to deny others their rights under the Constitution of the United States, or as seeking to alter the form of government of the United States by unconstitutional means.

A. The Loyalty Review Board shall disseminate such information to all departments and agencies. . . .

PART IV

Security Measures in Investigations

1. At the request of the head of any department or agency of the Executive Branch an investigative agency shall make available to such head, personally, all investigative material and information collected by the investigative agency concerning any employee or prospective employee of the requesting department or agency, or shall make such material and information available to any officer or officers designated by such head and approved by the investigative agency.

2. Notwithstanding the foregoing requirement, however, the investigative agency may refuse to disclose the names of confidential informants, provided it furnishes sufficient information about such informants on the basis of which the requesting department or agency can make an adequate evaluation of the information furnished by them, and provided it advises the requesting department or agency in writing that it is essential to the protection of informants or to the investigation of other cases that the identity of the informants not be revealed. Investigative agencies shall not use this discretion to decline to reveal sources of information where such action is not essential.

3. Each department and agency of the Executive Branch should develop and maintain, or the collection and analysis of information relating to the loyalty of its employees and prospective employees, a staff specially trained in security techniques, and an effective security control system for protecting such information generally and for protecting confidential sources of such information particularly. . . .

2

Two Case Studies

Following are examples of what happened to two people out of the many thousands whom the federal loyalty review program victimized.

O. EDMUND CLUBB
1951–1952

O. Edmund Clubb had served in the State Department mainly as a China expert for decades before the Loyalty and Security Board (LSB) took up his case in June 1951. He eventually was cleared, then immediately resigned in disgust and rage. The whole sordid affair is recounted in his 1974 book, *The Witness and I.*

. . . The five sat on one side of a long table, confronting me in accepted tribunal fashion. The reporter brought up one flank. I and my colleague-associate Melby faced them from a lonely position well across the room. I had confronted various tests before, but with factors that could be calculated at least approximately. This time I found myself in an encounter with the imponderable, a mystery created of elements outside my knowledge; and at issue were high stakes—my career, my reputation, and the happiness of my family.

The LSB sat in the joint capacity of accuser, prosecutor, judge, and jury in a matter where the accused was not enabled to know what it was all about. . . . The unknown persons whose statements the LSB had used as charges against me were not present. Throughout the hearing, the Board of its own initiative never identified any of its informants to me. Nor were the charges ever put into their original contexts. In addition to having been refused the right of confrontation and cross-examination of my accusers, I was even denied the right of access to the full text of the accusation; furthermore, it would become apparent in due course that the LSB upon occasion had substituted wording of its own invention that significantly altered the purport of the charge—to my disadvantage. . . .

The charges against me fell into three natural groups—political unorthodoxy, dangerous associations, and a visit to a leftist magazine 19 years before. For tactical purposes, I divided the specific charges into five categories:

(1) that I associated with Communists in Hankow in the period 1931–34;

(2) that I was "friendly" toward the USSR, 1935–37;

(3) that I was possessed of various political attitudes varying in shade

from "pink" to "100% pro-Red," and had been "friendly" toward Communism, at various times from 1931 to 1940;

(4) that I had had "close and habitual association" with a number of named persons; and,

(5) that in 1932 I had "delivered a sealed envelope to the office of the editor of the *New Masses* . . . for transmittal to one Grace Hutchins. . . ."

I had to wrestle with the LSB examination concerning my political beliefs and attitudes. I agreed with the suggestion of one of the Board members that I had been a "liberal" in the 1930s. In response to another question, I willingly conceded that I also had been pro-New Deal. It is notorious that in some quarters President Roosevelt's policies were violently opposed. Thus I felt it incumbent upon me to attack the concept, implicit in well over half of the Board's charges, that the casting of political epithets at a man automatically transformed him into a villain. I went on to argue that name-calling could not usually be accepted as a technically accurate description. History of course abounds with material to support my thesis, and I cited examples of calumny directed at Washington, Jefferson, and Lincoln. I could of course have adduced contemporary instances of name-calling in American domestic politics, but I refrained.

It is easily demonstrated that, in politics, it has long been true that "Orthodoxy is my doxy; heterodoxy is another man's doxy." And there are always those who, using the primitive yardstick *post hoc ergo propter hoc,* damn honest men as directly responsible for the events that they might forecast in reports to their governments.

It was evident that the phraseology used in some of the allegations against me expressed a political opprobrium a particular informant might feel for a point of view I held; nevertheless, such informants apparently avoided the realm of what the Board termed "specificity." It would appear rather that the LSB expected me to accommodate it, in the fashion of authoritarian States, by confessing specific sins to fit the general epithet and then crying *"mea culpa! mea culpa!"* and heaping ashes on my head in pretended penitence. I did not do so. I did not deny that my political thought might have differed from the Board's informant's in a particular case (or, as far as that goes, from the Board's), but I did not confess to having "sinned" by differing. . . .

> On January 18, 1952 the Secretary designated Mr. Nathaniel P. Davis to consider your appeal . . . from the decision of the Loyalty Security Board of the Department of State that you be separated from employment in the Foreign Service as constituting a security risk to the Department of State. . . .
> . . . After consideration of all the evidence, . . . Mr. Davis has found that no reasonable doubt exists as to your security risk to the Department of State and that therefore your removal from employment in the Foreign Service is not necessary or advisable in the interest of national security.
> The Secretary has reviewed and concurred in Mr. Davis' findings. . . .

Adjudication by another professional diplomat had given me victory, but I was under no illusions as to my position in the State Department hierarchy: it was fundamentally changed. As the *American Foreign Service Journal* had observed editorially the previous August: "The person so besmirched [by a loyalty process] can never obtain full retribution, nor can the government regain the full value of his services." Further, the well-known case of China Service officer John S. Service had demonstrated beyond cavil that "clearance" did not at all mean a definite end to the matter. Service had been dragged through hearing after hearing before grand jury, Congressional committee, and LSB from 1945 to 1951. Cleared six times by the LSB on the same charges, he was finally discharged summarily in December 1951 when the Loyalty Review Board decided that any failure on their part to doubt his loyalty would be extending "the mantle of charity" too far. It was to take Jack Service years of arduous litigation, with ultimate recourse to the Supreme Court, to win reversal of the Loyalty Review Board's action and reinstatement in the U.S. Foreign Service; and his legal costs added up to seventy thousand dollars. . . .

CASE NUMBER 16
1955

> The story of this experience is taken from a volume of similarly har-rowing interviews, *Case Studies in Personnel Studies,* which Adam Yarmolinsky collected and published in 1955. It is Number 16.

The employee in this case was a proof reader at the Government Printing Office and had been employed at that job for over seven years. His work did not involve access to any classified material and he held no supervisory position.

CHARGES

He had been the subject of a loyalty interrogatory under the former loyalty program, and was cleared without a hearing. The first indication that his case was being reviewed under the security program came in the form of a letter to him from the Personnel Director early in 1954 [stating] . . . that the employee's full field investigation had been completed and that he was required to appear before the Personnel Director and the Chief of the Employee Relations Section for preliminary questioning. This preliminary hearing actually took place before a Screening Board of three fellow employees without the presence of counsel.

During the course of that preliminary hearing, various names, affiliations and associations were mentioned, all of which were raised again at the

Excerpted from *Case Studies in Personnel Security,* ed. Adam Yarmolinsky (Washington, D.C.: Bureau of National Affairs, 1955), 14–19.

later hearing. The employee had not previously been informed as to the charges or questions that would be raised at the preliminary hearing, and was not given the right to have counsel present. A transcript of this preliminary proceeding was made, but no copy was given to the employee or made available to him prior to the formal hearing.

A month later, the employee received a letter stating that the security officer had reviewed the investigation and had concluded that his retention in employment was not consistent with the interests of the national security. The only charge was this statement:

> "Specifically, it is charged that you continued sympathetic association with a known Communist, read Communist literature and made pro-Communist statements."

No further specification was made in the letter. The employee was suspended immediately without pay and advised of his right to submit a statement and to ask for a hearing.

He retained counsel, who thereupon requested an elaboration of these charges. Counsel states that he personally called upon the security officer who, after thumbing through the transcript of the preliminary hearing, informed him of the names of some of the individuals and organizations underlying the general charge and which had been mentioned at the preliminary hearing. But the security officer refused to give counsel a copy of this transcript or to allow him to examine and read it. Counsel was also informed that the Government Printing Office did not use the Attorney General's list of subversive organizations as a guide for its charges, but rather relied upon the list of the House Committee on Un-American Activities.

Counsel made two formal requests of the security officer: (1) the names of informants which were not confidential and whom it might be possible to cross-examine during the course of the hearing; and (2) the opportunity, before the hearing, to read the transcript of the preliminary proceeding. When the security officer denied these requests, counsel asked that they be passed on to the Security Hearing Board prior to the formal hearing.

EMPLOYEE'S RESPONSE

On the basis of the information obtained by counsel and the employee's own recollection of the issues involved in the prior proceeding, a detailed answer to the general charge was made about a month after receipt of the security officer's letter. The replies to the three broad charges may be summarized as follows:

(1) The employee denied that he had ever had continued or sympathetic association with a known Communist. He stated that to the best of his recollection he had known only one Communist, A, whom he knew

from 1933 to 1935, had not seen or heard from since 1935, and with whose views he was in strong disagreement. In 1933 he had been working as a printer in Pennsylvania for an uncle of A. While the printing plant was closed for a short period he worked in a cooperative restaurant which A had organized. He soon returned to the printing plant. A would come into the plant occasionally and attempt to convert the employee to his Communist viewpoint, but without success. He had argued and disagreed violently with A on those occasions. Such was the nature and extent of his relationship with A.

The employee also stated that he had heard B, who he said was apparently once a Communist, speak at several public forums between 1946 and 1948. B was not a Communist at the time of these speeches and so stated at that time. The employee attended these lectures not because of any sympathy with B's views, but because of his interest in social and economic questions and a desire to hear such a controversial figure. He found himself in disagreement with B on many issues and felt that B's ideas were too materialistic.

The answer also touched upon the employee's relationship with nine other individuals who had been mentioned by the security officer to the employee's counsel. Included among these was Henry Wallace, with whom the employee had never had any association or sympathy. Most of the others were officials or members of the so-called People's Party, a very small political party formed to support the candidacy for President in the 1948 election of one General Holdridge. The employee had attended several public meetings of this Party but never joined it. The People's Party never appeared to be anything but a loyal and legitimate organization and never was cited as a Communist organization by the Attorney General or by any legislative committee. None of the persons in the People's Party known to the employee had seemed to him to be Communists or Communist sympathizers.

The answer discussed, in addition, the employee's association, with an individual who was his roommate and business associate many years earlier. For a time in the 1930s they had both been active in the Dollar-an-Hour Club, an outgrowth of the LaFollette Progressive Party. Both had also been interested at that time in various monetary reform movements.

(2) The employee stated that he had never knowingly subscribed to or purchased any Communist literature and that he had never been sympathetic to the pro-Communist articles he may have read. He admitted that more than fifteen years ago he occasionally scanned copies of the "Daily Worker" that had been purchased—out of curiosity rather than sympathy—by the above-mentioned roommate. He did so only to see what position, if any, the Communist Party was taking on matters of monetary and taxation reform in which he had an interest.

At the preliminary hearing, the employee had been asked about his subscription to "Consumer Reports." In his answer he stated that he did subscribe to that publication in order to avail himself of the Consumers

Union's testing services and to permit him to know the best product available for his needs and pocketbook. He observed that it was hard to believe that this could be considered as Communist literature. The employee further stated that he was not in a position to know whether certain Board members of Consumers Union had at one time been Communists, but he did note that the public press had reported that all present members of the Board of Consumers Union had signed non-Communist affidavits. Counsel later wrote a letter to the security officer, calling attention to the fact that the House Un-American Activities Committee had publicly announced that it had deleted the Consumers Union from its list of subversive organizations.

The answer further referred to a publication called "Action for Human Welfare," the official organ of the People's Party. The employee said he had been acquainted with this publication at the time he attended the organization's meetings, but had no reason to suspect that it was Communist.

(3) The employee denied that he had ever made pro-Communist statements. This part of the answer was based upon certain remarks referred to at the preliminary hearing. . . .

(4) The answer then concluded with a review of the employee's life and activities. His religious background was emphasized, together with his support of the LaFollette Progressive Party and his opposition to war as an instrument of national policy. He vigorously denied that at any time he had been sympathetic to or affiliated with the Communist Party or any Communist viewpoint.

Attached to the answer were fourteen affidavits. Many of them were from his associates in the Government Printing Office. Others were from his church associates and from members of his car pool. One was from a Republican Congressman. All of these persons testified that the employee had never expressed any sentiments that would permit one to suspect him of being sympathetic to Communism in any way, and that he was a devout Christian. Also attached was a religious publication to which the employee subscribed, stating that it is dedicated to the preservation of the American way and a free democratic economy by the revival and extension of Christianity and that the American answer to Communism is a revitalized Christian capitalism.

HEARING

At the formal hearing before the Security Hearing Board (a transcript of which was not available to the interviewer), the Government produced no witnesses. The Board and the security officer interrogated the employee at length and allowed counsel for the employee to ask questions only after they had finished. The Chairman indicated to the employee's counsel that he was not interested in four character witnesses offered on the employee's behalf, since the written record and the employee's testimony were before

him and were enough for him. But despite this reaction, counsel proceeded to call the witnesses and also made a concluding argument, although the Chairman was reluctant to let him do so. The witnesses were the employee's minister, a co-worker in his office, a co-worker in his car pool, and a member of his church who knew his family socially.

At the beginning of the hearing, counsel asked the Board if his two requests made through the security officer—relating to identity of informants and review of the transcript of the preliminary hearing—had been received. The Chairman said they had not and expressed surprise that counsel had not been permitted to read the transcript of the preliminary hearing. An hour's adjournment was then taken to enable counsel to read this transcript in the company of the employee.

The Board then made it clear that it would pay little attention to the portion of the charge relating to the making of pro-Communist statements. Some time was devoted to the charge of reading Communist literature, with inquiries being made as to why he scanned the "Daily Worker" and as to what other literature he read. The hearing thereafter was devoted mainly to a consideration of the employee's alleged associations with Communists. The employee, in answer to questions, repeated what he had said in his written answer.

Among the questions counsel remembers as having been asked of the employee are:

1. How do you distinguish between the Russian system of government and ours?
2. What was your reaction upon receiving these charges? Didn't you feel remorseful for some of the things you did in your life?
3. Don't you think that any person is a security risk who at one time or another associated with a Communist—even though it was not a sympathetic association and even though he may not have known at the time that the person was a Communist and even though the association terminated many years ago?

(These are phrased in accordance with counsel's best recollection, since the transcript was unavailable.)

RESULT

The employee was informed by letter three weeks after the hearing that the Public Printer had rendered an adverse decision as to his security status. The letter mentioned that the Board had made its recommendation adverse to the employee three days previously. It was not until after this determination had been communicated to the employee that counsel received a copy of the hearing transcript.

No reasons were given for either the recommendation or the decision. . . .

3

Cleaning Out the Unions
June 23, 1947

The Taft-Hartley Act, keystone of the Republican arch, amended the 1935 National Labor Relations Act in ways calculated to reduce organized labor's power (or rights). Among its provisions was one that tried to ban suspected Communists from leadership of their unions. To remove them—refuse to recognize them—the NLRB needed only to establish that they taught or believed in the "illegal or unconstitutional" overthrow of the government. (See *Doud v. American Communication Workers,* Chapter Six, Document 1.)

Sec. 101. The National Labor Relations Act is hereby amended to read as follows: . . .

9(h) No investigation shall be made by the Board of any question affecting commerce concerning the representation of employees, raised by a labor organization under subsection (c) of this section, no petition under section (e) (1) shall be entertained, and no complaint shall be issued pursuant to a charge made by a labor organization under subsection (b) of section 10, unless there is on file with the Board an affidavit executed contemporaneously or within the preceding twelve-month period by each officer of such labor organization and the officers of any national or international labor organization of which it is an affiliate or constituent unit that he is not a member of the Communist Party or affiliated with such party, and that he does not believe in, and is not a member of or supports any organization that believes in or teaches, the overthrow of the United States Government by force or by any legal or unconstitutional methods. The provisions of section 35 A of the Criminal code shall be applicable in respect to such affidavits. . . .

80th Congress, 1st Session, Public Law 101.

4

The Ordeal of John Howard Lawson

October 27, 1947

It was for good reason that Lawson was the first of the nineteen "unfriendly" witnesses called to testify before HUAC: He was a founder and the first president of the Screen Writers Guild and had sixteen films to his credit. The others who comprised the "Hollywood Ten"—nine did not testify—experienced the same rough treatment he did at the committee's hands and, like him, eventually went to jail for contempt of Congress.

Staff members present: Mr. Robert E. Stripling, Chief Investigator; Messrs. Louis J. Russell, H. A. Smith, and Robert B. Gaston, Investigators; and Mr. Benjamin Mandel, Director of Research.

THE CHAIRMAN: The record will show that a Subcommittee is present, consisting of Mr. Vail, Mr. McDowell, and Mr. Thomas.

MR. LAWSON: Mr. Chairman, I have a statement here which I wish to make—

THE CHAIRMAN: Well, all right, let me see your statement.

(*Statement handed to the Chairman.*)

THE CHAIRMAN: I don't care to read any more of the statement. The statement will not be read. I read the first line.

MR. LAWSON: You have spent one week vilifying me before the American public—

THE CHAIRMAN: Just a minute—

MR. LAWSON: —and you refuse to allow me to make a statement on my rights as an American citizen.

THE CHAIRMAN: I refuse to let you make the statement because of the first sentence. That statement is not pertinent to the inquiry. Now, this is a Congressional Committee set up by law. We must have orderly procedure, and we are going to have orderly procedure. Mr. Stripling, identify the witness.

MR. LAWSON: The rights of American citizens are important in this room here, and I intend to stand up for those rights, Congressman Thomas.

MR. STRIPLING: Mr. Lawson, will you state your full name, please?

MR. LAWSON: I wish to protest against the unwillingness of this Committee to read a statement, when you permitted Mr. Warner, Mr. Mayer, and others to read statements in this room. My name is John Howard Lawson.

MR. STRIPLING: When and where were you born?

MR. LAWSON: New York City.

United States House of Representatives, 80th Congress, 1st Session, Committee on Un-American Activities, *Hearings,* October 27, 1947.

MR. STRIPLING: What year?

MR. LAWSON: 1894.

MR. STRIPLING: Give us the exact date.

MR. LAWSON: September 25.

MR. STRIPLING: Mr. Lawson, you are here in response to a subpoena which was served upon you on September 19, 1947; is that true?

MR. LAWSON: That is correct.

MR. STRIPLING: What is your occupation, Mr. Lawson?

MR. LAWSON: I am a writer.

MR. STRIPLING: How long have you been a writer?

MR. LAWSON: All my life—at least thirty-five years—my adult life.

MR. STRIPLING: Are you a member of the Screen Writers Guild?

MR. LAWSON: The raising of any question here in regard to membership, political beliefs, or affiliation—

MR. STRIPLING: Mr. Chairman—

MR. LAWSON: —is absolutely beyond the powers of this Committee.

MR. STRIPLING: Mr. Chairman—

MR. LAWSON: But—

(*The chairman pounding gavel.*)

MR. LAWSON: It is a matter of public record that I am a member of the Screen Writers Guild. . . .

MR. STRIPLING: I repeat the question, Mr. Lawson: Have you ever held any position in the Screen Writers Guild?

MR. LAWSON: I stated that it is outside the purview of the rights of this Committee to inquire into any form of association—

THE CHAIRMAN: The Chair will determine what is in the purview of this Committee.

MR. LAWSON: My rights as an American citizen are no less than the responsibilities of this Committee of Congress.

THE CHAIRMAN: Now, you are just making a big scene for yourself and getting all "het up." (*Laughter.*) Be responsive to the questioning, just the same as all the witnesses have. You are no different from the rest. Go ahead, Mr. Stripling.

MR. LAWSON: I am being treated differently from the rest.

THE CHAIRMAN: You are not being treated differently.

MR. LAWSON: Other witnesses have made statements, which included quotations from books, references to material which had no connection whatsoever with the interest of this Committee.

THE CHAIRMAN: We will determine whether it has connection. Now, you go ahead—

MR. LAWSON: It is absolutely beyond the power of this Committee to inquire into my association in any organization.

THE CHAIRMAN: Mr. Lawson, you will have to stop or you will leave the witness stand. And you will leave the witness stand because you are in contempt. That is why you will leave the witness stand. And if you are just trying to force me to put you in contempt, you won't have to try much

harder. You know what has happened to a lot of people that have been in contempt of this Committee this year, don't you?

MR. LAWSON: I am glad you have made it perfectly clear that you are going to threaten and intimidate the witnesses, Mr. Chairman.

(*The Chairman pounding gavel.*)

MR. LAWSON: I am an American and I am not at all easy to intimidate, and don't think I am.

(*The Chairman pounding gavel.*)

MR. STRIPLING: Mr. Lawson, I repeat the question. Have you ever held any position in the Screen Writers Guild?

MR. LAWSON: I have stated that the question is illegal. But it is a matter of public record that I have held many offices in the Screen Writers Guild. I was its first president in 1933, and I have held office on the board of directors of the Screen Writers Guild at other times.

MR. STRIPLING: You have been employed in the motion-picture industry, have you not?

MR. LAWSON: I have.

MR. STRIPLING: Would you state some of the studios where you have been employed?

MR. LAWSON: Practically all of the studios, all the major studios.

MR. STRIPLING: As a screen writer?

MR. LAWSON: That is correct.

MR. STRIPLING: Would you list some of the pictures which you have written the script for?

MR. LAWSON: I must state again that you are now inquiring into the freedom of press and communications, over which you have no control whatsoever. You don't have to bring me here three thousand miles to find out what pictures I have written. The pictures that I have written are very well known. They are such pictures as *Action in the North Atlantic, Sahara*—

MR. STRIPLING: Mr. Lawson, are you now or have you ever been a member of the Communist Party of the United States?

MR. LAWSON: In framing my answer to that question I must emphasize the points that I have raised before. The question of Communism is in no way related to this inquiry, which is an attempt to get control of the screen and to invade the basic rights of American citizens in all fields.

MR. McDOWELL: Now, I must object—

MR. STRIPLING: Mr. Chairman—

(*The Chairman pounding gavel.*)

MR. LAWSON: The question here relates not only to the question of my membership in any political organization, but this Committee is attempting to establish the right—

(*The Chairman pounding gavel.*)

MR. LAWSON: —which has been historically denied to any committee of this sort, to invade the rights and privileges and immunity of American

citizens, whether they be Protestant, Methodist, Jewish, or Catholic, whether they be Republicans or Democrats or anything else.

THE CHAIRMAN (*pounding gavel*): Mr. Lawson, just quiet down again. Mr. Lawson, the most pertinent question that we can ask is whether or not you have ever been a member of the Communist Party. Now, do you care to answer that question?

MR. LAWSON: You are using the old technique, which was used in Hitler Germany in order to create a scare here—

THE CHAIRMAN (*pounding gavel*): Oh—

MR. LAWSON: —in order to create an entirely false atmosphere in which this hearing is conducted—

(*The Chairman pounding gavel.*)

MR. LAWSON: —in order that you can then smear the motion-picture industry, and you can proceed to the press, to any form of communication in this country.

THE CHAIRMAN: You have learned—

MR. LAWSON: The Bill of Rights was established precisely to prevent the operation of any committee which could invade the basic rights of Americans. Now, if you want to know—

MR. STRIPLING: Mr. Chairman, the witness is not answering the question.

MR. LAWSON: If you want to know—

(*The Chairman pounding gavel.*)

MR. LAWSON: —about the perjury that has been committed here and the perjury that is planned—

THE CHAIRMAN: Mr. Lawson—

MR. LAWSON: —permit me and my attorneys to bring in here the witnesses that testified last week and permit us to cross-examine these witnesses, and we will show up the whole tissue of lies—

THE CHAIRMAN (*pounding gavel*): We are going to get the answer to that question if we have to stay here for a week. Are you a member of the Communist Party, or have you ever been a member of the Communist Party?

MR. LAWSON: It is unfortunate and tragic that I have to teach this Committee the basic principles of American—

THE CHAIRMAN (*pounding gavel*): That is not the question. That is not the question. The question is: Have you ever been a member of the Communist Party?

MR. LAWSON: I am framing my answer in the only way in which any American citizen can frame his answer to a question which absolutely invades his rights.

THE CHAIRMAN: Then you refuse to answer that question; is that correct?

MR. LAWSON: I have told you that I will offer my beliefs, affiliations, and everything else to the American public, and they will know where I stand.

THE CHAIRMAN (*pounding gavel*): Excuse the witness—

MR. LAWSON: As they do from what I have written.

THE CHAIRMAN (*pounding gavel*): Stand away from the stand—

MR. LAWSON: I have written Americanism for many years, and I shall continue to fight for the Bill of Rights, which you are trying to destroy.

THE CHAIRMAN: Officers, take this man away from the stand—.

. . .

5

In Defense of the Hollywood Ten
October 1947

Before HUAC heard their testimony, the Hollywood Ten (or Nine-teen) were getting enormous support from their friends in the industry. John Huston organized a Committee for the First Amendment in their behalf. Within weeks it counted 500 members and had become the Committee of One Thousand. Twenty-eight of them, including Huston, Humphrey Bogart, Lauren Bacall, Ira Gershwin, Sterling Hayden, June Havoc, Gene Kelly, and Danny Kaye came to Washington for the hearings with a petition, of which the following is a part, and presented it to the House. Suffice it to say, the petition went nowhere, public sentiment being what it was. The committee quickly dissolved, its members themselves coming under suspicion. "Hell, I'm no politician," Bogart said contritely, "that's what I meant when I said our Washington trip was a mistake."

. . . 1. The investigative function of the Committee on Un-American Activities has been perverted from fair and impartial procedures to un-fair, partial and prejudiced methods.

II. The reputations and characters of individuals have been smeared and besmirched in the following manner:

a. The Committee on Un-American Activities has been guilty of a violation of the long established Anglo-Saxon-American principles of individual accountability. They have accomplished this by adopting the "mass guilt", i.e., guilt by association. Not only have the subpoenaed witnesses suffered by these methods, but mass lists have been publicized that contained many names of other people. These people were included in lists which have been designated by Committee members and counsel as "subversive," "pinko," "radical," "communistic," "disloyal," "un-American," etc. These people were neither subpoenaed nor given the opportunity to defend their characters.

b. The proceedings of the Committee have come to be regarded by the American people as a criminal trial. Nevertheless, American citizens have not been given the American privilege of ordinary self-defense and the right to cross-examine their accusers. The accused witnesses have become defendants in fact, have not been allowed the right of obtaining witnesses to testify on their behalf. Neither have they been allowed the full right of professional counsel in the defense of their characters.

Excerpted from *Report on Blacklisting*, Part I, John Cogley (New York: Fund for the Republic, 1956), 4–5. Copyright 1956 by Fund for the Republic.

c. Moreover, while theoretically the Committee is not supposed to apply punitive measures, because of its procedural abuses, it has punished individuals in a far more damaging way than the assessment of fines or personal imprisonment. They have done this by besmirching and damaging man's most precious possession, his reputation. . . .

6

Hollywood's Response
December 3, 1947

It did not take long for the film studios—which is to say, the New York financial interests that ran them—to capitulate before the onslaught of adverse publicity. No sooner were the Hollywood Ten cited for contempt than industry leaders, meeting at the Waldorf-Astoria, made the decision summed up in this extraordinary statement, extraordinary because it had the temerity to claim that never would the industry be "swayed by hysteria or intimidation from any source."

Members of the Association of Motion Picture Producers deplore the action of the ten Hollywood men who had been cited for contempt. We do not desire to prejudge their legal rights, but their actions have been a disservice to their employers and have impaired their usefulness to the industry.

We will forthwith discharge or suspend without compensation those in our employ and we will not re-employ any of the ten until such time as he is acquitted or has purged himself of contempt and declares under oath that he is not a Communist.

On the broader issues of alleged subversive and disloyal elements in Hollywood, our members are likewise prepared to take positive action.

We will not knowingly employ a Communist or a member of any party or group which advocates the overthrow of the Government of the United States by force or by illegal or unconstitutional methods. In pursuing this policy, we are not going to be swayed by hysteria or intimidation from any source. We are frank to recognize that such a policy involves dangers and risks. There is the danger of hurting innocent people. There is the risk of creating an atmosphere of fear. Creative work at its best cannot be carried on in an atmosphere of fear. We will guard against this danger, this risk, this fear. To this end we will invite the Hollywood talent guilds to work with us to eliminate any subversives, to protect the innocent, and to safeguard free speech and a free screen wherever threatened.

Excerpted from *The Inquisition in Hollywood: Politics in the Film Community, 1930–1960,* Larry Ceplair and Steven Englund (Garden City: Doubleday Anchor, 1980), 445. Copyright 1980 by Doubleday Anchor.

7

Trying the Communists
January 16, 1949

January 16th was the day the trial of the twelve (soon reduced to eleven) top Communists began in Manhattan on the basis of the indictment excerpted below. It was a tumultuous trial—thanks largely to Judge Harold Medina, who hardly concealed his bias—that lasted the better part of the year. (Not that the Communists' lawyers—most of whom themselves went to jail for contempt—distinguished themselves either.) The guilty verdict surprised no one.

The grand jury charges:

1. That from on or about April 1, 1945, and continuously thereafter up to and including the date of the filing of this indictment, in the Southern District of New York, and elsewhere, William Z. Foster, Eugene Dennis, also known as Francis X. Waldron Jr., John B. Williamson, Jacob Stachel, Robert G. Thompson, Benjamin J. Davis Jr., Henry Winston, John Gates, also known as Israel Regenstreif, Irving Potash, Gilbert Green, Carl Winter, and Gus Hall, also known as Arno Gust Halberg, the defendants herein, unlawfully, wilfully, and knowingly, did conspire with each other, and with divers other persons to the grand jurors unknown, to organize as the Communist party of the United States of America a society, group, and assembly of persons who teach and advocate the overthrow and destruction of the Government of the United States by force and violence, and knowingly and wilfully to advocate and teach the duty and necessity of overthrowing and destroying the Government of the United States by force and violence, which said acts are prohibited by Section 2 of the Act of June 28, 1940 (Section 10, Title 18, United States Code), commonly known as the Smith Act. . . .

8. It was further a part of said conspiracy that said defendants would cause to be organized clubs, and district and state units of said party, and would recruit and encourage the recruitment of members of said party.

9. It was further a part of said conspiracy that said defendants would publish and circulate, and cause to be published and circulated, books, articles, magazines, and newspapers advocating the principles of Marxism-Leninism.

10. It was further a part of said conspiracy that said defendants would conduct, and cause to be conducted, schools and classes for the study of the principles of Marxism-Leninism, in which would be taught and advocated the duty and necessity of overthrowing and destroying the Government of the United States by force and violence.

The New York Times, January 17, 1949.

4

Liberal Response and Counterresponse

1

As World War II drew to a close, long-standing tensions within the liberal community broke out into the open over Communism. That was because Communists (along with fellow travelers, sympathizers, etc.) had, as noted, rejoined the popular front segment of that community during the war. By 1945 conflicts between those who favored or opposed accommodation with Communism at home and abroad were flaring up wherever Communists established a significant presence: in New York's American Labor Party (a huge vote-getting alternative to the Tammany controlled Democratic Party), in Minnesota's formidable Farmer-Labor Party, and among California and Washington state Democrats.

It was soon apparent which faction would, by sheer mass and distinction, represent the liberal faith. At the heart of that resolutely anti-Communist faction was the newly organized Americans for Democratic Action, which boasted such impressive names as Eleanor Roosevelt, theologian Reinhold Neibuhr, United Auto Workers president Walter Reuther, and up and coming Minneapolis mayor Hubert H. Humphrey, among others of considerable renown. And while these hearty New Dealers often made President Truman aware that he was no Roosevelt, they stood with him in his dispute with Henry Wallace over foreign and domestic policies.

For pro- and anti-popular front liberals to fight it out among themselves, intramurally, as they did between 1945 and 1947, was one

thing. Quite another was the public's intervention, which occurred when the Truman administration introduced McCarthyism as a co-belligerent.

The executive order setting up loyalty review boards threw down a challenge to anti-Communist liberals. On its face it violated cherished liberal principles of due process. But on political grounds most liberals, some reluctantly, some not, went along with it. They believed (as did James Wechsler: see his piece on p. 54) that the loyalty review procedures were infinitely preferable to the draconian ones that the right would impose should it get the chance, that they were, under the circumstances, the least painful way to assuage the public's demand for blood, and that they could be eminently responsible and fair in locating dangerous subversives. A number of idealistic liberals (if we can call them that) spoke out against the Truman order, which they regarded as a dangerous concession to arbitrary power, with all its built-in abuse, and only the beginning of worse to come. (See Commager's argument on p. 52.) But the idealistic liberals, ridiculed or applauded for their naiveté, counted for little as time went by.

2

Like the Truman administration, then, the liberal community in general got caught up in the logic of making concessions to McCarthyism, especially after the Republican congressional sweep of 1946. Liberals backed Truman's veto of the anti-union Taft-Hartley Act, but, like Truman, they had no demonstrable objection to its McCarthyite feature, section 9(h). Interestingly, it was the conservative and autocratic boss of the mine workers' union, John L. Lewis, who suggested that organized labor should resist section 9(h). On the contrary, as Lewis surely knew, most labor leaders, though they despised the act as a whole, were pleased with the prospect of getting rid of the reds, whom they despised quite as much. True, liberals protested the 1949 trial of top Communists, but grudgingly, for the victims deserved to be punished, abominations that they were. But better than trying and jailing them—so liberals held—Communists should, like Cain, be labeled and shunned and left to wander the earth among strangers. That Communists appreciated this position, as ungenerous as it was self-defeating, may be doubted. If they were so abominable why should society *not* prosecute and jail them? Why should they *not* be deprived of their privileges and immunities?

At any rate, liberal groups did not take long to fall in line with the ethos of McCarthyism. The American Civil Liberties Union conducted its own purge of Communists or fellow travelers, the philosopher Corliss Lamont chief among them—his great wealth enabled Lamont to then launch the Emergency Civil Liberties Union, which specialized in defending people like him—this apart from its all too intimate relationship with the FBI. The National Association for the Advancement of Colored People loudly asserted its loyalty to America and its dislike of those African

Amercians—e.g., singer/actor Paul Robeson and the distinguished social scientist W. E. B. DuBois and those who belonged to the Civil Rights Congress—whose sundry persecutions they brought on themselves, according to the NAACP, because they flouted their sympathy for Communism. Robeson, his career destroyed, settled for a while in East Germany; DuBois joined the party near the end of his life; and the CRC, hounded to distraction, gave up the ghost.

The most flagrantly hostile act of liberal anti-Communism was the CIO's expulsion of its Communist-led unions in 1949. These unions— e.g., the Electrical Workers, the West Coast longshoremen, the Farm Equipment Workers, etc.—had been instrumental in the organization of the mass production industries and were closely connected to popular front liberalism. Nor, in the proceedings that led to their ouster, were they accused of malfeasance, corruption, racketeering, and the like. They were accused of supporting the Soviet Union rather than the United States, that is, opposing President Truman's foreign policy. Liberal anti-Communists did not criticize the expulsions on the grounds that it was an internal or private matter, involving no public agency, no government coercion. The argument is disingenuous. By now the labor movement heavily depended on government, on its enforcement of regulations affecting unions and on the largess it provided for many labor-sponsored programs, foreign and domestic. At the same time, the unions were more solidly allied with the administration and the Democratic Party than ever. Implicit in the expulsions was the belief that now organized labor would have full public support for its further and indefinite expansion. Its future never looked brighter.

Anti-Communist or Cold War liberals saw the 1948 presidential election as their vindication. Their popular front rivals were routed, and the New Deal was reaffirmed. Their euphoria thus rested on the conviction that the fate of the republic rested on their brand of liberalism—the liberalism of the "vital center," historian Arthur Schlesinger, Jr.'s, felicitous expression for the sort of hegemony they envisioned, according to which the welfare state would continue to expand at home (e.g., Truman's "Fair Deal") while Communism would be safely contained abroad and extremists of the left and right, utopians and ideologues, would be consigned to the trashcan of politics. All would be well in the best of possible worlds of the vital center.

This Panglossian vision received its most intelligent riposte from Dalton Trumbo, the best of the screenwriters among the Hollywood Ten Communists. In his pamphlet, *Time of the Toad,* Trumbo offered Schlesinger and the liberals a piece of paradoxical advice: for the sake of the very liberalism they professed they should defend Communists unconditionally, with their heart and soul. For without the Communists to the left of them, he asked, where would the vital center lie? Without Communists and other radicals raising hell, how would liberalism come across as moderate and legitimate to the American Masses? But if Schlesinger and the liberals were

familiar with the sensible dialectical way of thinking, politically they gave no indication of it, and they certainly did not follow it. They thought that the masses sided with their ideas for precisely the opposite reason, because they, the liberals, condemned the Communists and the advocates of the popular front and even supported measures to repress them.

<h2 style="text-align:center">3</h2>

Another and more intransigent form of anti-Communist liberalism must be mentioned because it anticipated the upsurge of virulent McCarthyism.

Intransigently anti-Communist liberals found their most effective advocate in philosopher Sidney Hook. Once a Communist or fellow traveler himself, Hook for years had been damning Communism and its soft-headed dupes—i.e., popular fronters—in the name if his own reading of Marx. He was a brilliant polemicist, as anyone who crossed swords with him could testify. It was in one of his famous polemics, a 1950 article, "Heresy Yes, Conspiracy No" (later expanded into a book, from which the passage below is excerpted), that Hook directly addressed mainstream liberals, often so susceptible to dupery, on the Communist issue. The title sums up his thesis. Liberals, he asserted, must be as ruthless toward Communists as brute reality dictated, Communists being conspirators on behalf of the Soviet Union and disloyal to public trust and not heretics in the grand American tradition of dissent. Liberals, it followed, should get over their scruples and call for the automatic dismissal of such moral traitors from public employment and presumably from private as well, lest the damage they do be irreparable.

But Hook failed to clear up the problem, inherent in his argument, which must have given every conscientious liberal, or American, pause. If Communists were by definition so skilled at cunning and dissimulation, how could they be found out? By what criteria were they to be distinguished from the innocent? Brushing aside these procedural niceties, Hook favored granting inquisitors what anounted to carte blanche authority to go after suspects. Here, then, was the rationale for a full-scale witch-hunt. And indeed, by the time "Heresy Yes, Conspiracy No" appeared as a book in 1953 that witch-hunt had become a fact of American life. Whether it disturbed Hook we have no way of knowing; he gave no sign of it in his writings. Communist perfidy remained his and the intransigent liberals' obsession.

1

Liberal Idealism: Contra Loyalty Reviews
September 1947

Five months after Truman's executive order, historian Henry Steele Commager excoriated the whole idea of loyalty review boards in an article ("Who Is Loyal to America") for *Harper's Magazine* and implied that it would be the opening assault on liberal reform itself.

. . . Finally, disloyalty tests are not only futile in application, they are pernicious in their consequences. They distract attention from activities that are really disloyal, and silence criticism inspired by true loyalty. That there are disloyal elements in America will not be denied, but there is no reason to suppose that any of the tests now formulated will ever be applied to them. It is relevant to remember that when Rankin was asked why his Committee did not investigate the Ku Klux Klan he replied that the Klan was not un-American, it was American!

Who are those who are really disloyal? Those who inflame racial hatreds, who sow religious and class dissensions. Those who subvert the Constitution by violating the freedom of the ballot box. Those who make a mockery of majority rule by the use of the filibuster. Those who impair democracy by denying equal educational facilities. Those who frustrate justice by lynch law or by making a farce of jury trials. Those who deny freedom of speech and of the press and of assembly. Those who press for special favors against the interest of the commonwealth. Those who regard public office as a source of private gain. Those who would exalt the military over the civil. Those who for selfish and private purposes stir up national antagonisms and expose the world to the ruin of war.

Will the House Committee on Un-American Activities interfere with the activities of these? Will Mr. Truman's disloyalty proclamation reach these? Will the current campaigns for Americanism convert these? If past experience is any guide, they will not. What they will do, if they are successful, is to silence criticism, stamp out dissent—or drive it underground. But if our democracy is to flourish it must have criticism, if our government is to function it must have dissent. Only totalitarian governments insist upon conformity and they—as we know—do so at their peril. Without criticism abuses will go unrebuked; without dissent our dynamic system will become static. The American people have a stake in the maintenance of the most thorough-going inquisition into American institutions. They have a stake in nonconformity, for they know that the American genius is nonconformist. They have a stake in experimentation of the most

radical character, for they know that only those who prove all things can hold fast that which is good.

It is easier to say what loyalty is not than to say what it is. It is not conformity. It is not passive acquiescence in the status quo. It is not preference for everything American over everything foreign. It is not an ostrich-like ignorance of other countries and other institutions. It is not the indulgence in ceremony—a flag salute, an oath of allegiance, a fervid verbal declaration. It is not a particular creed, a particular version of history, a particular body of economic practices, a particular philosophy.

It is a tradition, an ideal, and a principle. It is a willingness to subordinate every private advantage for the larger good. It is an appreciation of the rich and diverse contributions that can come from the most varied sources. It is allegiance to the traditions that have guided our greatest statesmen and inspired our most eloquent poets—the traditions of freedom, equality, democracy, tolerance, the tradition of the higher law, of experimentation, co-operation, and pluralism. It is a realization that America was born of revolt, flourished on dissent, became great through experimentation.

Independence was an act of revolution; republicanism was something new under the sun; the federal system was a vast experimental laboratory. Physically Americans were pioneers; in the realm of social and economic institutions, too, their tradition has been one of pioneering. From the beginning, intellectual and spiritual diversity have been as characteristic of America as racial and linguistic. The most distinctively American philosophies have been transcendentalism—which is the philosophy of the Higher Law—and pragmatism—which is the philosophy of experimentation and pluralism. These two principles are the very core of Americanism: the principle of the Higher Law, or of obedience to the dictates of conscience rather than of statutes, and the principle of pragmatism, or the rejection of a single good and of the notion of a finished universe. From the beginning Americans have known that there were new worlds to conquer, new truths to be discovered. Every effort to confine Americanism to a single pattern, to constrain it to a single formula, is disloyalty to everything that is valid in Americanism.

2

Liberal Realism: Pro Loyalty Reviews
November 1947

In *Harper's* in November 1947, well-known journalist to be James Wechsler, a deeply committed New Deal liberal, defended the administration's loyalty program ("How to Rid the Government of Communists"), in effect accusing Commager and liberals like him of being naive about the Communist threat, and about the conservative one as well.

In his eloquent plea for national sanity in *Harper's,* two months ago, Henry Steele Commager left unresolved the narrow but disturbing question now confronting this government: how can men in a movement run by a foreign power be eliminated from government without injustice and hysteria? How does democratic society protect itself without destroying its own character and emulating the totalitarianism it seeks to resist?

Two persuasive premises guide the thinking of the men who are now shaping government policy in this elusive realm. The first is that we are engaged in a worldwide diplomatic and ideological struggle with Russia, with little prospect that the conflict will be swiftly or easily resolved; the second is that one of Russia's most valuable weapons—present and potential—is an international army of agents organized as "native" Communist parties. Reasonable men must be legitimately frightened by the dimensions this two-world conflict has reached and the danger that it will end in the ultimate catastrophe or war; but unless one argues, as Henry Wallace appears to, that the burden of guilt in this duel rests on America and unless one dismisses as fantasy the modern record of the Communist parties, the need for minimum safeguards seems inescapable. . . .

Any "purge," however circumspect and limited, involves risks to democratic institutions. The hazards must be balanced against the consequences of wide-eyed innocence and simple-minded incredulity. . . . Communists (no less than fascists who operate in any remnants of the Nazi International and in such unites of potential fascist resurgence as The Christian Front) must be excluded from government—while their rights to raise hell through the public channels of democratic debate are vigorously reaffirmed. Ideas are not the enemy; an awareness of the distinction between communism as an idea and the Communist parties as battalions of Soviet espionage and sabotage is essential to any national wisdom. It is that distinction which both Congressman Rankin and William Z. Foster try to blur. Rankin, and the frightened men around him, would destroy all dissent as an expression of "communism." Foster publicly depicts the Communist party as a native American voice of dissent.

To say that these ambiguities are overwhelming and that any "loyalty" procedure in government is intrinsically doomed to become a replica of the Palmer raids in 1920 is in effect to let reaction run the program as it pleases. For the Communist apparatus does exist in the real world. If liberals cannot face the reality of Communist intrigue as they once recognized the scope of the fascist fifth column, the Congressional cops will run the show; if liberals cannot offer an affirmative, clearly-defined plan of democratic self-defense the witch-hunt may truly be upon us. . . .

The resilience of democratic society has repeatedly proved greater than the extreme right and extreme left have acknowledged. It faces a new test now. But on the basis of the evidence so far, the reports of democracy's death have once again been exaggerated. The loyalty program, despite a bad beginning, can still make sense.

3

In Defense of Liberal Anti-Communism
1949

Arthur Schlesinger, Jr., was a New Deal liberal of parts. He was a young Harvard professor of American history who wrote the highly praised (and best-selling) *Age of Jackson,* had a syndicated newspaper column and played an active role in Democratic Party affairs. His 1949 book, *The Vital Center,* set forth the basic liberal anti-Communist argument of the early Cold War years. The selection below tacitly justifies President Truman's translation of that argument into domestic policy.

. . . From the beginning, the Party had in addition an underground arm, operating apart from the formal organization of the CPUSA and working as the American section of the Socialist secret intelligence corps. Because clandestine operations of this kind are utterly foreign to American political life, many Americans dismiss them as wild fabrication. They are naive to do so. Doctrine and experience have equipped the CPUSA for underground activity. Leninism sanctioned the use by the Party of all methods in their war for survival against the American business classes; and the early history of the Party—A. Mitchell Palmer and the meeting at Bridgman, Michigan—confirmed in the minds of the Party leadership (both Foster and Browder were at Bridgman) an enduring psychology of clandestinity. Police raids, FBI penetration and civil persecution have fortified the Communist belief that they are a small and ill-armed band, acting in a ruthlessly hostile environment, and justified in using any methods to advance their cause.

The underground arm of the Party works through secret members and through fellow travelers. Secret members report directly to a representative of the National Committee; they have no local affiliations, are exempt from the usual Party discipline and are unknown to most of their Party brethren. Their Party cards usually are held in aliases, so that in the files they appear as "John Smith" with P.N. (party name) noted beside it. Fellow travelers are those who for one reason or another wish to keep some elbow room but maintain relations practically as close as actual membership. A curious freemasonry exists among underground workers and sympathizers. They can identify each other (and be identified by their enemies) on casual meeting by the use of certain phrases, the names of certain friends, by certain enthusiasms and certain silences. It is reminiscent of nothing so much as the famous scene in Proust where the Baron de Charlus and the tailor Jupien suddenly recognize their common corruption; "one does not arrive spontaneously at that pitch of perfection except when one meets in a

Excerpted from *The Vital Center,* Arthur Schlesinger, Jr. (Boston: Houghton Mifflin, 1949), 126–9. Copyright by Houghton Mifflin. Reprinted by permission.

foreign country a compatriot with whom an understanding then grows up of itself, both parties speaking the same language, even though they have never seen one another before."

There can be no serious question that an underground Communist apparatus attempted during the late thirties and during the war to penetrate the United States Government, to influence the formation of policy and even to collect intelligence for the Soviet Union. Though certain of the individual accusations, especially those of Elizabeth Bentley, are undoubtedly exaggerated, yet a hard substratum of truth survives in the stories told before the federal grand jury. . . .

These, then, are the proportions of the Communist movement in the United States: an organized party of 70,000 members, extending its influence by means of an underground apparatus and through the collaboration of fellow travelers; controlling a political party, several trade unions and a great many front organizations, and exerting a lingering power in cultural circles.

What kind of challenge does all this present to the United States? The espionage dangers, of course, are obvious and acute. No loyal citizen can underestimate these dangers, although there is probably little that he can do individually to grapple with them. All Americans must bear in mind J. Edgar Hoover's warning that counter-espionage is no field for amateurs. We need the best professional counterespionage agency we can get to protect our national security.

Beyond this field, however, it is hard to argue that the CPUSA in peacetime presents much of a threat to American security. In every area where Communist influence can be identified and exposed, the Communists have lost ground in the last two years. Does anyone seriously believe that even the Communist Party is absurd enough to contemplate a violent revolution in the United States? . . .

4

A Communist Advises Anti-Communist Liberals
1949

By the time he appeared before the HUAC as one of the Hollywood Ten, the writer Dalton Trumbo had twenty-seven screen credits to his name. His high salary reflected his status in the industry. He wrote a tract, *The Time of the Toad,* while awaiting the disposition of his contempt citation. (With the others he went to jail in 1950.) In it Trumbo attempted to prove how short-sighted, how destructive to their own cause, anti-Communist liberals like Arthur Schlesinger, Jr., were.

. . . Sometimes the inflamed grenadiers of the cold war, even though moving toward a common goal, break the line of march to stab a laggard, as when Mr. Arthur M. Schlesinger, Jr., defending "The Right to Loathsome Ideas" among university personnel, ran afoul of Mr. Morris Ernst.

From the chilly heights of three years at Harvard, where he holds an associate professorship in the department in which his father occupies the Francis Lee Higginson chair of history, Mr. Schlesinger hurled the epithet "wretched nonentities" at three University of Washington professors who, combining sixty-six years of university teaching in their total experience, had been discharged—two for stating they were Communists, one for saying he had been.

Deploring the fact that the discharged men are "far more powerful in martyrdom than they were in freedom," and denouncing them as "contemptible individuals who have deliberately loved a political lie"— although it was their statement of the truth which proved their undoing— Mr. Schlesinger arrived at the tortuous conclusion that, "No university administration in its right senses could knowingly hire a Communist. . . . But, once given academic tenure, none of these can properly be fired on the basis of beliefs alone short of clear and present danger."

Mr. Ernst, perceiving the flaws in the argument, hastened to point out that the moral right to refuse to hire a scoundrel also carries with it the obligation to fire him, no matter how long he has browsed in the academic pasture. As for Mr. Schlesinger's theory of free speech in relation to clear and present danger, Mr. Ernst developed a totally new concept of speech. He distinguished between free speech as commonly practiced, and "secret speech" as practiced by the Communists. The latter variety, he asserted, carries with it no immunities whatever.

Mr. Louis Russell, investigator for the Un-American Activities Committee and an avid reader of the *Daily Worker,* the *People's World, Masses and Mainstream,* and *Political Affairs,* would be perplexed at Mr. Ernst's

Excerpted from *The Time of the Toad,* Dalton Trumbo (West Nyack: Journeyman Press, 1979), 43–4. Copyright 1979 by Journeymen Press.

ideas about the "secrecy" of such speech. But he would agree with his conclusion, as one day Mr. Schlesinger will too, if he hasn't already; for they are all possessed, in varying degrees, of the same affliction. . . .

But it should occur in this battle of the mind against encroaching and oppressive law that an occasional Communist appears upon the lists, he must be defended too. Not with the high-piping invective of a Schlesinger, not while calling him a scoundrel worthy of hell's damnation, for if you defend him in this manner your case is fatally weakened. If, because of the political labels attached to men, you have lost all capacity to judge them by their words and acts; if, in brief, you believe a Communist to be a scoundrel per se, then you cannot defend him. But by the bitter necessities of history and of logic, neither can you defend yourself.

Adolph Hitler said: "Bismark told us that liberalism was the pacemaker of Social Democracy. Indeed not say here that Social Democracy is the pace-maker of Communism." Similarly Mr. J. Parnell Thomas equates "New Dealism" with Communism.

The legal principles which protect one against the force of the state protect all. If a Communist comes first under attack and is overwhelmed, the breach opened by his fall becomes an avenue for the advance of the enemy with all his increased prestige upon you. You need not agree with the Communist while you engage in his and your common defense. You may, indeed, oppose him with every honorable weapon in your arsenal, dissociate yourself from his theories and repudiate his final objectives. But defend him you must, for his defeat in the Constitutional battle involves the overturn of principles which thus far have stood as our principal barrier, short of bloodshed, against fascism. . . .

5
Throwing the Communists Out of the CIO
November 1949

By 1949 the CIO as a whole was ready to expel its Communist-led unions—unions that had been instrumental in establishing the organization and winning its victories. To Walter Reuther, a left-liberal of impeccable credentials, fell the main task of arguing the CIO's case. It was in fact not so much an argument as a pretext: Nothing less than total renunciation would have saved the unions in question from their preordained fate. Included below are responses by the Communist side.

. . . The Committee recommends that the Constitution of the C.I.O. adopted in Potland, Oregon, on November 25, 1948, be re-adopted by this Convention as of this date, November 1, 1949, with the following changes:

(A) Page 10: Article IV concerning Officers and Executive Board is amended by the insertion of a new Section 4 which reads as follows: "Section 4. No individual shall be eligible to serve either as an officer or as a member of the Executive Board who is a member of the Communist Party, any fascist organization, or other totalitarian movement, or who consistently pursues policies and activities directed toward the achievement of the program or the purposes of the Communist Party, any fascist organization, or other totalitarian movement, rather that the objectives and policies set forth in the constitution of the C.I.O." . . .

JOSEPH SELLY, PRESIDENT
OF THE AMERICAN COMMUNICATIONS ASSOCIATION

Several speakers have referred to the fact that this proposed amendment to the constitution represents a fundamental and basic change in the character of this labor organization, of this Federation. I don't think that point can receive too much emphasis. It is my humble opinion that the adoption of this resolution so completely reverses the fundamental policies of C.I.O. on which it was founded as to make the organization unrecognizable, as to give it a character not only different but the opposite of the character it formerly enjoyed.

And what was the fundamental characteristic of C.I.O. which endeared it to millions of workers throughout this country, which made it possible to conduct effectively an organizing job among all the groups in this country, which made it the hope and made it express the aspirations of

Congress of Industrial Organizations, Eleventh Constitutional Convention, *Proceedings* (Cleveland, 1949), 240, 262–3, 267, 314–6.

the Negro group and other minority groups, the people of my own faith, the Jewish faith, and all other peoples? That characteristic was that C.I.O., unlike the organizations that preceded it, was founded on the principle of the democratic rights of the rank and file of the organizations affiliated to it.

We have spoken much at one convention after another on civil rights resolutions and other resolutions about our devotion to the fundamental American principle of freedom of thought and expression. Let me remind you gentlemen that is pure demagogy unless we agree such freedom of thought and expression, freedom of opinion and differences must be granted to the minority group; and I will go further and say unless we learn the lesson that there must be tolerance not merely of a minority but a minority of unpopular opinions, unless that remains the policy of C.I.O. we will have surrendered one of the most cherished heritages of the American people.

A long time ago the revolutionists set this yardstick to judge the kind of nation we should have today,—and I am referring to Washington and Jefferson and William Lloyd Garrison and Wendell Phillips, those gentlemen, risking their lives for this principle, were subjected to abuse. Garrison was rode through the streets of Boston because he dared to say the Negroes should be free and were equal to the white man. He dared to say that in an atmosphere where it was an unpopular opinion; but the people fortunately ultimately acknowledged the principles of Jefferson and Garrison and Phillips and history affirmed what they stated in the beginning. . . .

All of us, of course, get up and say we are in favor of the enforcement of the Constitution of the United States and of the Bill of Rights. All of us have engaged in many struggles in order to make this a reality, and I urge upon those whose support this resolution that they consider carefully what they are doing, because they are here now proposing an amendment to the C.I.O. constitution which they are at the same time arguing is in violation of the Constitution of the United States and of the Bill of Rights. We are considering here the enactment of a loyalty oath, a purgatory oath. . . .

WALTER REUTHER, PRESIDENT
OF THE UNITED AUTO WORKERS

Every time you get into this basic question as to whether or not free people, through their democratic organizations, have a right to protect themselves and their freedoms, these people raise pious, hypocritical slogans, they talk about unity, they talk about autonomy, they talk about the democratic rights of the minority, they raise the civil rights issue, and they do everything they can to be-cloud the real issues involved in this debate. . . .

The Communist minority in our organization, like the disciplined

Communist majority throughout the world, want the rights and privileges without the obligations and responsibilities, and we are saying here and now that those people who claim the rights and privileges must also be prepared to accept the responsibilites of the obligations.

There is room in our movement for an honest difference of opinion. Sincere opposition is a healthy thing in a labor movement. But there is a fundamental difference between honest opposition and sincere difference of opinion and the kind of obstructionism and sabotage carried on by the Communist minority, because the Communist minority is a trade union opposition group who disagree with C.I.O. policies, because they believe that there are other policies that ought to take the place of our current policies. They are not a trade union group. In one sense they are to be pitied more than despised, because they are not free men, they are not free agents working in this movement. Their very souls do not belong to them. They are colonial agents using the trade union movement as a basis of operation in order to carry out the needs of the Soviet Foreign Office. And when you try to understand the basic characteristics of the Communist minority opposition group you have got to begin to differentiate between the kind of a minority opposition group of that kind and a minority opposition group that has a basic, honest trade union opposition in their differences with the official policies of their organization. . . .

HARRY BRIDGES, PRESIDENT OF THE WEST COAST LONGSHOREMEN'S UNION

The resolution, I notice, deals with a series of charges. There are four pages of the resolution in hysterical language setting forth reasons why the Union is so-called Communist dominated, and that its officers are serving as agents of a foreign union. And yet when I look at the charges I don't find one single charge that says the Union has not done a job for its members and has not organized hundreds of thousands of workers in an important basic industry, that the Union has not struggled to advance hours, wages and conditions—not a single economic charge is levied against the Union.

I look and I see that the resolution states that the charges are that they are Communist controlled, conceived and dominated—No. 1, in that the Union opposed the Marshall Plan. No. 2, the Union is against the Armament Pact, and so on down the line, the Atlantic Pact, etc. It goes onto say that the Union disagreed with the C.I.O. in matters of critical affairs, that the Union disagreed with the C.I.O. in their action to repeal the Taft-Hartley law, that the Union accepted into its ranks the Farm Equipment Workers.

I have here the minutes of the ILWU convention last April and a copy of a telegram sent by the C.I.O. It says here that any action taken with respect to the merger of the Farm Equipment Workers with another Union shall be by the voluntary action of its membership, and if the

membership of the Farm Equipment Workers want to join the UE, I would think that it's their business. However, the resolution speaks for itself in that respect. There is not one single charge that this Union has organized, has not improved wages and obtained seniority, union security, welfare plans, and other things.

So now we have reached the point where a trade union, because it disagrees on political matters with the National C.I.O. can be expelled. And yet we say we are not a political organization. Who is guilty of not following basic trade union policies and principles? In the Union that I represent, wages, hours, conditions, and the economic program come first. It has no loyalty to any political programs or any political party or any government except the American government. Neither does its membership nor its officers take second place to any union in their Americanism and their patriotism.

6

Liberal Anti-Communism in Extremis
1953

Sidney Hook, a philosophy professor and polemicist extraordinaire, had broken with Communism in the early 1930s. He remained a Marxist, combining it with a belief in American pragmatism, even as his hatred of Communism grew more and more virulent. The rise of McCarthyism gave Hook his opportunity to present his case for suppressing Communists in the name of the liberalism he claimed to value. He cogently set it forth in an essay, "Heresy Yes, Conspiracy No," for the July 9, 1950, *Sunday Times Magazine,* which he later expanded into a book of the same title.

. . . Who are the leaders of the ritualistic liberals? They are some "professional" liberals, who are more hostile to anti-Communists than to communists, some inhumanists who call themselves Humanists, some irrationalists who think of themselves as Rationalists, some who have actively cooperated with Communist front organizations and who still regard communism as a kind of left wing liberalism, some absolute pacifists and that extreme wing of the Quakers which believes in peace at any price—even the price of freedom. The habitat of this group is in the main in the colleges and universities but they are also found in strategic places in the media which influence public opinion. They consist, with the exception of a few fellow travelers of the Communist Party who have changed their strategy of infiltration, of men and women full of the milk of human kindness. Unfortunately they carry it in their head instead of their breast. . . .

The failure to recognize the distinction between heresy and conspiracy is fatal to a liberal civilization, for the inescapable consequence of their identification is either self-destruction when heresies are punished as conspiracies, or destruction at the hands of their enemies, when conspiracies are tolerated as heresies.

A heresy is a set of unpopular ideas or opinions on matters of grave concern to the community. The right to profess publicly a heresy of any character, on any theme, is an essential element of a liberal society. The liberal stands ready to defend the honest heretic no matter what his views against any attempt to curb him. It is enough that the heretic pays the price of unpopularity which he cannot avoid. In some respects each of us is a heretic, but a liberal society can impose no official orthodoxies of *belief,* disagreement with which entails loss of liberty or life.

A conspiracy, as distinct from a heresy, is a secret or underground movement which seeks to attain its ends not by normal political or educational processes but by playing outside the rules of the game. Because it

undermines the conditions which are required in order that doctrines may freely compete for acceptance, because where successful it ruthlessly destroys all heretics and dissenters, a conspiracy cannot be tolerated without self-stultification in a liberal society.

A heresy does not shrink from publicity. It welcomes it. Not so a conspiracy. The signs of a conspiracy are secrecy, anonymity, the use of false names and labels, and the calculated lie. It does not offer its wares openly but by systematic infiltration into all organizations of cultural life, it seeks to capture strategic posts to carry out a policy alien to the purposes of the organization. There is political conspiracy, which is the concern of the state; but there may also be a conspiracy against a labor union, a cultural or professional association, or an educational institution which is not primarily the concern of the state but of its own members. In general, whoever subverts the rules of a democratic organization and seeks to win by chicanery what cannot be fairly won in the process of free discussion is a conspirator.

Communist *ideas* are heresies, and liberals need have no fear of them where they are freely and openly expressed. They should be studied and evaluated in the light of all the relevant evidence. No one should be punished because he holds them. The Communist *movement,* however, is something quite different from a mere heresy, for wherever it exists it operates along the lines laid down by Lenin as guides to Communists of all countries, and perfected in great detail since then. . . .

It is or should be now clear that "association" by way of membership in the Communist Party is not innocent or coincidental but is *a form of active co-operation and collaboration* in carrying out the purposes of a conspiratorial organization. The Communist Party sees to it that all members are instructed about the purposes as seen as they join. Continued membership is possible only in virtue of a series of continued *acts* of obedience to instructions. Those who dub the active co-operation required of all members of the Communist party "guilt by association" coyly suggest by that phrase the innocuous association of chance or occasional encounters with Communists in social gatherings. They simply ignore the fact that all members of the Communist Party must "associate" by active co-operation with its purposes or be expelled.

Ritualistic liberals legitimately criticize the dangerous nonsense of those who proscribe heresy. But they carry their criticism to a point where they give the impression that the country is in the grip of a deadly reign of terror or hysteria much more dangerous than Communist expansion from without and infiltration from within. Because someone has given a silly characterization of a subversive organization, they imply that there are no subversive organizations. The sad history of recent American liberal movements, however, shows that the instructions given to American Communists by Otto Kuusinen, as Secretary of the Communist International, bore bitter fruit for liberals. Kuusinen advised: "We must create a whole solar system of organizations and smaller committees around the Communist

Party, so to speak, smaller organizations working under the influence of the Party." (*American Communist,* May 1931.)

The problem of membership in Communist front organizations which often conceal their purposes is much more difficult. Many innocent people have been ensnared by these organizations. No hard and fast rule can be laid down as a guide. The number of such organizations an individual has joined, the time he joined, his function and activities upon joining—all these, as we shall see, are highly relevant in determining the degree to which an individual is untrustworthy from the point of view of security. Only those exceptional souls who have never made a mistake or have never been fooled can shut the gates of understanding and charity against all members of such groups and pronounce a blanket judgment against them. This troublesome question should not be made a matter of legislation but of judicious administration.

Because some security regulations in government are questionable, and because some blunders have been made, ritualistic liberals intimate that no security regulations are necessary and that the existing laws against treason and criminal conspiracy are sufficient for all purposes. They do not understand that the purpose of the security program is not punishment for acts committed but prevention of acts threatened by those who are under instructions to commit them or whose behavior or habits make them dangerous risks. By artfully collecting instances of foolishness from the press and blowing up their significance, they convey a very misleading picture comparable to what an account of American business would be like if only bankruptcies were reported, or an account of public order that featured only crime stories. . . .

Liberalism in the twentieth century must toughen it fibre, for it is engaged in a fight on many different fronts. It must defend the free market in ideas against the racists, the professional patrioteers, and those spokesmen of the status quo who would freeze the existing inequalities of opportunity and economic power by choking off criticism. It must also be defended against those agents and apologists of Communist totalitarianism who, instead of honestly defending their heresies, resort to conspiratorial methods of anonymity and other techniques of fifth columnists. It will not be taken in by labels like "left" and "right." These terms came into use after the French Revolution, but the legacy of the men who then called themselves "left"—the strategic freedoms of the Bill of Rights—is today everywhere repudiated by those who are euphemistically referred to as "leftists" but who are actually Communists more reactionary than many of those who are conventionally called "rightists." . . .

7

The Case of the American Civil Liberties Union
1950–1953

Corliss Lamont, professor of philosophy and longtime fellow traveler, tells in this reminiscence, taken from his 1981 book *Yes to Life,* how the American Civil Liberties Union—bastion of liberalism—of which he had been a faithful member for decades treated him and others like him during the McCarthy era; indeed, how it prostituted itself, as it later admitted. Lamont, it should be added, was himself the subject of inquisition, but, given his great wealth, he had the means to successfully fight it. He also helped to set up the Emergency Civil Liberties Union, a radical alternative to the ACLU.

From 1940 to 1955 the Civil Liberties Union compromised on many basic issues and often took an apologetic attitude in defending the Bill of Rights. It watered down its criticism of the House Committee on Un-American Activities, adopted a weak position on the Government's "loyalty-security" program, boasted of its close and friendly relations with the FBI, approved the Internal Security Act's exclusion of Communists and Fascists as immigrants to the United States and, worst of all, refused at any time to denounce the compilation and use of the U.S. Attorney General's list of subversive organizations.

In 1950 Patrick Murphy Malin, a Professor of Economics at Swarthmore College, replaced as Executive Director of the ACLU Roger Baldwin, who had passed the usual retirement age of sixty-five. Mr. Malin did not have wide experience in the field of civil liberties, was overwhelmed by the complexity of the job and lacked the fighting spirit which had characterized Baldwin. Instead of assuming independent leadership and trying to recover lost territory for the ACLU, Malin weakly went along with the right-wing Directors and cooperated with them in taking the Civil Liberties Union further toward compromise and political partisanship. . . .

Meantime, the group I had come to consider the Cold War bloc grew increasingly annoyed over my frequent opposition to Board policies and had become fearful that my defiance of the McCarthy Committee in September, 1953 would detract from the ACLU's "respectability." The upshot was that after I had been renominated in November, 1953 for a new three-year term on the Board, several Directors, including Morris Ernst, Norman Thomas and Ernest Angell, Chairman of the Board, threatened to resign if my name was retained on the ballot. At the next meeting of the Board the majority yielded to these bludgeoning tactics and rescinded my nomination.

I had come to the end of my more than twenty years' association with

Excerpted from *Yes to Life,* Corliss Lamont (New York: Horizon Press, 1981), 136–7, 140–1. Copyright 1981 by Horizon Press.

the Civil Liberties Union. Although a number of rank-and-file members of the ACLU in New York City urged that I permit my nomination as a Director through the special section of the By-Laws providing for such nomination by twenty-five regular members, I declined the suggestion. I told my friends that the situation had become too confused and unpleasant for me to continue as a Director, and that I was unwilling to go on working with a group which had forgotten the meaning of fair play. . . .

In August, 1977, *The New York Times* broke a story by Anthony Marro about the American Civil Liberties Union that astonished and bewildered civil libertarians and the general public throughout the United States. "For about seven years in the 1950's," Mr. Marro's report began, "a number of officials of the American Civil Liberties Union gave the Federal Bureau of Investigation on a continuing basis information about the organization, its activities and some of its members, according to materials obtained from the Bureau's files. In addition, the materials suggest that several of the officials asked the Bureau to help them identify Communist Party members who might be trying to gain seats on the boards of the ACLU's state affiliates. . . ."

Mr. Marro's story was based on a careful sifting of over 10,000 documents out of some 20,000 in the FBI files on the ACLU which obtained them under the Freedom of Information Act. The documents showed that during the great anti-Communist witch-hunt the collaboration was so intimate that top officers of the two organizations actually acted as informers for one another. It also revealed that members of ACLU governing committees handed over to the FBI confidential documents, including correspondence between ACLU officials, drafts of position papers and even Minutes of meetings. I was profoundly shocked by these revelations.

An official news release on the situation by the Civil Liberties Union stated: "The files show that on a number of occasions, almost entirely during the McCarthy era, certain persons who were then ACLU officials were in contact with the FBI to provide or obtain information about the political beliefs or affiliations of other ACLU members and officials, particularly those who were thought to be Communists. Whatever their motive, such contacts with the FBI were wrong, inexcusable and destructive of civil liberties principles. These incidents took place in a different era and are contrary to the way the ACLU operates today."

As a member of the Board of Directors of the Civil Liberties Union, I myself was caught in the web of ACLU-FBI intrigue. During those years certain Directors of the Union became worried over a ridiculous rumor that I was a member of the Communist Party. So it was that in the early 1950's Patrick Malin, then Executive Director of the ACLU, made a surprise report to a full meeting of the Board: "I was down in Washington a few days ago and dropped in on J. Edgar Hoover at the FBI. I asked him whether Corliss Lamont was a member of the Communist Party and he said, 'No'." I protested strongly against Malin's little interview on the grounds that it violated our principle of functioning on an independent

basis and, in effect, gave the FBI clearance power in the selection of ACLU officers and staff. No other member of the Board present raised the slightest objection, but it did agree that the incident should not be mentioned in the Minutes of the meeting.

It turned out that during the same period Malin had sought the help of the FBI in trying to keep Communists off the Boards of affiliates in Detroit, Los Angeles, Denver and Seattle. When Malin first revealed his *tête-à-tête* with Hoover, I did not realize that he was carrying on such improper relations with the FBI. And so I unfortunately let the matter drop after my verbal protest.

Morris L. Ernst, who for twenty-five years shared the general counselship of the Civil Liberties Union with Arthur Garfield Hays, played a special role in the relations of the organization with the FBI. He became J. Edgar Hoover's personal attorney and referred to him as a "treasured friend." Ernst was not only a prime mover in the general ACLU-FBI collaboration, but independently started to pass information to the FBI as early as 1942.

In my opinion the collaboration between the ACLU leadership and the FBI was a scandalous betrayal of American civil liberties. It stemmed directly from the fanatical anti-Communism of the times, typified by the rantings of Senator Joseph McCarthy. Many ACLU personnel swallowed McCarthy's moonshine about a terrible Communist threat and became more concerned with exposing and crushing Communists than with preserving civil liberties. This was a crass violation of the trust that had been placed in the leadership of the Civil Liberties Union by the general membership of the organization and the American people. . . .

5

McCarthy the Man; McCarthyism Triumphant

1

When we left the introduction to chapter three, it will be recalled, the Truman administration was on a roll in the year or so following its astonishing return to office. The cold War was going its way. The Soviet Union and its European allies were safely contained. So were Truman's Republican critics. Communists and popular front liberals were completely marginalized.

This idyll abruptly ended in the early fall of 1949. To an incredulous public the president announced that the Soviets had just exploded an atomic bomb. Thus was undone America's military advantage over the Soviets' larger army. Could the Soviets have accomplished this feat by themselves? Or did spies, Americans among them, provide the secrets? The questions answered themselves. A few weeks after this trauma came another: China officially fell to Mao Zedong's Communist forces. The Nationalist government, to which the United States had given billions, was expected to lose the civil war, but the end, when it came in October, was extremely painful nonetheless. Apart from America's sentimental ties with China, there was the terrifying geopolitical fact that almost the whole of Asia, the "world island," was now colored red. And China was the most populous country on earth. However accurately a State Department white paper explained the defeat, blaming it on the Chinese government, its magnitude could not be gainsaid. The Republicans certainly had an issue.

The administration itself made their task easier. Within months of

China's fall federal prosecutors successfully tried Alger Hiss for perjury, claiming that he had, in the 1930s, when he worked for the State Department, passed classifed documents to his accuser, Whittaker Chambers, then a Soviet courier, who produced microfilms of the documents, which he had kept hidden all those years. Here is not the place to go into such an extraordinarily complex and controversial trial. The point is that it gave powerful credence to the charge that Communist agents occupied high places in Democratic administrations. If a man like Hiss, who had accompanied Roosevelt to Yalta (granted, he was one of hundreds), had helped organize the United Nations, and was obviously being groomed for yet greater deeds of statesmanship—if he could have done what he did, who could be trusted? For anti-Communist inquisitors in particular Hiss's conviction was a godsend.

Six months later Truman ordered American troops to South Korea on word that Communist North Korea had attacked it. It was bad enough in the ensuring weeks that Communists were killing American boys, but they were also defeating them in battle, driving them to the tip of the peninsula. Suddenly, however, the picture changed. By a deft maneuver, General Douglas MacArthur smashed the North Koreans and quickly conquered the entire country, right up to the Chinese border. By the late fall of 1950 victory seemed at hand. But America rejoiced too soon. Catching Mac-Arthur and the American army by surprise, the Chinese entered the war with a massive show of force. The Americans fell back headlong to the 38th parallel, dividing line between the two Koreas. There the war settled into a cruel and costly stalemate. Meanwhile, Truman fired MacArthur for insubordination—for urging the expansion of the war into China. Mac-Arthur returned home to tremendous acclaim, especially by the right who made much of the administration's unwillingness to decisively beat the Communists.

Such, in brief, was the Cold War crises or trauma of 1949–51 out of which emerged McCarthyism full-blown, symbolized by the emergence of the man after whom the ism took its name and who bequeathed it to posterity.

2

But the crisis, the trauma, of those years, considerable as it was, in itself is insufficient to explain McCarthy the individual and the effect he in turn exerted on events. After all, plenty of politicians were ideologically indistinguishable from him, and practiced "McCarthyism" as a matter of course—to mention, for example, only some of his fellow Senators: William Jenner of Indiana, Karl Mundt of South Dakota, Pat McCarran of Nevada, Kenneth Wherry of Nebraska, Styles Bridges of New Hampshire, John Butler of Maryland, and James Eastland of Mississippi—but who lacked the peculiar qualities that made him an historical figure. Among the numerous anti-Communist vigilantes of his day he was sui generis.

Nothing in his career prepared the nation for his astonishing rise and notoriety. Some of his biographers have tried to demonstrate, by a jaundiced inquiry into his background, that the loathsome attributes were there all along, were integral to his character. More recent biographies, those published long after his death, have been more objective and have demonstrated that even those who knew him well could never have predicted the day before he delivered the speech in Wheeling that overnight he would become a household name, much less a national symbol. He was, in fact, a prototypical Midwestern Republican, scarcely heard of outside Wisconsin and perhaps not all that well known there too. And under normal circumstances he would have remained scarcely heard of for the duration of his public life.

McCarthy was born in 1908 into a family of struggling Irish-American farmers outside Appleton, Wisconsin. He would have been a small farmer too had he not pulled himself up by his intelligence and grit, going on to college in his mid-twenties and from there to law school. Charm and ambition got him elected state judge at the age of 31. Shortly after Pearl Harbor he joined the Marines and served as an intelligence officer. Hostile biographers make much of his mendacities concerning his military performance. Running for office, he claimed to have seen a good deal of action as a tail gunner and been wounded as well; neither was true. ("Tail gunner Joe" would dog his political trail.) Such mendacities, however, were not uncommon among politicians returning from the war, and they certainly give us no insight into why he became the historical McCarthy. In the 1946 Republican primary he challenged the legendary incumbent Senator, Robert M. LaFollette, Jr., son of an even more legendary father, and won. As for his red-baiting his Democratic opponent in the general election, that too hardly varied from the standard Republican line against liberals that year. And neither does his record as senator yield any clues, except for one perhaps: his willingness to breach traditional rules of conduct, especially binding on freshmen, and say nasty things to venerable colleagues. Otherwise, he scarcely merited notice.

3

News of the Soviet atomic bomb, the fall of China, and the trial and conviction of Alger Hiss were fresh in the public's mind when McCarthy gave his February 9, 1950, Wheeling speech. The Associated Press account was his epiphany. For what the press picked up went beyond even the extreme rhetoric of the far right and approached that of the lunatic fringe. Not only did he claim to have the names of 205 State Department Communists, he intimated that the administration, in keeping them on, knew who they were and approved of what they did. Here was a U.S. senator explaining to Americans why their situation was so worrisome, maybe desperate, why the enemy, getting stronger by the day, might be winning the Cold War. He had thus crossed the political Rubicon. Not content

with criticizing his opponents for having erred in being too gullible, trusting, and foolish, he now said, in effect, that they were complicit in treason, maybe traitors themselves. Small wonder his charge proved to be such a bombshell.

He did not have the names, or rather, the names he released, few in any case, were of little consequence. They were liberals, and in one or two instances they might have espoused the popular front line, but Communists they definitely were not (even assuming, falsely, that Communists were automatically traitors). But instead of retreating, McCarthy pushed ahead, day after day, the battle growing more intense as higher and higher officials, including the president, joined in. Though his numbers continually changed, becoming something of a bitter joke, McCarthy insisted that he would in due course reveal them. That promise kept the media and the public on edge. As for the criticisms he received, the extent and virulence of which increased in direct proportion to his notoriety, he laughed them off with a fresh outrage. Nothing seemed to daunt him.

His whole case, he finally claimed, rested on his exposure of *one* alleged traitor—no longer the 205 or fifty-seven or whatever number he conjured up—Johns Hopkins Professor Owen Lattimore, an expert on Central Asia, who had occasionally served as a State Department consultant. Now, in the spring of 1950, Senate Democrats, convinced they at last had McCarthy, charlatan that he was, went into action, setting up a five-man special committee to examine the allegation. McCarthy produced not a scintilla of hard evidence; only hearsay, gossip, innuendo, and downright lies from the mouths of informers. Yet he escaped unbruised. Most Republicans refused to back the Democrats in their attempt to denounce him, the first step to more severe punishment. A handful of moderate Republicans did back one brave senator, Margaret Chase Smith of Maine, in her repudiation of his tactics, but their effort went nowhere too. His gamble having paid off, McCarthy was emboldened to go further.

The next phase of the Cold War assured his personal vindication and marked the apogee of McCarthyism. The Korean War, coupled with a spate of atomic spy trials, above all Julius and Ethel Rosenberg's, husband and wife and parents of young sons, both executed, convinced more and more Americans, even a majority, that McCarthy deserved their gratitude for possessing the courage to tell the truth, that his explanation of the crisis in which they now found themselves was right on target and that whatever his detractors said about him, no matter how often they invoked the epithet, "McCarthyism," counted for precious little on balance. The 1950 Congressional election gave an idea of his popularity; certainly it was interpreted as his victory. A pro-McCarthy Republican defeated his fiercest foe, Maryland's three-term conservative Senator Millard Tydings. By the time of the presidential election two years later, Republican Party leaders, among them candidate Eisenhower, routinely deferred to him. They did not want to alienate someone who was doing such a splendid job of smearing Democrats, in particular President Truman, Secretaries of State

George Marshall and Dean Acheson, and candidate Adlai Stevenson, for having committed "twenty years of treason."

Republicans in that election took control of the executive and legislative branches for the first time in twenty-four years. Having been handily re-elected in the sweep, McCarthy saw his dream come true: He got his very own investigative committee, formally called the Investigative Subcommittee of the Committee on Government Operations. In a masterly stroke, he brought in Roy Cohn as chief council. Cohn was a talented young man with the best of anti-Communist credentials, having shown what he could do in the Truman Justice Department. Before long he was McCarthy's trusted sidekick and co-conspirator. Though McCarthy's committee competed with a plethora of other such committees—the inexhaustible depth and magnitude of the Communist menace accounted for their proliferation in Washington and across the country—his committee received the most media coverage because he alone was sure-fire copy. Aware of this, the Eisenhower administration fell over itself to appease him. It hoped to contain him, to keep him focused on traditional objects of inquiry, leftists, Democrats, un-Americans, etc., and stay clear of government officials, now Republican officials. But power was what interested McCarthy, and the traditional objects of inquiry no longer held power. His crusade having borne him this far, he was not about to submit to the test of party loyalty. He was not going to betray the vocation that destiny had conferred on him.

4

It was the Democratic 81st and 82nd Congresses whose tenure coincided with the traumatic period of the Cold War alluded to above and which, in response, legislated heavy sanctions against civil liberties more restrictive than any peacetime laws since the Alien and Sedition acts, and in some ways surpassing those of the Civil War, which were the Internal Security, or McCarran, Act of 1950 and two years later, the Immigration and Nationality, or McCarran-Walter, Act. There is no need here to specify in what respects these two laws exemplified strident McCarthyism; the documents below speak for themselves. Worthy of comment are Truman's veto messages, both of which Congress easily overrode, as he knew it would. He wrote them for the record, in the conviction, correct as it turned out, that history would see it his way.

And rather stirring veto messages they are. Several passages would lead us to think that he was a card-carrying member of the Civil Liberties Union. For instance, from his remarks on the Internal Securities Act: "In a free country we punish men for the crimes they commit but never for the opinions they have. And the reason this is so fundamental to freedom is not, as many suppose, that it protects the few unorthodox from suppression by the majority. To permit freedom of expression is primarily for the benefit of the majority, because it protects criticism and criticism leads to

progress." Or from his remarks on the Immigration and Nationality Act: "Seldom has a bill exhibited the distrust evidenced here for citizens and aliens alike. . . . These provisions are worse than the infamous Alien Act of 1798 . . . which gave the President the power to deport any alien deemed 'dangerous to the peace and safety of the United States.' Alien residents were thoroughly frightened and citizens much disturbed by that threat to liberty."

These enactments especially bothered Truman because, first, they vastly enlarged the repressive authority of existing agencies—the State Department, the Immigration and Naturalization Service, the Justice Department, etc.—while adding powerful new agencies, those, for example, that would register "Communist front" and "Communist action" organizations and others that would oversee the detention camps for those arrested in the event of a "national emergency"; and second, the vague statutory language encouraged these agencies to behave with untrammeled caprice. The Internal Security Act, Truman feared, "would open a Pandora's Box of opportunities for official condemnation of organizations and individuals for perfectly honest opinions which happen to be stated also by Communists." Similarly, regarding the Immigration and Naturalization Act: "No standards or definitions are provided to guide direction in the exercise of powers so sweeping. To punish undefined 'activities' departs from traditional American insistence on established standards of guilt. To punish an undefined 'purpose' is thought control."

Such spirited objections must have puzzled Truman's critics on the far right and left. Both of them could have plausibly argued that the very things he complained of and feared his administration had been doing for years, beginning with his loyalty review order and attorney general's list of Communist front organizations. He had already opened the Pandora's box. The laws he criticized only took off from the precedents he had set. Only by now the vital center had shifted decisively to the right, where McCarthyism held sway, and there was little the Truman administration could do about it.

1

McCarthy Anticipates McCarthyism
April 3, 1947

The "Town Hall Meeting of the Air" was a popular radio program of the 1930s and 1940s. For an hour once a week four people debated the burning issues of the day. On April 3, 1947, Joseph R. McCarthy, the recently elected and attractive young Wisconsin Senator, took the affirmative on the question, "Should the Communist Party Be Outlawed in the United States?" (The debate was published later that month in the magazine *Town Meeting*.) How prescient he was—about himself and the age to which he gave his name—is evident from his opening remarks, some of which appear below.

The Communist Party might well be compared to a huge iceberg in a shipping lane. The most dangerous part of the iceberg is under water and invisible and you can no more bring the underground communist organization up to the surface then you can cause that huge iceberg to float upon the face of the sea.

Now it is wishful thinking of the most dangerous kind to urge that the mere passage of a law and that alone can destroy the communist menace. However, one of the questions tonight is, can anything be gained for America by continuing to place upon the ballot the name of a group dedicated to the destruction of this country by force? Or putting the question in our form, does a group whose first loyalty is to a foreign nation have any right on our ballot? (*Applause.*) The answer to that, ladies and gentlemen, is also definitely, "No." (*Applause.*)

I realize full well that merely outlawing the Communist Party and wiping the name "Communist" from the ballot is but one of the many actions to be taken.

In the short time available, let me mention a few of the equally important items that are *musts* on our program if we are to survive the communist menace.

1. The Department of Justice should rule that the Communist Party is an agency of a foreign power and subject to the Voorhis Act and the Logan Act, which laws concern themselves with conspiracy against the nation and action on the part of foreign agents.
2. The FBI should be empowered and directed to publish the names of all the Communist front organizations such as Youth for Democracy, Progressive Citizens of America, and on down the line.
3. All Communist aliens should be forced to leave the country.

Excerpted from *Town Meeting*, April 3, 1947, 7–8.

4. Communists being the agents of foreign powers, should be barred from representing clients or groups before labor and other boards.
5. Communists and members of communist front organizations should be required to register with a federal agency and be fingerprinted.

In short, we must shift from a negative to a positive policy.

2

Versions of the Wheeling Speech
February 10 and 20, 1950

There is no accurate report on the February 9th speech that made McCarthy famous. What we do have is, first, an interview he held the following day in Salt Lake City with a local reporter, Dan Valentine (which is in the private possession of Edwin R. Bayley, author of *Joe McCarthy and the Press*), in the course of which the number of State Department Communists dropped from 205—that much had been accurately reported—to 57; and, second, his elaboration of the original speech on the Senate floor ten days later, in the course of which he did name some names, that is, offer allegations without proof.

FEBRUARY 10

McCARTHY: Last night I discussed the "Communists in the State Department." I stated I had the names of 57 card-carrying members of the Communist party. I noticed today that the State Department has denied that. They say that they don't know of a single one in the State Department. Now I want to tell the Secretary of State this, if he wants to call me tonight at the Utah Hotel I will be gald to give him the names of those 57 card-carrying Communists. I might say this, however, Dan, the day that Alger Hiss was exposed the President signed an order to the effect that no one in the State Department could give any information as to the disloyalty or the Communistic activities of any State Department employee. Then later they went a step further. They said, in addition to that, no one in the Department can give any information as to the employment of any man in the State Department. Now, obviously, before we will give him the information, give him the names of the Communists whom we, names he should certainly have himself (if I have them, he should have them) I want this: an indication of his good faith. The best way to indicate that is to say that at least as far as these 57 are concerned, when you give their names then all information as to their Communistic activities, as to their disloyalty, will be available to any proper Congressional investigating committee. Have I made myself clear, Dan?

VALENTINE: In other words, Senator, if Secretary of State Dean Acheson would call you at the Hotel Utah tonight in Salt Lake City (SENATOR McCARTHY: That's right) you could give him 57 names of

Excerpted from *Joe McCarthy and the Press,* Edwin R. Bayley (Madison: University of Wisconsin Press, 1981), 20–1. Copyright 1981 by the University of Wisconsin Press. Reprinted by permission. United States Congress, 81st Congress, 2nd Session, *Congressional Record,* 1955–7.

actual card-carrying Communists in the State Department of the United States—actual card-carrying Communists.

McCARTHY: Not only can, Dan, but I will, on condition (VALENTINE: I don't blame you for that) that they lift this veil of secrecy and allow the Congressional Committee to know about the Communistic activities and disloyalty in that Department.

FEBRUARY 20

. . . You will recall last spring there was held in New York what was known as the World Peace Conference—a conference which was labeled by the State Department and Mr. Truman as the sounding board for Communist propaganda and a front for Russia. Dr. Harlow Shapley was the chairman of that conference. Interestingly enough, according to the new release put out by the Department in July, the secretary of state appointed Shapley on a commission which acts as liaison between UNESCO and the State Department.

This, ladies and gentlemen, gives you somewhat of a picture of the type of individuals who have been helping to shape our foreign policy. In my opinion the State Department, which is one of the most important government departments, is thoroughly infested with Communists.

I have in my hand fifty-seven cases of individuals who would appear to be either card-carrying members or certainly loyal to the Communist Party, but who nevertheless are still helping to shape our foreign policy.

One thing to remember in discussing the Communists in our government is that we are not dealing with spies who get thirty pieces of silver to steal the blueprints of a new weapon. We are dealing with a far more sinister type of activity because it permits the enemy to guide and shape our policy. . . .

This brings us down to the case of one Alger Hiss, who is important not as an individual anymore but rather because he is so representative of a group in the State Department. It is unnecessary to go over the sordid events showing how he sold out the nation which had given him so much. Those are rather fresh in all of our minds. However, it should be remembered that the facts in regard to his connection with this international Communist spy ring were made known to the then Undersecretary of State Berle three days after Hitler and Stalin signed the Russo-German Alliance Pact. At that time one Whittaker Chambers—who was also part of the spy ring—apparently decided that with Russia on Hitler's side, he could no longer betray our nation to Russia. He gave Undersecretary of State Berle—and this is all a matter of record—practically all, if not more, of the facts upon which Hiss's conviction was based.

Undersecretary Berle promptly contacted Dean Acheson and received word in return that Acheson (and I quote) "could vouch for Hiss absolutely"—at which time the matter was droppded. And this, you under-

stand, was at a time when Russia was an ally of Germany. This condition existed while Russia and Germany were invading and dismembering Poland, and while the Communist groups here were screaming "warmonger" at the United States for their support of the allied nations.

Again in 1943, the FBI had occasion to investigate the facts surrounding Hiss's contacts with the Russian spy ring. But even after that FBI report was submitted, nothing was done. . . .

As you hear this story of high treason, I know that you are saying to yourself, "Well, why doesn't the Congress do something about it?" Actually, ladies and gentlemen, one of the important reasons for the graft, the corruption, the dishonesty, the disloyalty, the treason in high government positions—one of the most important reasons why this continues—is a lack of moral uprising on the part of the 140 million American people. In the light of history, however, this is not hard to explain.

It is the result of an emotional hangover and a temporary moral lapse which follows every war. It is the apathy to evil which people who have been subjected to the tremendous evils of war feel. As the people of the world see mass murder, the destruction of defenseless and innocent people, and all of the crime and lack of morals which go with war, they become numb and apathetic. It has always been thus after war. However, the morals of our people have not been destroyed. They still exist. This cloak of numbness and apathy has only needed a spark to rekindle them. Happily, this spark has finally been supplied.

As you know, very recently the secretary of state proclaimed his loyalty to a man guilty of what has always been considered as the most abominable of all crimes—of being a traitor to the people who gave him a position of great trust. The secretary of state, in attempting to justify his continued devotion to the man who sold out the Christian world to the atheistic world, referred to Christ's Sermon on the Mount as a justification and reason therefor, and the reaction of the American people to this would have made the heart of Abraham Lincoln happy. When this pompous diplomat in striped pants, with a phony British accent, proclaimed to the American people that Christ on the Mount endorsed communism, high treason, and betrayal of a sacred trust, the blasphemy was so great that it awakened the dormant indignation of the American people.

He has lighted the spark which is resulting in a moral uprising and will end only when the whole sorry mess of twisted, warped thinkers are swept from the national scene so that we may have a new birth of national honesty and decency in government.

3

Mrs. Smith's Declaration of Conscience
June 1, 1950

With McCarthy becoming more and more of a cause célèbre, Margaret Chase Smith, Republican senator from Maine, delivered a widely publicized attack on him before the Senate. It was published separately under the title, *Declaration of Conscience*. She was congratulated for her bravery, but her remarks had scant effect, least of all on her fellow Republicans. McCarthy listened to the speech with polite disdain.

I speak as briefly as possible because too much harm has already been done with irresponsible words of bitterness and selfish political opportunism. I speak as simply as possible because the issue is too great to be obscured by eloquence. I speak simply and briefly in the hope that my words will be taken to heart.

I speak as a Republican. I speak as a woman. I speak as a United States Senator. I speak as an American.

The United States Senate has long enjoyed worldwide respect as the greatest deliberative body in the world. But recently that deliberative character has too often been debased to the level of a forum of hate and character assassination sheltered by the shield of congressional immunity.

It is ironical that we Senators can in debate in the Senate directly or indirectly, by any form of words, impute to any American who is not a Senator any conduct or motive unworthy or unbecoming an American—and without that non-Senator American having any legal redress against us—yet if we say the same thing in the Senate about our colleagues we can be stopped on the grounds of being out of order.

It is strange that we can verbally attack anyone else without restraint and with full protection and yet we hold ourselves above the same type of criticism here on the Senate Floor. Surely the United States Senate is big enough to take self-criticism and self-appraisal. Surely we should be able to take the same kind of character attacks that we "dish out" to outsiders.

I think that it is high time for the United States Senate and its members to do some soul-searching—for us to weigh our consciences—on the manner in which we are performing our duty to the people of America—on the manner in which we are using or abusing our individual powers and privileges.

I think that it is high time that we remembered that we have sworn to uphold and defend the Constitution. I think that it is high time that we remembered that the Constitution, as amended, speaks not only of the freedom of speech but also of trial by jury instead of trial by accusation.

Whether it be a criminal prosecution in court or a character prosecu-

Excerpted from *Declaration of Conscience,* Margaret Chase Smith (Garden City: Doubleday, 1972), 13–14. Copyright 1972 by Doubleday.

tion in the Senate, there is little practical distinction when the life of a person has been ruined.

Those of us who shout the loudest about Americanism in making character assassinations are all too frequently those who, by our own words and acts, ignore some of the basic principles of Americanism:

The right to criticize;

The right to hold unpopular beliefs;

The right to protest;

The right of independent thought.

The exercise of these rights should not cost one single American citizen his reputation or his right to a livelihood nor should he be in danger of losing his reputation or livelihood merely because he happens to know someone who holds unpopular beliefs. Who of us doesn't? Otherwise none of us could call our souls our own. Otherwise thought control would have set in.

The American people are sick and tired of being afraid to speak their minds lest they be politically smeared as "Communists" or "Fascists" by their opponents. Freedom of speech is not what it used to be in America. It has been so abused by some that it is not exercised by others. . . .

4

Democratic Rebuttal
July 20, 1950

Here, in part, is Maryland's Millard Tydings's defense of his committee's finding before the full Senate that there was nothing to McCarthy's charges against Lattimore and the others he had mentioned. Tydings, a conservative Democrat, was to pay a high price for his integrity.

Mr. President, I am not investigating the Senator from Wisconsin. However, I must investigate the charges made by the Senator if I am to do the job and put credence and credibility in what might be connected with these charges. That is what the American people want to know, because when a Senator says there are 516, 205, 57, 108, or 25 spies, or 1 spy, even in the State Department, it is not the statement of a man on the corner of Ninth and G Streets who is carrying on a casual conversation with people who are going home from work. It is the voice of the Republic. It is the voice of the Government. It is a challenge, at a time when men are faced with perhaps the cruelest and most violent enemy in all the history of Christendom, the Red Communists who today in Europe and in the Far East and all over the globe are taking such a toll of freedom, democracy, human life, and liberty. . . .

Who has been on trial, here? Has it been the State Department? I do not think so. Has it been the Congress? I do not think so. It has been the Federal Bureau of Investigation. It is the agency created by this body to hunt spies, crooks, thieves, income-tax dodgers, saboteurs, file robbers, grafters, any any others who have unfair and illegal contact with the Government of the United States. . . .

Oh, what headlines the great spy case made. I can see the room now, packed with teeming people, with the kleig lights and the radio on, Owen Lattimore sitting there, a little bit of a figure who had come halfway around the world as fast as he could come to answer the charges. There he sat. The investigation was new then, and if one of us uttered a syllable to the effect that there might not be complete proof of the charges, we were Red sympathizers and fellow travelers. We were supposed to adopt the rule of guilt by accusation—accuse a man, take him out and shoot him. That is the old Russian system.

With reference to Lattimore, four members of the committee who saw fit to file reports—the majority reports and the one by the Senator from Massachusetts [Mr. LODGE]—say the charges are not proved. The Senator from Wisconsin said his file would show that Lattimore was the top Red agent and a Communist. We heard it read. So far four members of the

United States Congress, 81st Congress, 2nd Session, *Congressional Record*, 10708, 10712.

committee have said that that is not so. What difference does that make? The newspapers will not have time to print much of what I am saying here today in rebuttal to 5 months of false smears and headlines. They can say, "What do we care about this except to wind it up, and if there are bad men in our Government, get them out, and if the charges are not true, say so. . . . We are not going to waste time now printing very much about there charges. The poor devils whose names were paraded across the headlines will be lucky if they get a mention on page 73 in the last column under the weather reports."

5

Total Security Through the McCarran Act
September 23, 1950

After the Korean War began in the summer of 1950 scores of anti-Communist bills circulated in Congress. They were amalgamated, under Nevada's rabidly anti-Communist Senator Pat McCarran's direction, into the Internal Security Act. Approved overwhelmingly by both houses, the act, as already noted—and as the president himself stated in his veto message—gave the government unprecedented authority to restrict civil liberties, including the authority to round up people and detain them in camps in a national emergency.

SEC. 2. As a result of evidence adduced before various committees of the Senate and House of Representatives, the Congress hereby finds that—

(1) There exists a world Communist movement which, in its origins, its development, and its present practice, is a world-wide revolutionary movement whose purpose it is, by treachery, deceit, infiltration into other groups (governmental and otherwise), espionage, sabotage, terrorism, and any other means deemed necessary, to establish a Communist totalitarian dictatorship in the countries throughout the world through the medium of a world-wide Communist organization. . . .

(4) The direction and control of the world Communist movement is vested in and exercised by the Communist dictatorship of a foreign country.

(5) The Communist movement in the United States is an organization numbering thousands of adherents, rigidly and ruthlessly disciplined. Awaiting and seeking to advance a moment when the United States may be so far extended by foreign engagements, so far divided in counsel, or so far in industrial or financial straits, that overthrow of the Government of the United States by force and violence may seem possible of achievement, it seeks converts far and wide by an extensive system of schooling and indoctrination. Such preparations by Communist organizations in other countries have aided in supplanting existing governments. The Communist organization in the United States, pursuing its stated objectives, the recent successes of Communist methods in other countries, and the nature and control of the world Communist movement itself, present a clear and present danger to the security of the United States and to the existence of free American institutions, and make it necessary that Congress, in order to provide for the common defense, to preserve the sovereignty of the United States as an independent nation, and to guarantee to each State a republican form of government, enact appropriate legislation recognizing the existence of such world-wide conspiracy and designed to prevent it from accomplishing its purpose in the United States. . . .

81st Congress, 2nd Session, Public Law 831.

SEC. 7. (a) Each Communist-action organization (including any organization required, by a final order of the Board, to register as a Communist-action organization) shall, within the time specified in subsection (c) of this section, register with the Attorney General, or on a form prescribed by him by regulations, as a Communist-front organization.

(b) Each Communist-front organization . . . shall . . . register with the Attorney General, on a form prescribed by him by regulations, as a Communist-front organization. . . .

(d) Upon the registration of each Communist organization under the provisions of this title, the Attorney General shall publish in the Federal Register the fact that such organization has registered as a Communist-action organization, or as a Communist-front organization, as the case may be, and the publication thereof shall constitute notice to all members of such organization that such organization has so registered. . . .

SEC. 12. (a) There is hereby established a board, to be known as the Subversive Activities Control Board, which shall be composed of five members, who shall be composed of five members, who shall be appointed by the President, by and with the advice and consent of the Senate. . . .

(e) It shall be the duty of the Board—

(1) upon application made by the Attorney General under section 13 (a) of this title, or by any organization under section 13 (b) of this title, to determine whether any organization is a "Communist-action organization" within the meaning of paragraph (3) of section 3 of this title, or a "Communist-front organization" within the meaning of paragraph (4) of section 3 of this title; and

(2) upon application made by the Attorney General under section 13 (a) of this title, or by any individual under section 13 (b) of this title, to determine whether any individual is a member of any Communist-action organization registered, or by final order of the Board required to be registered, under section 7 (a) of this title. . . .

SEC. 22. The Act of October 16, 1918 . . . is hereby amended to read as follows: "That any alien who is a member of any one of the following classes shall be excluded from admission into the United States:

"(1) Aliens who seek to enter the United States whether solely, principally, or incidentally, to engage in activities which would be prejudicial to the public interest, or would endanger the welfare or safety of the United States;

"(2) Aliens who, at any time, shall be or shall have been members of any of the following classes:

"(A) Aliens who are anarchists;

"(B) Aliens who advocate or teach, or who are members of or affiliated with any organization that advocates or teaches, opposition to all organized government;

"(C) Aliens who are members of or affiliated with (i) the Communist Party of the United States; (ii) any other totalitarian party of the United States; (iii) the Communist Political Association; (iv) the Communist or

other totalitarian party of any State of the United States, of any foreign state, or of any political or geographical subdivision of any foreign state; (v) any section, subsidiary, branch, affiliate, or subdivision of any such association or party; or (vi) the direct predecessors or successors of any such association or party, regardless of what name such group or organization may have used, may now bear, or may hereafter adopt;

"(D) Aliens not within any of the other provisions of this paragraph (2) who advocate the economic, international, and governmental doctrines of world communism or the economic and governmental doctrines of any other form of totalitarianism, or who are members of or affiliated with any organization that advocates the economic, international, and governmental doctrines of world communism, or the economic and governmental doctrines of any other form of totalitarianism, either through its own utterances or through any written or printed publications issued or published by or with the permission or consent of or under the authority of such organization of paid for by the funds of such organization. . . .

"(F) Aliens who advocate or teach or who are members of or affiliated with any organization that advocates or teaches (i) the overthrow by force or violence or other unconsitutional means of the Government of the United States or of all forms of law; or (ii) the duty, necessity, or propriety of the unlawful assaulting or killing of any officer or officers (either of specific individuals or of officers generally) of the Government of the United States or of any other organized government, because of his or their official character; or (iii) the unlawful damage, injury, or destruction of property; or (iv) sabotage;

"(G) Aliens who write or publish, or cause to be written or published, or who knowingly circulate, distribute, print, or display, or knowingly cause to be circulated, distributed, printed, published, or displayed, or who knowingly have in their possession for the purpose of circulation, publication, or display, any written or printed matter, advocating or teaching opposition to all organized government, or advocating (i) the overthrow by force or violence or other unconstitutional means of the Government of the United States or of all forms of law. . . .

SEC. 102. (a) In the event of any one of the following:

(1) Invasion of the territory of the United States or its possessions,

(2) Declaration of war by Congress, or

(3) Insurrection with the United States in aid of a foreign enemy, and if, upon the occurrence of one or more of the above, the President shall find that the proclamation of an emergency pursuant to this section is essential to the preservation, protection and defense of the Constitution, and to the common defense and safety of the territory and people of the United States, the President is authorized to make public proclamation of the existence of an "Internal Security Emergency."

(b) A state of "Internal Security Emergency" (hereinafter referred to as the "emergency") so declared shall continue in existence until terminated

by proclamation of the President or by concurrent resolution of the Congress. . . .

SEC.103. (a) Whenever there shall be in existence such an emergency, the President, acting through the Attorney General, is hereby authorized to apprehend and by order detain, pursuant to the provisions of this title, each person as to whom there is reasonable ground to believe that such person probably will engage in, or probably will conspire with others to engage in, acts of espionage or of sabotage. . . .

6

McCarthy Unbound
May 24, 1951

A few weeks after President Truman dismissed General MacArthur for insubordination, McCarthy abandoned whatever restraints he may still have had in blaming the administration, and his chief bête noire, Secretary of State Acheson, in particular, for the rise of Communism.

. . . Let me, if I may, give Senators a specific example. If we multiply this case by thousands, perhaps we can better understand why General MacArthur felt that he had a duty to bring the truth to the American people even if it meant the end of his glorious military career.

Let us take the case of Bob Smith, from Middleburg, Pa. When the Communists started to pour across the Yalu Bob Smith was up at Chanjin Reservoir. He was wounded. He lay in a gutter for 3 days and nights. The Communists overran his position. He played dead. They took off his shoes and some of his clothing. Then he and some other wounded GI's crawled to a dugout or hut. A unit of Marines learned about those wounded soldiers, and slugged a bloody path through the Communist ring and rescued them.

Today Bob Smith is at home in Middleburg, Pa., but his hands and his feet are still in the hills on this side of the Yalu—a tribute to the traitorous Red Communist clique in our State Department, who have been in power ever since before the days of Yalta. I suggest that when the day comes that Bob Smith can walk, when he gets his artificial limbs, he first walk over to the State Department and call upon the great Red Dean of fashion if he is still there. He should say to him, "Mr. Acheson, I was there while MacArthur's order stood countermanded by you. I saw the Communists pour across the Yalu. I saw your agrarian reformers on horseback firing rockets at us—reincarnations of the horsemen of Genghis Khan." He should say to Acheson: "You and your lace handkerchief crowd have never had to fight in the cold, so you cannot know its bitterness."

He should say to him, "You never felt the shock of bullets, so you cannot know their pain."

He should say to him, "Dean, thousands of American boys have faced those twin killers because you and your crimson crowd betrayed us."

He should say, "Mr. Acheson, if you want to at long last perform one service for the American people you should not only resign from the State Department but you should remove yourself from this country and go to the nation for which you have been struggling and fighting so long."

United States Congress, 82nd Congress, 1st Session, *Congressional Record,* 1287.

7

McCarthy's Assault on General Marshall
1952

> Following is an extract from the introduction McCarthy wrote to a book he brought out in 1952, *America's Retreat from Victory, the Story of George Catlett Marshall*. That book consisted of a very long speech he delivered on the Senate floor a year earlier in which he accused the revered public servant (army chief of staff, secretary of state, secretary of defense, etc.) of complicity in the rise of Communism, particularly in China. The implication, quite obviously, is that Marshall always had been a traitor.

On June 14, 1951, I reviewed the public career of George Catlett Marshall from the beginning of World War II before the United States Senate. It was an exhaustive review, running to 72,000 words, drawn from the acknowledged sources of this period.

Among the questions raised by that speech were these: What were McCarthy's motives? Why did McCarthy single out the Secretary of Defense and spend so much time preparing such a searching documentation of his history?

Those questions recalled the advice given me by some of my friends before I gave the history of George Marshall. "Don't do it, McCarthy," they said. "Marshall has been built into such a great hero in the eyes of the people that you will destroy yourself politically if you lay hands on the laurels of this great man."

My answer to those well-meaning friends was that the reason the world is in such a tragic state today is that too many politicians have been doing only that which they consider politically wise—only that which is safe for their own political fortunes.

My discussion of General Marshall's career arose naturally and inevitably out of a long and anxious study of the retreat from victory which this Administration has been beating since 1945. In the company with so many of my fellow citizens I have become alarmed and dismayed over our moral and material enfeeblement.

The fact that 152 million American people are officially asked by the party in power to adopt Marshall's global strategy during a period of time when the life of our civilization hangs in the balance would seem to make it imperative that his complete record be subjected to the searching light of the public scrutiny.

As a backdrop for the history of Marshall which I gave on June 14, there is the raw, harsh fact that since World War II the free world has been losing 100 million people per year to international Communism. If I had

named the men responsible for our tremendous loss, all of the Administration apologists and the camp-following elements of press and radio led by the *Daily Worker* would have screamed "the Big Lie," "irresponsible," "smear," "Congressional immunity," etc., etc. However, it was the Truman branch of the Democratic Party meeting at Denver, Colorado, which they called a "great victory"—Dean Gooderham Acheson and George Catlett Marshall. By what tortured reasoning they arrived at the conclusion that the loss of 100 million people a year to Communism was a "great victory," was unexplained.

The general picture of our steady, constant retreat from victory, with the same men always found at the time and place where disaster strikes America and success comes to Soviet Russia, would inevitably have caused me, or someone else deeply concerned with the history of this time, to document the acts of those molding and shaping the history of the world over the past decade. However, an occurence during the MacArthur investigation was the immediate cause of my decision to give the Senate and the country the history of Marshall. . . .

Another item of interest in regard to Marshall is found in the *Reader's Digest* of January 1944.

The late Frederick C. Painton was describing an interview had with General Marshall by 60 Anglo-American correspondents in Algiers. . . .

> A door opened, a hush fell, General Marshall walked in. He looked around the room, his eyes calm, his face impassive. "To save time," he said, "I'm going to ask each of you what questions you have in mind." His eyes turned to the first correspondent. "What's your question?" A penetrating query was put; General Marshall nodded and went on the the next man-and so around the room, until 60 correspondents had asked challenging questions ranging from major strategy to technical details of the war on a dozen fronts.
>
> General Marshall looked off into space for perhaps 30 seconds. Then he began. For nearly 40 minutes he spoke. His talk was a smooth, connected, brilliantly clear narrative than encompassed the war. And this narrative, smooth enough to be a chapter in a book, included a complete answer to every question we had asked.
>
> But what astounded us most was this: as he reached the point in his narrative which dwelt upon a specific question, he looked directly at the man who had asked the question!
>
> Afterward I heard many comments from the correspondents. Some said they had just encountered the greatest military mind in history. Others exclaimed over the encyclopedic detail Marshall could remember. All agreed on one thing: "That's the most brilliant interview I have ever attended in my life."

The above interview becomes extremely interesting when compared to Marshall's inability to recall what he was doing on the morning of Pearl Harbor. Originally, Marshall testified that he was out horseback riding and for that reason could not be contacted. Later, he testified his memory had been refreshed and that he actually had not been horseback riding but was at home with his wife. The third version of where the Army Chief of Staff

was on the fateful morning is contained in Arthur Upton Pope's book *Litvinoff* which the diary account of Litvinoff's trip from Russia to the United States shows that Marshall was meeting Litvinoff at the airport on Pearl Harbor morning. While the question of whether Marshall was riding horseback, or with his wife, or with Litvinoff seems unimportant today, it does form a very interesting comparison of Marshall's memory on those two occasions. . . .

8

McCarthy in Full Stride
April 29, 1953

Soon after taking over as chairman of the Permanent Subcommittee on Investigations, McCarthy conducted a probe of the State Department's Information Program. He had sent two members of his staff to check out libraries run by the program in Germany to see if books by Communist authors were on the shelves. The deputy director of the Office of Public Affairs for the High Commissioner, Theodore Kaghan, had contemptuously referred to the staff members as "junketeering gumshoes." Following is a portion of the hearings in which McCarthy is out to get Kaghan. The State Department later fired him.

THE CHAIRMAN. You wrote a number of plays. Is that right?

MR. KAGHAN. Yes, I did.

THE CHAIRMAN. Would you say they followed the Communist line?

MR. KAGHAN. I would not say they followed the Communist line.

THE CHAIRMAN. Would you say they were acceptable to the Communists?

MR. KAGHAN. I think they were, by and large, not necessarily in detail.

THE CHAIRMAN. Not necessarily in detail. I have gone over a number of them, and I have had my staff read the others. I find that they seem to follow largely the same pattern, that you have someone representing the Communist Party, arguing the Communist line. You have someone very weakly arguing against it. In the end, you find the man against the Communist cause has been converted, in practically all the plays. Is that a correct statement?

MR. KAGHAN. No, sir; I do not agree with the statement. You have made a dramatic judgement about whether the arguments against communism were weak. I doubt that they were weak. If they were weak, it wouldn't have been a good play.

THE CHAIRMAN. Let me quote from one, if I may.

You recall the Unfinished Picture?

MR. KAGHAN. Yes, sir; that is a play I wrote in the University of Michigan for which I got a $1,000 prize. The University of Michigan is not a leftwing university.

THE CHAIRMAN. What was that?

MR. KAGHAN. I say the University of Michigan is not known to be a leftwing university.

United States Senate, 83d Congress, 1st Session, Permanent Subcommittee on Investigations of the Committee on Government Operations, *Hearings*, 176–8, 199–200.

THE CHAIRMAN. I do not quite get the import of that. Does that mean that you could not have been leftwing or you could not have attended?

MR. KAGHAN. I mean that the play would probably not have won a prize if it were a Communist play.

THE CHAIRMAN. Who awarded this prize?

MR. KAGHAN. The univeristy itself. It was the Avery Hopwood award. I have forgotten the name of it. Drama, fiction, essay, and poetry.

I won several drama prizes, and that was the last year's prize.

THE CHAIRMAN. Mr. Kaghan, let me first refer to the Unfinished Picture, and read a few excerpts from it. Tell me whether you think this would be a good anti-Communist propaganda or not. These are the words that you put in your actor's mouth. Page 22 of the Unfinished Picture. Here is the language, the words, in one of your act mouth:

> How can I enjoy life knowing there is so much misery?
> What should I do, get married to some slave? On what?
> It's just because I want to live that I am doing this?

talking about Communist activity.

> I don't want to creep through life like a slave. I don't want to get married and bring up children to be more slaves. If my children can't be free, I don't want them to be born.

Would that be good anti-Communist propaganda?

MR. KAGHAN. That sounds like a good American statement.

THE CHAIRMAN. Let me read from page 24. See if this is a good American statement.

> What is wrong with what we have got? You ought to thank God you have got it.

Answer:

> Thank God? You ought to thank Morgan and Rockefeller for leaving you what they did if you want to thank anyone.
> Julia, do you know what you are saying?
> JULIA. Of course I know what I am saying. What do you expect me to do? Pray every night for God to let me go to college? I would rather write a letter to the President. At least that might get an answer.

Is that good anti-Communist propaganda?

MR. KAGHAN. Sir, I would rather not discuss excerpts, lines read by you, from the play which I haven't read for years and haven't got a copy of handy. It depends on the rest of the play.

THE CHAIRMAN. Let me read some more of the play.

> Now, Gordon wouldn't have been shot if he hadn't been a Negro worker. There was no reason for his being shot except the cop didn't think his life was worth anything. It was purely a case of race discrimination of the worst type, equal to the lynching business going on in the South. The communists Party is

fighting militantly against that, and the mass funeral tomorrow is in protest against discrimination and the rising tide of fascism.* * *

The Communist Party wants to unite all workers in a struggle for their rights against a decadent system of capitalism. Gordon was a worker, and because he was a worker he was shot, like many other workers will be shot if they don't organize and put up a united front against their enemies, the capitalist class, which is rapidly becoming a Fascist regime. It's up to us to show our solidarily with all workers, and with minorities, like the Negroes.

Would you say that would be good anti-Communist propaganda?

MR. KAGHAN. Sounds like a long-winded soapbox speech.

THE CHAIRMAN. No, answer my question. Do you think that is either Communist propaganda or anti-Communist propaganda?

MR. KAGHAN. That would probably be a Communist character speaking.

THE CHAIRMAN. All right. Let us read some more. He says:

I would like to add something. This isn't a race discrimination only. It is probably a capitalist attempt to split the ranks of the workers. We have to bear that in mind. It is important. If the white workers and the Negro workers get together, they have more power than they would otherwise. The bosses want to arouse antagonism between the whites and the Negroes so they wont get together and fight for their rights. That is why we are going to the funeral tomorrow. We have got to show our solidarity.

Would you say that is the Communist line or not?

MR. KAGHAN. That would appear to be a Communist speaking. I assume it is a Communist speaking. But the intent of the play was, as I recall it, to show that communism was not a way out for America.

THE CHAIRMAN. I hand you your own play, and ask you to read the concluding paragraphs, and tell us whether that does not end up with the Communist victorious. Is that not the end of all of your plays?

MR. KAGHAN. I didn't hear your question.

THE CHAIRMAN. Scan through the latter part of your play, and see if the conclusion is not a victory for the Communist argument.

MR. KAGHAN. I can say it wasn't without scanning it, sir.

THE CHAIRMAN. Well, will you read the last several paragraphs?

MR. KAGHAN. The part that is underlined in red?

THE CHAIRMAN. Yes, I think "red" is the right color. But you may read anything else. If what is in red is out of context, you read what explains it.

MR. KAGHAN. I am not familiar with the full play, sir. I will read this part if you wish.

Alice says weakly:

Yes, go and lie down among my ruins. Smell the dust and ashes.

JULIA. Why don't you start burning the whole mess now, you and your Reds. Why do you leave me to look at the wreckage? Why don't you burn it? What are you waiting for?

GERTRUDE. There's not enough wreckage yet, my child. We have to wait.

THE CHAIRMAN. Will you read that last line again?

MR. KAGHAN. (reading):

There's not enough wreckage yet. We have to wait.

THE CHAIRMAN. Is that the end of the play?

MR. KAGHAN. No; there is another line.

THE CHAIRMAN. Would you read the next line?

MR. KAGHAN. (reading):

FRANCES. Say, doesn't anyone want any supper tonight? (No one answers her, and Alice is looking up slowly to her as the curtain falls.)

THE CHAIRMAN. Was that play produced by the Communists?

MR. KAGHAN. No, sir; it was produced at the University of Michigan. . . .

THE CHAIRMAN. One of your responsibilities is supervising the entire information program, including the libraries?

MR. KAGHAN. Yes, sir.

THE CHAIRMAN. Now, do I understand that since Secretary Dulles issued the new order, you have been removing books by Communist authors from the shelves of the libraries?

MR. KAGHAN. We have been removing the books that the Department has advised us to remove, by author.

THE CHAIRMAN. And they have been giving you a list of the authors by name?

MR. KAGHAN. Yes, they have.

THE CHAIRMAN. And you do not have a blanket order to remove the works of all known Communist authors?

MR. KAGHAN. We had a blanket order of that kind, that famous "et cetera" order, and I think it has since been clarified, and specific names of authors are being supplied as they are found out, as they find we have such books.

THE CHAIRMAN. Have you, on your own, ordered the removal of the works of all known Communist authors, or have you ordered the removal of only those authors named by the State Department?

MR. KAGHAN. It would be my responsibility to follow the orders of the State Department in that. I would not give an order to remove any books of that kind at such a time without instructions from the Department.

THE CHAIRMAN. Even though you knew other known Communist authors' works were on the shelves, you would not order their removal?

MR. KAGHAN. If I knew there were other Communist authors' works on the shelves, I would probably order their removal, but I was not aware of the list of people on the shelves.

THE CHAIRMAN. So that we have this picture completely clear, I assume it is agreed that the public affairs officer, a man in your position, should have available the works of Communists, so that you can tell what they are doing, what they are thinking, and can have enough knowledge so that you can fight communism. And we are speaking about these books on the shelves. We are speaking about books not on the shelves of some private library for the public affairs officers, but books for the general public of Germany. Is that right?

MR. KAGHAN. That is right.

THE CHAIRMAN. So these Communist books are not books merely for your benefit or something for men allegedly fighting communism. They were available for the German people in our libraries with our approval.

MR. KAGHAN. Yes, they were.

THE CHAIRMAN. And you say you have taken the works of how many authors off the shelves?

MR. KAGHAN. When I left there were 4 or 5 authors off. They may be more now. Possibly half a dozen before I left. When I directed someone to take them off, that order would go to the man in charge of the American Houses, who was in charge of the libraries, and he would remove the books. . . .

THE CHAIRMAN. Let me ask you: Did you write a play, Beyond Exile?

MR. KAGHAN. The name is familiar; yes.

THE CHAIRMAN. Does this play consist largely of a series of conversations between a father and son?

MR. KAGHAN. Sir, I don't remember what that play was about.

THE CHAIRMAN. Well, I will refresh your recollection, then, if I may. Here is one of the speeches made by the son to the father. And this consists largely of a running argument, the father trying to convince the son he should not be a Communist, the son trying to convince the father that he should be a Communist. Let us take the finale of this play. The son says:

> Well, that's a fine how-do-you-do. It isn't enough that my father has to be a capitalist, but he's got to come out openly and betray his employees, just like all the other dirty capitalists. Do I have to come here and tell my own father that he is a slavedriver, an exploiter of labor, an enemy to civilization?

And the father, finally, in the close, has this to say. He says:

> Peter, Peter, for God's sake listen to me, Peter. You were right, do you hear, you were right! I have been all wrong, Peter.

Would you say that that would make good anti-Communist propaganda?

MR. KAGHAN. No, sir. It sounds pretty corny, now.

THE CHAIRMAN. Is it merely corny? Is not that the Communist Party line right down to the last period?

MR. KAGHAN. One of those statements would be the Communist Party line, yes. One of the characters that said that, apparently—

THE CHAIRMAN. What part of this would not be the Communist line? The son arguing with the father that he should be a Communist, pointing out that the father is a dirty capitalist, an exploiter of labor, and the father ending by saying: "You were right, do you hear, you were right! I have been all wrong, Peter."

Is that not Communist propaganda?

MR. KAGHAN. That would be Communist propaganda if that is what the whole play ends up with and is about. I don't recall what the play is about.

THE CHAIRMAN. Would you like to review that play and give me your view of it?

MR. KAGHAN. If you wish; yes, sir.

THE CHAIRMAN. Yes; I would like to have you do it.

I think this is what we will let you do. We will be going over your plays. Just so there will be no claim that we have taken the material out of context, I believe you should review these plays of yours and come back here tomorrow morning, and tell us which ones you consider are Communist-line plays and which ones are not; whether you think we have been unfair to you in reading the excerpts that we have.

Now let me ask you this question. If you today felt the same as you felt in 1939, would you think that you were a proper man to head this information program?

MR. KAGHAN. No, sir. . . .

9

McCarthy as Hero
1954

William F. Buckley, founder and publisher of the conservative *National Review,* needs no introduction. In him and L. Brent Bozell, who was also associated with the magazine, McCarthy found his most responsible apologists. Following is a piece from their book, *McCarthy and His Enemies,* which they wrote while he was still riding high. The year of its appearance marked the year of McCarthy's spectacular fall.

. . . . We propose to survey McCarthy's record with a view to answering these two questions: Does the evidence he presents justify him (a) in raising the loyalty issue, and (b) in using the particular words that he uses in making his charges? Let us, however, be very clear as to why these are different questions, and why they both need to be asked.

To be sure, McCarthy does not commit separately the two sins with which he is charged. Obviously he does not accuse an employee of being a "pro-Communist" without at the same time (directly or indirectly) raising the question of the employee's loyalty. But clearly, while in certain situations McCarthy ought to be censured for having used certain words in describing his target, he may nevertherless have been justified in raising the question whether his target is a loyalty risk.

McCarthy's friends may feel we are wasting time in fastidiously recording the precise language in which McCarthy couches his charges. After all, they will say, the particular words that McCarthy used do not, anyway, stick in the public's mind; the public recalls merely that a man's allegiance has been called into question. So why hold him to account for the exact working of his accusations? And, as a matter of fact, McCarthy's most violent critics appear to take precisely this position—except, of course, where it turns out that McCarthy has a particularly good case, in which event they hold McCarthy to the exact phrase he used. (For example, after Owen Lattimore was clearly shown to be at best a loyalty risk, they would not let McCarthy forget that he had called Lattimore "the top Soviet espionage agent'" not simply a "loyalty risk.") For the most part, however Liberal talk about "smearing" focuses not so much on McCarthy's language as on the contention that, however he happens to phrase it, manages to put a person's good name under a cloud, and this on the basis of insufficient evidence. Be that as it may, we intend to analyze method under both tests, hardening again to Lord Acton's counsel that one should try to make out for one's opponents an even stronger and more impressive case than they present themselves.

But before we do this, a word needs to be said about two other fashionable tests by which we are invited to judge the sufficiency of McCarthy's evidence. What might be called the *absolute* test of whether McCarthy has "smeared" people is proposed by the Liberal's question: Is there a discrepancy between what a man has actually done, or what a man has actually thought? If this test could be applied, it would surely be the final word as to whether a "smear" has been leveled; but it is obviously unserviceable for purposes of evaluating the charge that a man is pro-Communist. In most other situations the test is indeed serviceable, and of course advisable. If, for example, a man is charged with being a member of the Americans for Democratic Action, we can tell whether a smear has been born simply by finding out whether he *is* a member of the Amercians for Democratic Action; and this we can do easily enough because members of the ADA do not, as a rule, conceal their membership. But one of the Communist movement's greatest single strengths lies in the skill and determination with which it *prevents* society from finding out which citizens are loyal Communists, and thus disloyal citizens. Thus it becomes very difficult to determine whether X, in calling Y a Communist, has smeared him. The best we can do in the circumstances is to ask whether the charge (by which we mean both the specific accusation and the general impugnation of the person's loyalty) *is justified in the light of necessarily circumstantial evidence.*

In addition to the "absolute proof" test, we must reject what might be called the "legal sufficiency" test. Many of McCarthy's critics are given to pointing out that his evidence in nearly every case is insufficient to establish that the accused has broken the law, which is usually true. But they are also given to saying that this is evidence of McCarthy's irresponsibility, which is foolishness. Only in the rare exception does McCarthy even *accuse* his targets of having broken the law. But he does insist, as a general thing, that the evidence he offers is sufficient to warrant the dismissal of his targets from government service. Thus, those who quarrel with McCarthy on this score (taking the position that only proven lawbreakers should be dismissed from the government) should address their grievances to those who drafted the rules for government employment—not to McCarthy, who merely plays by these rules. For by 1947, at the very latest, Congress and both political parties had explicitly endorsed the notion that government service is a privilege, not a right; and that therefore government personnel must meet standards a good deal more exacting than those set forth in the criminal code. Job security for civil servants was therefore to depend not only on their staying outside the law's reach, but also on their satisfying their superiors that their employment was in the national interest.

All this appears to be obvious; but it apparently is not, else we would not hear, so frequently, that McCarthy is to be damned because he goes after government employees without adhering to the standards of proof required of a district attorney going after a thief. . . .

This, then is "McCarthy's method." Notwithstanding the hectically promoted public impression, McCarthy does not make a practice of fabricating evidence. He does, however, make a practice of acting on the

proposition—on which he insists the government also act—that Alger Hiss was not the last of the Socialist agents in our midst, and that Hiss' comrades do not publicly parade their allegiance to the Soviet Union.

We have likened McCarthy's role to that of the prosecutor; but let us keep in mind the hazards of carrying the analogy too far. The greatest psychological propaganda victory the Communists and the Liberals have scored in this whole area has been to force everyone to discuss the loyalty-security issue in the terminology of law. The authors of this book are themselves guilty of having used, in the preceding pages, the organically inappropriate imagery of the law, because otherwise they could not join issue with the opposition. But it is palpably foolish to speak, in the area of government security, of "defendant" and "prosecutor," of "guilt" and "innocence," of "proof," of the "presumption of innocence," of the "right to confront one's accuser," of the "right to cross-examine" of "judgment by one's peers," and the rest of it. So long as we continue to use this terminology we can hardly hope to understand the problem at hand, much less to cope with it. We have, in fact, understood and coped with it just to the extent that we have fought ourselves free, at some points, from the legal imagery and its misleading implications.

It is all to the good that we make the district attorney respect the rights of the accused and depend, for a verdict of "guilty," upon the unanimous approval of the jury. Only at our peril do we abandon such revered customs. But let us not be deceived by certain similarities between the role of a public prosecutor and the role of a McCarthy, or between the position of the accused in a murder trial and the position of a Vincent in a security proceeding. The differences between the two are far greater than the similarities, and they reflect all the wisdom we have acquired about how to deal with the Communists in our midst.

The essence of McCarthy—and McCarthyism—lies in bringing to the loyalty-security problem a kind of skepticism with which it had not been approached before. Others took it for granted that Service backed the Chinese Communists and gave away classified material because he was fooled. McCarthy was prepared to suppose he did so because he was a pro-Communist. Others explained Shapley's party-lining in terms of devotion to world peace; McCarthy recognized that devotion to world Communism was an alternative hypothesis that merited equal treatment. And he keeps on being skeptical if, as so often happens, the evidence does not conclusively establish either hypothesis, McCarthy is there to insist that we cannot afford to *act* on any but the hypothesis that favors national security. McCarthy would unquestionably admit that Service *might* be innocent; but he would never consent to reinstate him in a position of public trust.

This is the heart of McCarthy's method. It is in many respects as revolutionary as the Communist movement itself—and so it is unlikely to commend itself to people so short on knowledge, or even instincts, as to the nature and resources of the Socialist conspiracy as not to realize that we live in an unbrave new world, in which certain cherished habits of mind are not only inappropriate but suicidal.

6

Judicial Acquiescence

By appointing four justices Truman made the Supreme Court his own. It was, to be sure, still the New Deal court that Roosevelt had shaped, but with an enormous difference, one that bears directly on the subject of McCarthyism.

The New Deal court gave a revolutionary interpretation to the Constitution. On the one hand, it withdrew the court's historical protection of economic liberty, allowing the democratic system, or majority rule, to regulate economic liberty as it saw fit. On the other hand, it extended its protection to civil liberties as laid down in the Bill of Rights on the grounds that civil liberties occupied a privileged status in the law, that dissentient groups and individuals, however unpopular their views, had rights that the majority could not violate. During World War II, the New Deal court did not stand in the government's way on civil liberties or any other issues, but no sooner was it over that the court resumed its reading of the Constitution.

Within a few years, however, three of Roosevelt's arch civil libertarian justices died—Harlan F. Stone, Frank Murphy, and Wiley B. Rutledge—and were replaced by men of a very different temper—Fred M. Vinson, Sherman Minton, and Tom C. Clark. What distinguished the latter three was their utter mediocrity. Though justices almost invariably reflect the beliefs of the president who chooses them, the important question is what kind of people are they. No one can deny the greatness of John Marshall, partisan Federalist that he was (did Jefferson detest anyone more?), which is not to say that the views of the Truman justices should be attributed to

their mediocrity. After all, two of Roosevelt's most gifted appointees, Felix Frankfurter and Robert H. Jackson, joined the Truman majority, making it the New Deal-Truman court. The hyphen spoke volumes.

For one thing, the hyphen represented the culmination and epitome of the New Deal. When in 1935–36 the old conservative court began invalidating New Deal legislation, the standard New Deal defense, passionately put forward by some of the best legal minds—notable among them being Harvard professor Felix Frankfurter—was that the judiciary had no warrant for asserting its supremacy over the political process, for imposing its philosophy of life on the nation. And so when a majority of the New Deal court held, in a famous case, that a state could not punish the parents of a child who refused on religious grounds to pledge allegiance to the flag because the First Amendment forbade it, Frankfurter, now a justice, took great exception. He saw no difference between this kind of judicial interference and the kind that once protected property rights. He obviously had consistency on his side. And so did the Truman court when in case after case it refused to interfere with administrative and legislative forms of McCarthyism, when it left political and other minorities to the tender mercies of a public driven by Cold War tensions. In most of these cases, it was two of Roosevelt's appointees, Hugo Black and William O. Douglas, who in dissent stayed true to the ideological inconsistency of the Roosevelt New Deal court. They acknowledged the government's near total authority to regulate the economy but urged firm judicial checks against the slightest diminution of civil liberties. To them, the Bill of Rights was sacrosanct.

Had the Black-Douglas view prevailed—had Murphy and Rutledge not died in 1949 and the Truman court been different than it was—McCarthyism might have received a tremendous rebuff at its outset. This piece of speculation of course raises an unanswerable question: How would the American people and Congress have reacted to a court that coddled subversives and traitors when the republic was in such acute danger? As it was, by submitting to electoral majorities on fundamental civil liberties issues, the Truman court ceased to be a co-equal branch of the federal government, deferring as it did to the other branches. But it was the branch whose specific responsibility, whose constitutional mandate, was the safeguarding of minority rights. Walking the Supreme Court chambers at night, as was its wont, John Marshall's ghost must have been as distraught as Hamlet's father.

1

The Court Gives the Go-Ahead
May 8, 1950

The Truman (or Vinson) Court signaled the direction it would take in the case, *American Communications Association v. Douds,* argued by the Chief Justice, when it upheld Section 9(h) of the Taft-Hartley Act (see Chapter Three, Document Three), which denied unions National Labor Relations Board protection unless their leaders signed an affidavit swearing that they were not nor had ever been Communists. "Never before," said Justice Black in his dissent (from the ruling excerpted below) "has this court held that the Government could for any reason attaint persons for their political beliefs or affiliations."

[Section 9(h)] does not interfere with speech because Congress fears the consequences of speech; it regulates harmful conduct which Congress had determined is carried on by persons who may be identified by their political affiliations and beliefs. The [National Labor Relations] Board does not contend that political strikes, the substantive evils of which 9(h) is aimed, are the present or pending products of advocacy of the doctrines of Communism or the expression of belief in the overthrow of the Government by force. On the contrary, it points out that such strikes are called by persons who, so Congress has found, have the will and power to do so *without* advocacy or persuasion that seeks acceptance in the competition of the market. Speech may be fought with speech. Falsehoods and fallacies must be exposed, not suppressed, unless there is not sufficient time to avert the evil consequences of noxious doctrine by argument and education. That is the command of the First Amendment. But force may and must be met with force. Section 9(h) is designed to protect the public not against what Communists and others identified therein advocate or believe, but against what Congress has concluded they have done and are likely to do again. . . .

It is contended that the principle that statutes touching First Amendment freedoms must be narrowly drawn dictates that a statute aimed at political strikes should make the calling of such strikes unlawful but should not attempt to bring about the removal of union officers, with its attendant effect upon First Amendment rights. We think, however, that the legislative judgment that interstate commerce must be protected from a continuing threat of such strikes is a permissible one in this case. The fact that the injury to interstate commerce would be an accomplished fact before any sanctions could be applied, the possibility that a large number of such strikes might be called at a time of external or internal crisis, and the practical difficulties which would be encountered in detecting illegal activities of this kind are factors which are persuasive that Congress should

339 U.S. 401, 406, 413.

not be powerless to remove the threat, not limited to punishing the act. . . .

The unions' argument as to bill of attainder cites the familiar cases, *Lovett, Garland, Cummings*. Those cases and this also, according to the argument, involve the proscription of certain occupations to a group classified according to belief and loyalty. But there is a decisive distinction: in the previous decisions the individuals involved were in fact punished for *past* actions; whereas in this case they are subject to possible loss of position only because there is substantial ground for the congressional judgment that their beliefs and loyalties will be transformed into *future* conduct.

2

Defining the Fifth
February 26, 1951

> In this important decision from *Rogers v. United States,* Chief Justice
> Vinson, on the Court's behalf, severely limited the scope of Fifth
> Amendment protection against self-incrimination. Note Black's dis-
> sent.

This case arises out of an investigation by the regularly convened
grand jury of the United States District Court for the District of Colorado.
The books and records of the Communist Party of Denver were sought as
necessary to that inquiry and were the subject of questioning by the grand
jury. In September, 1948, petitioner, in response to a subpoena, appeared
before the grand jury. She testified that she held the position of Treasurer
of the Communist Party of Denver until January, 1948, and that, by virtue
of her office, she had been in possession of membership lists and dues
records of the Party. Petitioner denied having possession of the records
and testified that she had turned them over to another. But she refused to
identify the person to whom she had given the Party's books, stating to the
court as her only reason: "I don't feel that I should subject a person or
persons to the same thing that I'm going through." The court thereupon
committed petitioner to the custody of the marshal until ten o'clock the
next morning, expressly advising petitioner of her right to consult with
counsel.

The next day, counsel for petitioner informed the court that he had
read the transcript of the prior day's proceedings and that, upon his advice,
petitioner would answer the questions to purge herself of contempt. How-
ever, upon reappearing before the grand jury, petitioner again refused to
answer the question. The following day she was again brought into court.
Called before the district judge immediately after he had heard oral argu-
ment concerning the privilege against self-incrimination in another case,
petitioner repeated her refusal to answer the question, asserting this time
the privilege against self-incrimination. After ruling that her refusal was
not privileged, the district judge imposed a sentence of four months for
contempt. . . .

If petitioner desired the protection of the privilege against self-
incrimination, she was required to claim it. *United States v. Monia,* 317
U.S. 424, 427 (1943). The privilege "is deemed waived unless invoked."
United States v. Murdock, 284 U.S. 141, 148 (1931). Furthermore, the
decisions of this Court are explicit in holding that the privilege against self-
incrimination "is solely for the benefit of the witness," and "is purely a
personal privilege of the witness." Petitioner expressly placed her original
declination to answer on an untenable ground, since a refusal to answer

340 U.S. 368–71, 378–81.

cannot be justified by a desire to protect others from punishment, much less to protect another from interrogation by a grand jury. Petitioner's claim of the privilege against self-incrimination was pure afterthought. Although the claim was made at the time of her second refusal to answer in the presence of the court, it came only after she had voluntarily testified to her status as an officer of the Communist Party of Denver. To uphold a claim of privilege in this case would open the way to distortion of facts by permitting a witness to select any stopping place in the testimony. . . .

Requiring full disclosure of details after a witness freely testifies as to a criminating fact does not rest upon a further "waiver" of the privilege against self-incrimination. Admittedly, petitioner had already "waived" her privilege of silence when she freely answered criminating questions relating to her connection with the Communist Party. But when petitioner was asked to furnish the name of the person to whom she turned over Party records, the court was required to determine, as it must whenever the privilege is claimed, whether the question presented a reasonable danger of further crimination in light of all the circumstances, including any previous disclosures. As to each question to which a claim of privilege is directed, the court must determine whether the answer to that particular question would subject the witness to a "real danger" of further crimination. . . .

Mr. Justice Black, dissenting. . . .

Apparently, the Court's holding is that at some uncertain point in petitioner's testimony, regardless of her intention, admission of associations with the Communist Party automatically effected a "waiver" of her constitutional protection as to all related questions. To adopt such a rule for the privilege against self-incrimination, when other constitutional safeguards must be knowingly waived, relegates the Fifth Amendment's privilege to a second-rate position. Moreover, today's holding creates this dilemma for witnesses: On the one hand, they risk imprisonment for contempt by asserting the privilege prematurely; on the other, they might lose the privilege if they answer a single question. The Court's view makes the protection depend on timing so refined that lawyers, let alone laymen, will have difficulty in knowing when to claim it. In this very case, it never occurred to the trial judge that petitioner waived anything. . . .

I believe that today's expansion of the "waiver" doctrine improperly limits one of the Fifth Amendment's great safeguards.

I would reverse the judgment of conviction.

3

Loyalty, Past, Present, and Future
June 4, 1951

In *Garner v. City of Los Angeles Board of Public Works,* Justice Tom
Clark, speaking for the majority, upheld the right of any community to
fire employees who refused to sign a loyalty pledge of the sweeping
kind Los Angeles drew up.

Petitioners are citizens of the United States and civil service em-
ployees of the City of Los Angeles. In 1948 the City of Los Angeles
passed Ordinance No. 94,004 which requires each of its employees to
subscribe to an oath of loyalty which included, *inter alia,* an affirmation
that he does not advise, advocate, or teach, and has not within the five years
prior to the effective date of the ordinance "advised, advocated or taught,
the overthrow by force, violence or other unlawful means, of the Govern-
ment of the United States of America or of the State of California," and
that he is not and has not within that period been "a member of or affiliated
with any group, society, association, organization or party which advises,
advocates or teaches, or has, within said period, advised, advocated
or taught, the overthrow by force, violence or other unlawful means
of the Government of the United States of America, or of the State of
California."

The ordinance also requires each employee to execute an affidavit
stating "whether or not he is or ever was a member of the Communist
Party of the United States of America or of the Communist Political
Association, and if he is or was such a member, stating the dates when he
became, and the periods during which he was, such a member." . . .

We think that a municipal employer is not disabled because it is an
agency of the State from inquiring of its employees as to matters that may
prove relevant to their fitness and suitability for the public service. Past
conduct may well relate to present fitness; past loyalty may have a reason-
able relationship to present and future trust. Both are commonly inquired
into in determining fitness for both high and low positions in private
industry and are not less relevant in public employment. The affidavit
requirement is valid. . . .

Mr. Justice Douglas, with whom Mr. Justice Black joins, dissent-
ing. . . .

Petitioners were disqualified from office not for what they are today,
not because of any program they currently espouse . . . , but for what
they once advocated. They are deprived of their livelihood by legislative
act, not by judicial processes. We put the case in the aspect most invidious

341 U.S. 720, 731.

to petitioners. Whether they actually advocated the violent overthrow of Government does not appear. But here, as in the *Cummings* case, the vice is in the presumption of guilt which can only be removed by the expurgatory oath. That punishment, albeit conditional, violates here as it did in the *Cummings* case the constitutional prohibition against bills of attainder.

4

Suppression Legalized: *Dennis v. United States*
June 4, 1951

No book of documents on McCarthyism dares omit the Supreme Court's Dennis decision, written by Chief Justice Vinson, which sanctioned the prosecution of Communists under the Smith Act and broadly legitimated the red scare in general. (Eugene Dennis was party chairman and stood for all eleven defendants.) The government had been waiting impatiently for the decision; now it could go ahead and try the rest of the party leaders, untold hundreds of them. Black's rejoinder, as indignant as it was eloquent and to the point, went on to become one of the Court's famous utterances.

The indictment charged the petitioners with willfully and knowingly conspiring (1) to organize as the Communist Party of the United States of America a society, group and assembly of persons who teach and advocate the overthrow and destruction of the Government of the United States by force and violence, and (2) knowingly and willfully to advocate and teach the duty and necessity of overthrowing and destroying the Government of the United States by force and violence. The indictment further alleged that § 2 of the Smith Act proscribes these acts and that any conspiracy to take such action is a violation of § 3 of the Act. . . .

The very language of the Smith Act negates the interpretation which petitioners would have us impose on that Act. It is directed at advocacy, not discussion. Thus, the trial judge properly charged the jury that they could not convict if they found that petitioners did "no more than pursue peaceful studies and discussions or teaching and advocacy in the realm of ideas." He further charged that it was not unlawful "to conduct in an American college and university a course explaining the philosophical theories set forth in the books which have been placed in evidence." Such a charge is in strict accord with the statutory language, and illustrates the meaning to be placed on those words. Congress did not intend to eradicate the free discussion of political theories, to destroy the traditional rights of Americans to discuss and evaluate ideas without fear of governmental sanction. Rather Congress was concerned with the very kind of activity in which the evidence showed these petitioners engaged.

But although the statute is not directed at the hypothetical cases which petitioners have conjured, its application in this case has resulted in convictions for the teaching and advocacy of the overthrow of the Government by force and violence, which, even though coupled with the intent to accomplish that overthrow, contains an element of speech. For this reason, we must pay special heed to the demands of the First Amendment marking out the boundaries of speech. . . .

341 U.S. 407, 502–3, 505, 508, 509–10, 516–17, 579–81.

The rule we deduce from these cases is that where an offense is specified by a statute in nonspeech or nonpress terms, a conviction relying upon speech or press as evidence of violation may be sustained only when the speech or publication created a "clear and present danger" of attempting or accomplishing the prohibited crime. . . .

In this case we are squarely presented with the application of the "clear and present danger" test, and must decide what that phrase imports. . . .

Obviously, the words cannot mean that before the Government may act, it must wait until the *putsch* is about to be executed, the plans have been laid and the signal is awaited. If Government is aware that a group aiming at its overthrow is attempting to indoctrinate its members and to commit them to a course whereby they will strike when the leaders feel the circumstances permit, action by the Government is required. The argument that there is no need for Government to concern itself, for Government is strong, it possesses ample powers to put down a rebellion, it may defeat the revolution with ease needs no answer. For that is not the question. Certainly an attempt to overthrow the Government by force, even though doomed from the outset because of inadequate numbers or power of the revolutionists, is a sufficient evil for Congress to prevent. The damage which such attempts create both physically and politically to a nation makes it impossible to measure the validity in terms of the probability of success, or the immediacy of a successful attempt. In the instant case the trial judge charged the jury that they could not convict unless they found that petitioners intended to overthrow the Government "as speedily as circumstances would permit." This does not mean, and could not properly mean, that they would not strike until there was certainty of success. What was meant was that the revolutionists would strike when they thought the time was ripe. We must therefore reject the contention that success or probability of success is the criterion. . . . Petitioners intended to overthrow the Government of the United States as speedily as the circumstances would permit. Their conspiracy to organize the Communist Party and to teach and advocate the overthrow of the Government of the United States by force and violence created a "clear and present danger" of an attempt to overthrow the Government by force and violence. They were properly and constitutionally convicted for violation of the Smith Act. The judgments of conviction are

Affirmed.

Mr. Justice Black, dissenting. . . .

At the outset I want to emphasize what the crime involved in this case is, and what it is not. These petitioners were not charged with an attempt to overthrow the Government. They were not charged with nonverbal acts of any kind designed to overthrow the Government. They were not even charged with saying anything or writing anything designed to overthrow the Government. The charge was that they agreed to assemble and to talk and publish certain ideas at a later date: The indictment is that they con-

spired to organize the Communist Party and to use speech or newspapers and other publications in the future to teach and advocate the forcible overthrow of the Government. No matter how it is worded, this is a virulent form of prior censorship of speech and press, which I believe the First Amendment forbids. I would hold § 3 of the Smith Act authorizing this prior restraint unconstitutional on its face and as applied. . . .

So long as this Court exercises the power of judicial review of legislation, I cannot agree that the First Amendment permits us to sustain laws suppressing freedom of speech and press on the basis of Congress' or our own notions of mere "reasonableness." Such a doctrine waters down the First Amendment so that it amounts to little more than an admonition to Congress. The Amendment as so construed is not likely to protect any but those "safe" or orthodox views which rarely need its protection. . . .

Public opinion being what it now is, few will protest the conviction of these Communist petitioners. There is hope, however, that in calmer times, when present pressures, passions and fears subside, this or some later Court will restore the First Amendment liberties to the high preferred place where they belong in a free society.

5

New York Leads the Way
March 3, 1952

New York State's Feinberg law gave loyalty review boards broad authority to fire public school employees, kindergarten through college, who might be "subversive," i.e., belong to "subversive" organizations or know people who did or have done something else in their past or have questionable views, etc. Under its provisions hundreds were summarily dismissed, most of them in New York City. In this case, *Adler v. Board of Education of New York,* the Court, through Justice Sherman Minton, served notice that all communities could follow the New York example. Douglas's minority opinion cannot be improved on as a condemnation of the whole loyalty review system.

. . . A teacher works in a sensitive area in a schoolroom. There he shapes the attitude of young minds towards the society in which they live. In this, the state has a vital concern. It must preserve the integrity of the schools. That the school authorities have the right and the duty to screen the officials, teachers, and employees as to their fitness to maintain the integrity of the schools as a part of ordered society, cannot be doubted. One's associates, past and present, as well as one's conduct, may properly be considered in determining fitness and loyalty. From time immemorial, one's reputation has been determined in part by the company he keeps. In the employment of officials and teachers of the school system, the state may very properly inquire into the company they keep, and we know of no rule, constitutional or otherwise, that prevents the state, when determining the fitness and loyalty of such persons, from considering the organizations and persons with whom they associate.

If, under the procedure set up in the New York law, a person is found to be unfit and is disqualified from employment in the public school system because of membership in a listed organization, he is not thereby denied the right of free speech and assembly. His freedom of choice between membership in the organization and employment in the school system might be limited, but not his freedom of speech or assembly, except in the remote sense that limitation is inherent in every choice. Certainly such limitation is not one the state may not make in the exercise of its police power to protect the schools from pollution and thereby to defend its own existence.

Mr. Justice Douglas, with whom Mr. Justice Black concurs, dissenting.

I have not been able to accept the recent doctrine that a citizen who enters the public service can be forced to sacrifice his civil rights. I cannot for example find in our constitutional scheme the power of a state to place

342 U.S. 493, 508–10.

its employees in the category of second-class citizens by denying them freedom of thought and expression. The Constitution guarantees freedom of thought and expression to everyone in our society. All are entitled to it; and none needs it more than the teacher.

The public school is in most respects the cradle of our democracy. The increasing role of the public school is seized upon by proponents of the type of legislation represented by New York's Feinberg law as proof of the importance and need for keeping the school free of "subversive influences." But that is to misconceive the effect of this type of legislation. Indeed the impact of this kind of censorship on the public school system illustrates the high purpose of the First Amendment in freeing speech and thought from censorship.

The present law proceeds on a principle repugnant to our society— guilt by association. A teacher is disqualified because of her membership in an organization found to be "subversive." The finding as to the "subversive" character of the organization is made in a proceeding to which the teacher is not a party and in which it is not students, the parents, the community become informers. Ears are cocked for tell-tale signs of disloyalty. The prejudices of the community come into play in searching out the disloyal. This is not the usual type of supervision which checks a teacher's competency; it is a system which searches for hidden meanings in a teacher's utterances.

What was the significance of the reference of the art teacher to socialism? Why was the history teacher so openly hostile to Franco Spain? Who heard overtones of revolution in the English teacher's discussion of the Grapes of Wrath? What was behind the praise of Soviet progress in metallurgy in the chemistry class? Was it not "subversive" for the teacher to cast doubt on the wisdom of the venture in Korea?

What happens under this law is typical of what happens in a police state. Teachers are under constant surveillance; their pasts are combed for signs of disloyalty; their utterances are watched for clues to dangerous thoughts. A pall is cast over the classrooms. There can be no real academic freedom in that environment. Where suspicion fills the air and holds scholars in line for fear of their jobs, there can be no exercise of the free intellect. Supineness and dogmatism take the place of inquiry. A "party line"—as dangerous as the "party line" of the Communists—lays hold. It is the "party line" of the orthodox view, of the conventional thought, of the accepted approach. A problem can no longer be pursued with impunity to its edges. Fear stalks the classroom. The teacher is no longer a stimulant to adventurous thinking; she becomes instead a pipe line for safe and sound information. A deadening dogna takes the place of free inquiry. Instruction tends to become sterile; pursuit of knowledge is discouraged; discussion often leaves off where it should begin.

7

Inquisition Triumphant

In the early 1950s America's endemic hatred of Communism turned into the great American red scare. It was the trauma of those years (already much discussed in these pages), that led the public to demand a response by government and throughout the nation of the radical kind McCarthy was identified with. So it was that the repression that had begun rather tentatively when the Cold War got under way increasingly took on the aspect of a generalized inquisition. And in doing so—to repeat the point often made here—it in fact exacerbated the fear that called it forth and which it was supposed to assuage. In the end, only an external force as seismic as the one that brought on the fear was able to calm the nerves and break the self-reinforcing cycle.

1

The various un-American activity committees, federal and local, boldly swung into action; they had been subdued for a while. The enormous publicity they generated in every community they visited was directed against the enemies of the people from whom they demanded an accounting and who were then reviled and ostracized and perhaps jailed. The function of the committees, HUAC first among equals, was to perform a community ritual that otherwise defied rationality. Unfriendly witnesses—those who rejected the absolution that came with the confessing of sins and the naming of names—faced two choices: a contempt citation and therefore jail by talking back, attempting to answer questions on their own

terms; or complete silence by taking the Fifth Amendment (on the grounds that their testimony might tend to incriminate them). But to take the Fifth was, in the eyes of society, tantamount to an admission of guilt, and to thus suffer the dire consequences, whether one worked for lily livered capitalists or such highly respected institutions as Ivy League colleges and *The New York Times;* terrified by the prospect of being excoriated by critics or facing investigation themselves, they too marched to the beat of McCarthyism.

Author Lillian Hellman worked out a novel way of dealing with the problem of avoiding a contempt citation at any rate. She agreed to speak freely about herself but not about others she was politically involved with. Not that this arrangement saved her or anyone else who used it from the blacklist and penury. For unfriendly witnesses there was no way out.

The loyalty review boards that began with President Truman's 1947 executive order became, in the 1950s, America's ubiquitous order of the day. That just about every public employee passed through the loyalty review system would scarcely be an exaggeration. All but a few were of course swiftly processed, given only the most cursory check, the assumption being that it was worth the trouble to single out those few for special attention. For those few, the loyalty review boards might more aptly have been labeled star chamber tribunals, so named for the infamous judicial proceedings of olden days that took place at the king's behest behind closed doors. Loyalty review boards could not imprison or kill their accused, as star chamber tribunals could, only remove them from their jobs. But they were similar to the tribunals in how they gathered evidence and what they did with it and who decided on the procedures they would follow, the person whose fate lay in the balance having only such rights as they deigned to allow. In effect, they too were closed-door affairs.

To be sure, *public* boards or tribunals did at least grant some slight measure of due process. As we noted, they entitled the accused to bring a lawyer and appeal to higher authorities. The private sector rarely bothered with even these inadequate provisions. In certain industries, entertainment above all, a sort of division of labor sprung up. They came to rely on professional star chamber services, on expert inquisitors whose patriotic credentials were above reproach (e.g., ex-FBI agents). Their task was to protect vulnerable companies from an easily aroused public by issuing certificates of clearance for individuals in the employ of those companies whose names had cropped up somewhere or other. The individuals in question had to clear themselves to the satisfaction of the ad hoc star chamber tribunal (even if it consisted of one inquisitor) in the usual fashion—by a show of repentance, by the naming of fellow culprits. Names and more names were accordingly the inquisitor's stock in the trade, the fount of their power and profits, the basis of their leverage. Names were broadcast in their own publications, such as *Red Channels, Counterattack,* and *Confidential Information,* in other publications that were closely associ-

ated with them—*American Legion Magazine, The Tablet, Sign* (the last two were Catholic weeklies) among others—by a host of syndicated columnists, and in the hearings and reports of un-American activities committees. Because they charged a fee for their services, the inquisitors who sat on the tribunals ran a classic protection racket, in this instance protection not from violence (which the protector would commit), but from public exposure and obloquy. To the companies, the service fees and the poor taste they left were trivial, little more than a nuisance, compared to the harm that they feared would come if the red scare could be directed against them.

One other facet of star chamber tribunals should be mentioned: their frequent use of professional or expert witnesses, usually ex-Communists or government agents who had infiltrated the party. Their cachet made their testimony especially persuasive to those already predisposed to believe them. The tendency to corruption obviously applied to them, for they too received fees for their appearances, many as retaineers sent wherever they were needed, at a court trial of party members, at a longshoreman's hearing, at a review of a public school teacher hauled up for belonging to a "subversive" organization, etc. These witnesses on demand were an organic part of the star chamber syndrome.

What might be described as administrative despotism also characterized the red scare at its height. Now administrative despotism was merely the right assumed by federal and state government agencies and those who represented them to construe their authority broadly enough—the crisis required no less of them—to punish anyone who, in their judgment, bore the stigma of Communism. That the Criminal Divison of the Justice Department, the Internal Revenue Service, and the Immigration and Naturalization Service construed their enormous authority—their capacity to inflict harm—in such a latitudinarian way, has been remarked on before. The Post Office did its bit by keeping track of those who got what mail from what countries, even forcing recipients to pick it up themselves. Among the most aggressively punitive agencies was the State Department's Passport Division. A person hardly known to the public at large ran it as her own bailiwick. Frances Knight did not account to anyone in deciding who could leave the country and who not. Some of her victims, notably entertainer Paul Robeson, experienced a catch-22 disaster, a two-pronged blacklist: unable to perform at home, neither could they seek work abroad. There is no point in giving further examples of administrative despotism, they are so bountiful (even the Veterans' Administration and the Health, Education, and Welfare Department indulged in it), and the archives will undoubtedly turn up more.

There is no point either in piling up examples at the state level, where the despotism was at least as onerous and damaging. The general introduction cited one—how New York's insurance commissioner, an otherwise invisible bureaucrat if there ever was one, destroyed by fiat a worthy organization, the International Workers Order, because it was tethered to the

Communist Party. Many such invisible bureaucrats acted with unwonted bravado against offending leftists during the red scare.

2

By definition the red scare was a mass phenomenon, and in the early 1950s that mass may have comprised a majority of the electorate. Like any mass, this one too, it can be assumed, was mostly passive in its sympathies and looked for guidance to its leaders, the activists who dedicated themselves to the faith McCarthy symbolized, who set agendas and operated networks of mutual support, or whose wealth gave them a privileged status in the movement, or who belonged to public and private institutions that commanded large resources and a good deal of prestige. These very disparate groups formed a vanguard that was drawn together by the one abiding passion they shared, that Communism was the sum of human iniquity and that to destroy it all means were justified. There were the several veterans' organizations, the biggest, most potent, and aggressively inquisitorial being the American Legion. There was the Catholic Church, which now had the chance not only to get back at its historic foe, Communism and the left in general, but to establish its patriotic bonafides in a land that had always kept Catholics in their place and at times had cruelly persecuted them (a number of Catholics conspicuously dissented from the Church's love affair with McCarthyism, and with McCarthy in particular, notably *Commonwealth* magazine and such liberal clergymen as Bishop Bernard Sheil of Chicago). There were the newly prosperous entrepreneurs in the burgeoning "sun belt" states of California and especially Texas, whose millionaire oilmen contributed heavily to far right causes, McCarthy's prominent among them. Business interests of a more moderate cast nevertheless saw an opportunity to translate the red scare into public policies favorable to them. There was the "China lobby," so named because it consisted of powerful entrepreneurs and religious and political groups who sought for specific reasons of their own to reclaim the Chinese mainland. Conservative trade unions' hatred of left-wing rivals can be summed up in the maxim, the enemies of my enemies are my friends. And, finally, there was the whole enormous complex of law enforcement and national security institutions that gathered intelligence on, and helped in the prosecution of, those whom society declared politically dangerous. Without such a vanguard, McCarthyism might have dissipated as quickly as the other red scares had.

This chapter and the next attempts to give some idea, through documents, of what McCarthyism, its vanguard and rank-and-file both, wrought in its heyday—what it accomplished in seeking to purge America of evildoers and make America over in its image, and what cruelties it inflicted on its victims.

1

Blacklisters at Work: *Red Channels*
June 1950

With the financial backing of right-wing groups, among them members of the China lobby, three ex-FBI agents published *Counterattack,* a newsletter that exposed people in the entertainment industry whom it claimed were red. Which is to say that it also cleared people who feared exposure—for a fee. In late June 1950 the *Counterattack* group brought out *Red Channels,* a book that cut a wide swath across the industry to the benefit of the exposed/clearance experts. It drew on sources as numerous as they were raw and gossip-laden: Communist publications, FBI, HUAC and other government files, letterheads, etc. Its potency may be measured by the number of entertainers and writers who lost their careers from among the 151 it listed, or smeared. Of the five given below, two, Leonard Bernstein and Arther Miller, survived the onslaught in good shape. The others, who had been quite successful, took a long time to recover from the blacklist.

LARRY ADLER
 Harmonica Player

	Reported as:
Committee for the First Amendment	Signer. Advertisement, *Hollywood Reporter,* 10/24/47, p. 5; *Un-Am. Act. in California, 1948,* p. 210.
National Council of the Arts, Sciences and Professions	Signer for Wallace. *Daily Worker,* 10/19/48, p. 7; *New York Times,* 10/20/48.
People's Songs	Member, Board of sponsors. Bulletin of People's Songs, 5/47.
Progressive Citizens of America	Sponsor. Program, 10/25/47. Candidate for officer of Los Angeles Branch. *Un-Am. Act. in California, 1948,* p. 355.
Hollywood Independent Citizens Committee of the Arts, Sciences and Professions	Member of Executive Council. *Un-Am. Act. in California, 1947,* p. 189.
Joint Anti-Fascist Refugee Committee	Supporter. Deposition filed in the McCullough case, Federal Court, Hartford, Connecticut, 9/49.

Excerpted from *Red Channels* (New York: American Business Consultants Inc., June, 1950), 11, 49–50, 59–60, 110–12.

National Council of American-Soviet Friendship	Supporter. Deposition filed in the Mc-Cullough case, Federal Court, Hartford, Connecticut, 9/49.
Abraham Lincoln School	Supporter. Deposition filed in the Mc-Cullough case, Federal Court, Hartford, Connecticut, 9/49. . . .

LEONARD BERNSTEIN
Composer, Conductor

Reported as:

People's Songs, Inc.	Sponsor. Letterhead, 3/48.
Scientific and Cultural Conference for World Peace	Sponsor. Official program, 3/49.
American-Soviet Music Society	Affiliated. Un-Am. Act. Com. *Review of Scientific and Cultural Conference for World Peace*, 4/19/49, p. 52.
Hanns Eisler Concert	Sponsor. Un-Am. Act. Com. *Review of Scientific and Cultural Conference for World Peace*, 4/19/49, p. 43.
Protest Against Deportation of Hanns Eisler	Signer. Un-Am. Act. Com. *Review of Scientific and Cultural Conference for World Peace*, 4/19/49, p. 43.
Committee for Reelection of Benjamin J. Davis, 1945	Affiliated. Un-Am. Act. Com. *Review of Scientific and Cultural Conference for World Peace*, 4/19/49, p. 41.
Progressive Citizens of America	Signer. Arts, Sciences and Professions Council, statement in defense of Communist cases. Un-Am. Act. Com. *Review of Scientific and Cultural Conference for World Peace*, 4/19/49, p. 37.
World Federation of Democratic Youth	Affiliated. Un-Am. Act. Com. *Review of Scientific and Cultural Conference for World Peace*, 4/19/49, p. 36. . . .

PAUL DRAPER
Dancer

Reported as:

Joint Anti-Fascist Refugee Committee	Entertainer. Mundt Bill Rally, Madison Square Garden, NYC, 5/17/48. *Daily Worker*, 5/10/48.

National Council of the Arts, Sciences and Professions	Signer. Advertisement in support of Hollywood Ten. *Variety,* 12/1/48. Nominee for office. Theatre Division rally, "Wallace Program for the Theatre," 9/20/48. Handbill. Signer for Wallace. *Daily Worker,* 10/19/48, p. 7; *NY Times,* 10/20/48.
Scientific and Cultural Conference for World Peace	Sponsor. Official program, 3/49.
Friends of the Abraham Lincoln Brigade	Sponsor. *NY Journal-American,* 1/25/50.
American Youth for Democracy	Sponsor. Un-Am. Act. Com. *Review of Scientific and Cultural Conference for World Peace,* 4/19/49, p. 22.
Voice of Freedom Committee	Sponsor. Un-Am. Act. Com. *Review of Scientific and Cultural Conference for World Peace,* 4/19/49, p. 35.
National Council of American-Soviet Friendship	Entertained at benefit. Un-Am. Act. Com. *Review of Scientific and Cultural Conference for World Peace,* 4/19/49, p. 50; *NY Journal-American,* 1/25/50. . . .

WILL GEER
Actor—Screen, Stage, Radio

	Reported as:
Communist	Identified as Communist by Walter S. Steele. *Hearings of House Un-Am. Act. Com. on H.R. 1884 and H.R. 2522.*
Scientific and Cultural Conference for World Peace	Sponsor. Official program, 3/49.
May Day Parade, 1947, 1948	Sponsor. Un-Am. Act. Com. *Review of Scientific and Cultural Conference for World Peace,* p. 54.
Committee for Reelection of Benjamin J. Davis	Sponsor. *Daily Worker,* 9/25/45, p. 12.
American Peace Mobilization	Entertainer. *New Masses,* 5/27/41, p. 27.
Daily Worker Benefit	Entertainer. *Daily Worker,* 8/13/37, p. 5.

International Workers Order	Sponsor. *New Masses,* 8/27/40, p.21.
Mother Bloor Celebration Committee	Director of play program. Booklet, front cover. Married to Herta Ware, grand-daughter of Ella Reeve Bloor, veteran Communist Party leader. *House Un-Am. Act. Com. Index II,* p. S111.
People's Songs	Master of ceremonies. *Daily Worker,* 9/20/47, p. 11.
Voice of Freedom Committee	Participant. *House Un-Am. Act. Com. Index II,* p. 113.
Daily Worker	Subject of article. Article states Geer made motion picture in USSR in 1935. Referring to his then current play "On Whitman Avenue," the following is quoted: "Of all the social dramas, agit-prop plays, people's revues and mass chants Geer has ever appeared in during the past two and one half decades, his current vehicle 'is the most educational,' he asserts." *Daily Worker,* 6/4/46, p. 11.

ARTHUR MILLER
Playwright—"Death of a Salesman," "All My Sons"

	Reported as:
American Youth Congress	Signer of call. Official proceedings, 1/28 30/38.
Book Find Club	Writer. *Book Find News,* 5/46, p. 7; 1/46, p. 3. Author of Club selection. *Book Find News,* 1/46, p. 3.
Civil Rights Congress	Signer. Statement in defense of Eisler. *Daily Worker,* 2/28/47, p. 2. Signer. Statement defending Communist Party. *Daily Worker,* 4/16/47, p. 2. Speaker, "Abolish America's Thought Police." *Daily Worker,* 10/6/47, p. 8.
Committee of Welcome for the Very Rev. Hewlett Johnson	Member. *Daily Worker,* 9/22/48, p. 5.
International Workers Order	Defender of tax exemption for IWO. *Fraternal Outlook,* 11/48, p. 6.

Jewish Life	Contributor. *Jewish Life,* publication of Morning Freiheit Association, 3/48, p. 7.
Mainstream and *New Masses*	Speaker at rally to defend Howard Fast, 10/16/47. *New Masses,* 10/28/47, p. 2.
National Council of the Arts, Sciences and Professions	Signer for Wallace. *Daily Worker,* 10/19/48, p. 7. Member, Initiating Committee. Writers for Wallace. *Daily Worker,* 9/21/48, p. 7. Co-chairman. Performance, "The Journey of Simon McKeever," and "I've Got the Tune," Carnegie Hall, 6/21/49. Official program. Sponsor. Committee to Abolish the House Un-American Activities Committee. *NY Journal-American,* 12/30/48.
New York Council of the Arts, Sciences and Professions	Speaker. Rally against the "Foley Square Convictions", 10/27/49. *Daily Worker,* 10/24/49, p. 5.
Progressive Citizens of America	Sponsor. Program, 10/25/47. . . .

2

The California Loyalty Oath
September 1950

In the fall of 1950, eight teachers and administrators at San Francisco State College were dismissed for refusing to swear to the following loyalty oath. Named after its sponsor, Representative Harold R. Levering, it had been passed by the legislature and signed by Governor Earl Warren. Not until 1967 did the California Supreme Court declare it unconstitutional. But not until 1979 did the remaining refuseniks return to their jobs with back pay, about a thousand dollars for every year lost.

And I do further swear (or affirm) that I do not advocate, nor am I a member of any party or organization, political or otherwise, that now advocates the overthrow of the Government of the United States or of the State of California by force or violence or other unlawful means; that within five years immediately preceding the taking of this oath (or affirmation) I have not been a member of any party or organization, political or otherwise, that advocated the overthrow of the Government of the United States or of the State of California by force or violence or other unlawful means except as follows _____ (if no affiliations, write in the words "No exceptions") and that during such time as I am a member or employee of the _____ (name of public agency) I will not advocate nor become a member of any party or organization, political or otherwise, that advocates the overthrow of the Government of the United States or of the State of California by force or violence or other unlawful means.

Excerpted from *The California Oath Controversy,* David P. Gardner (Berkeley: University of California Press, 1967), 219. Copyright 1967 by University of California Press.

3

Reagan Versus the Reds
July 30, 1951

The Screen Actors Guild, during the years Ronald Reagan was its
president, capitulated utterly to the blacklist, having even agreed not
to defend actors who were accused of "offending American public
opinion." He never denied—indeed, he was proud of the fact—that he
was at this time a secret FBI informer. Following is from a triumphal
piece Reagan wrote for the *Citizen News* titled, "Reds Beaten in Holly-
wood."

Communism failed in Hollywood because the overwhelming ma-
jority of the members of the Screen Actors Guild, the Screen Extras
Guild, the writers' and directors' guilds and the workers in the Holly-
wood studio craft unions are and always have been opposed to commu-
nism.

Day after day in this year's hearings by the House Committee on Un-
American Activities, the same story has been unfolded—a story of commu-
nist frustration and failure in the party's bold plot to seize control of the
talent guilds and craft unions, through which the subversive brethren
hoped eventually to control contents of films and thus influence the minds
of 80,000,000 movie goers.

The extent of Hollywood's victory over the Communist Party is all the
more remarkable because Hollywood for many years was a prime target of
the Red propagandists and conspirators in this country.

They were trying to carry out orders from Joseph Stalin, who had said:
"The cinema is not only a vital agitprop (active propaganda) device for the
education and political indoctrination of the workers, but is also a fluent
channel through which to reach the minds and shape the desires of people
everywhere. The Kinofikatsiya (turning propaganda into films) is inevita-
ble. The task is to take this affair into your hands, and vigorously execute it
in every field."

So the Red enemies of our country concentrated their big guns on
Hollywood. And they failed completely. But not before they had suc-
ceeded in bringing about two years of disastrous strikes and bloody fight-
ing in which American workmen battled other American workmen at the
studio gates. And, unfortunately, not before the communists had fooled
some otherwise loyal Americans into believing that the Communist Party
sought to make a better world. Those dupes know today that the real aim
of the Communist Party is to try to prepare the way for Russian conquest
of the world.

The Screen Actors Guild members are justifiably proud of the key role

Excerpted from "Reds Beaten in Hollywood," Ronald Reagan, *Citizen News,* July 30,
1951, 18–20.

they played in bringing about the final defeat of the communist conspirators in Hollywood.

Actually, there were very few actors in Hollywood who became Party members. But there were quite a number who were tricked many years ago into lending their names or giving money to organizations or causes that later proved to be influenced or dominated by communists.

Today, even the fellow traveller has disappeared from the Hollywood scene.

But it was not so in 1945 and 1946 when the communist-backed Conference of Studio Unions battled with the anti-communist International Alliance of Theatrical Stage Employes, led by Richard Walsh and Roy Brewer.

To win, the Reds had to get the actors to join in the jurisdictional strike on the side of the strikers. If the actors didn't go to work, the studios would shut and the Reds would have won a great victory.

They tried every trick in the bag but the actors, led by the Board of Directors of Screen Actors Guild, out-thought them and out-fought them. We fought them on the record and off the record.

We fought them in meetings and behind the scenes.

Our Red foes even went so far as to threaten to throw acid in the faces of myself and some other stars, so that we "never would appear on the screen again." I packed a gun for some time and policemen lived at my home to guard my kids.

But that was more than five years ago and those days are gone forever, along with the deluded Red sympathizer and fellow traveller.

Never again can the communists hope to get anywhere in the movie capital. And it looks to me as if the die-hard Reds in this country are now concentrating their plotting in other industries such as defense plants. I hope that all such industries will take a leaf out of Hollywood's book and actively combat the communist conspirators wherever they may be found.

And any American who has been a member of the Communist Party at any time but who has now changed his mind and is loyal to our country should be willing to stand up and be counted; admit, "I was wrong," and give all the information he has to the government agencies who are combatting the Red plotters.

We've gotten rid of the communist conspirators in Hollywood. Let's do it now in other industries!

4
The Industry Goes Along
1951

In his pioneer study of blacklisting (*Report on Blacklisting*), John Cogley amassed many examples of how industry representatives felt about the radio and television networks in which they advertised employing anyone of questionable provenance. In their vague and general and pusillanimous statements, three examples of which follow, they revealed the extent to which they, like the networks and the advertisers, succumbed to the inquisitorial ethos.

1. We would never knowingly engage a Communist for any of our radio or television programs. Also, we would never knowingly engage anyone who aids either directly or indirectly the Communist cause. We carry out this policy in the employment of literally thousands of people in connection with our radio and televison programs. . . .

 From the policy statement by the Procter and Gamble Company

2. We buy "Studio One" as a package from CBS through our agency, McCann-Erikson. These two businesses, as well as all of us at Westinghouse, have a great stake in our capitalistic society. It is therefore in our own best interests never to engage in any activities that would jeopardize the free enterprise system.

 Like any large corporation in America, we are interested in making sure we have no Communists or subversives on our programs. We expect CBS to screen as closely as possible to make certain we do not use anybody who has been proved to be Communistic or a Communist sympathizer.

 L. W. Scott, Advertising Manager,
 Consumer Products,
 Westinghouse Electric Corporation, Pittsburgh, Pa.

3. Our company takes an active interest in the selection of talent appearing on its radio and television shows, but, of course, depends heavily on its advertising agency to determine the qualifications and public acceptance of such talent. If our agency has no doubt about the talent to be used in a particular show, we usually concur in its recommendation. If there is doubt, we usually make an investigation on our own. If such talent is shown to be affiliated with the Communist Party, or an organi-

Excerpted from *Report on Blacklisting*, Part II, John Cogley (New York: Fund for the Republic, 1956), 192–3. Copyright 1956 by Fund for the Republic.

zation opposed to the Constitution of the United States, we simply do not employ or retain them.

D. W. Stewart, Manager,
Advertising Division, The Texas Company
(Texaco Petroleum Products), New York

5

How to Get Off, or Avoid Getting On, the Blacklist
1952

In 1952 an enterprising radio script writer of small distinction named Vincent Hartnett broke away from *Counterattack* to form his own clearing house, AWARE Inc., at which he did rather well for a while. He had a number of clients, among them such major companies as Borden, American Broadcasting Company, and Lever Brothers. AWARE put out a little guidebook, *The Road Back,* which, as its title suggests, gave wrongdoers the chance to purge themselves, become born-again Americans as it were. Here is its twelve-step program of self-redemption.

1. Questions to ask oneself: Do I love my country? Do I believe my country in danger? Can I do anything to relieve that danger? Will I tell the full, relevant and unflattering truth?

2. Recognition that, whatever the subject's intentions at the time, his name, efforts, money or other support gave aid and comfort to the Communist conspiracy.

3. Full and frank disclosure, in written form, of all connections past and present with subversive elements, organizations, causes and individuals. Attach pertinent literature, correspondence, record of financial contributions, programs, newspaper clippings or other documentary material. Identify those who drew the subject into unfortunate situations and actions; identify those the subject in turn involved. (This disclosure may be used publicly or privately, as circumstances indicate.)

4. Voluntary and cooperative interview with the Federal Bureau of Investigation on the basis of the foregoing full and frank disclosure. The content of such interviews remains inviolate with the FBI.

5. A written offer to cooperate, as a witness or source of information with:

 a. The Committee on Un-American Activites of the House of Representatives, Room 225A, Old House Office Building, Washington 25, D.C.

 b. Subcommittee on Internal Security of the Senate Judiciary Committee, Senate Office Building, Washington 25, D.C.

 c. Subversive Activities Control Board, Washington, D.C.

 d. Any other committee in Senate or House properly interested in some or all of the information the subject may have.

Excerpted from *The Road Back* (New York: AWARE Inc., 1952), 8–9.

 e. Any other security agency of the federal government, as may be appropriate.

 f. Any state legislative committee or executive office investigating subversive activities.

 g. Any local authorities (police departments, grand juries, county and federal-district prosecutors and agencies) interest in local subversive activities.

6. In the subjects union(s), he should make his new position on communism clearly known by statements in meetings, letters or statements in union publications, etc. Whatever else he may do, he should not support the Communist or crypto-Communist element on any issue, no matter how attractive or insignificant it may then appear. Other union issues may then be freely debated without subversive interference.

7. The subject should make public his new position on communism by all other means available: statements in trade publications, "Letters to the Editor," personal correspondence to all who might be interested: such as anti-Communist journalists and organizations, employers, friends and fellow professionals.

8. Outside the field of entertainment-communications many opportunities for establishing a new position are available: political, social and civic clubs, parent-teacher organizations, library and school committees, religious and cultural groups. They may be urged to increase the number of anti-Communist speakers, books, lectures, candidates, etc.

9. Support anti-Communists persons, groups and organizations.

10. The subject should keep himself informed by subscribing to recommended anti-Communist magazines, reading anti-Communist books, government reports and other literature.

11. The subject should support anti-Communist legislation having responsible endorsement.

12. If the subject's new convictions draw him to, or back to, religion, so much the better; he achieves the best of all reasons for opposing communism. He can become actively anti-Communist in his church or other religious organizations. In church groups, as everywhere, he can combat neutralism and anti-anti-communism.

6

The Pathos of Larry Parks
March 21, 1951

Parks had been scheduled to appear before HUAC in 1947 as one of the original nineteen. The fact that he did not enabled him to become a star, thanks to his big hit, *The Al Jolson Story* (in which he played Jolson). Three and a half years later HUAC called him again. What transpired is a study in cruelty. With his career on the line, Parks named names, but reluctantly. His career collapsed anyway, and he died before he had a chance to restore it.

. . . MR. PARKS: Well, as I asked the counsel and as I asked the Committee, if you will allow this, I would prefer not to mention names under these circumstances: That these were people like myself who—and I feel that I—have done nothing wrong ever. I mean along this line. I am sure none of us is perfect. Again, the question of judgment certainly is there, and even that is debatable, but these are people—

MR. WOOD: Just a moment. Do you entertain the feeling that these parties that you were associated with are likewise guiltless of any wrong?

MR. PARKS: This is my honest opinion: that these are people who did nothing wrong, people like myself.

MR. WOOD: Mr. Parks, in what way do you feel it would be injurious to them, to divulge their identities, when you expressed the opinion that at no time did they do wrong?

MR. PARKS: If you think it's easy for a man who has—I think I have worked hard in my profession, climbed up the ladder a bit. If you think it's easy for me to appear before this Committee and testify, you're mistaken, because it's not easy. This is a very difficult and arduous job for me for many reasons. One of the reasons is that as an actor my activity is dependent a great deal on the public. To be called before this Committee at your request has a certain inference, a certain innuendo that you are not loyal to this country. This is not true. I am speaking for myself. This is not true. But the inference and the innuendo is there as far as the public is concerned. Also as a representative of a great industry—not as an official representative—but as an actor of the motion-picture industry that is fairly well known, in that respect I am a representative of the industry. This is a great industry. At this particular time it is being investigated for Communist influence.

MR. WOOD: Don't you think the public is entitled to know about it?

MR. PARKS: Hmm?

MR. WOOD: Don't you feel the public is entitled to know about it?

United States House of Representatives, 82nd Congress, 1st Session, Committee on Un-American Activities, *Hearings*, March 21, 1951.

MR. PARKS: I certainly do, and I am opening myself wide open to any question that you can ask me. I will answer as honestly as I know how. And at this particular time, as I say, the industry is—it's like taking a pot shot at a wounded animal, because the industry is not in as good a shape today as it has been—economically, I'm speaking. It has been pretty tough on it. And, as I say, this is a great industry, and I don't say this only because it has been kind to me. It has a very important job to do to entertain people, in certain respects to call attention to certain evils, but mainly to entertain, and in this I feel that they have done a great job. Always when our country has needed certain help, the industry has been in the forefront of that help.

MR. TAVENNER: You are placing your reluctance to testify upon the great job that the moving-picture industry is doing or can do?

MR. PARKS: On the question of naming names, it is my honest opinion that the few people that I could name, these names would not be of service to the Committee at all. I am sure that you know who they are. These people I feel honestly are like myself, and I feel that I have done nothing wrong. Question of judgment? Yes, perhaps. And I also feel that this is not—to be asked to name names like this is not—in the way of American justice as we know it, that we as Americans have all been brought up, that it is a bad thing to force a man to do this. I have been brought up that way. I am sure all of you have. And it seems to me that this is not the American way of doing things—to force a man who is under oath and who has opened himself as wide as possible to this Committee—and it hasn't been easy to do this—to force a man to do this is not American justice.

MR. WOOD: Well, I am glad, of course, to give considerable leeway to the range of your statement, because I for one am rather curious to understand just what the reasons are in your mind for declining to answer the question.

MR. PARKS: I'm not declining. I'm asking you if you would not press me on this. . . .

MR. WOOD: The witness has said he doesn't refuse to answer, so I assume he is ready to answer.

MR. MANDEL: I think the Committee and the individual members of the Committee are all seeking within themselves to do the right thing. There is no question about that. I think, in the same spirit, no one can, with the heritage that Mr. Parks has to uphold, think that he isn't as loyal as any member of this Committee, and that he has to do the right thing as we Americans in our elections do and choose. Of course, when the final gong goes down, he intends, as he indicated, to respect the will of this Committee, but, I think justly, he reserves the right to talk to you gentlemen and possibly persuade you to think differently.

MR. WOOD: The Committee took the view, sir, that perhaps there might be some merit in your contention if we were still in an open hearing, but we are not. It is an executive session.

MR. MANDEL: I realize that, and I want to thank the Committee for this consideration. I think it should have been done first before we started

here, but this session is a very private session or executive session, which is very considerate of the Committee, and the record should so state. May I have a minute to talk to Mr. Parks?

MR. WOOD: Yes. You may retire if you like.

MR. MANDEL: I make this request of the Committee: I want no promise from you, but just as a matter of finding what is the sportsmanlike attitude, that what he gives you will not be used in that way if it can be helped, without embarrassing these people in the same position he finds himself in today.

MR. WOOD: Nobody on this Committee has any desire to smear the name of anybody. That isn't of benefit to this Committee in the discharge of its duties. I think all of the American people who have viewed the work of the Committee dispassionately and impartially will agree with that.

MR. MANDEL: The reason I asked is because, in the struggle that Mr. Parks is going through, I think the internal struggle would go a little lighter having that statement from you.

MR. TAVENNER: If you will just answer the question, please. The question was: Who were the members of the Communist Party cell to which you were assigned during the period from 1941 until 1945?

MR. PARKS: Well, Morris Carnovsky, Joe—

MR. TAVENNER: Will you spell that name?

MR. PARKS: I couldn't possibly spell it. Carnovsky, Joe Bromberg, Sam Rossen, Anne Revere, Lee Cobb.

MR. TAVENNER: What was the name?

MR. PARKS: Cobb. Gale Sondergaard, Dorothy Tree. Those are the principal names that I recall. . . .

MR. TAVENNER: What was the name of Dorothy Tree's husband? Was it not Michael Uris?

MR. PARKS: Yes.

MR. TAVENNER: Was he a member?

MR. PARKS: Not to my knowledge.

MR. TAVENNER: Do you know whether Michael Uris was a member of any other cell of the Communist Party?

MR. PARKS: No, I don't know this at all.

MR. TAVENNER: I believe he was a writer, was he not, as distinguished from an actor?

MR. PARKS: I think he was a writer, yes.

MR. TAVENNER: The persons whose names you have mentioned were all actors?

MR. PARKS: Yes, that's correct.

MR. TAVENNER: Can you recall the names of others who were at one time members of that cell?

MR. PARKS: That's about all I recall right now. . . .

MR. WALTER: I think you could get some comfort out of the fact that the people whose names have been mentioned have been subpoenaed, so

that if they ever do appear here it won't be as a result of anything that you have testified to.

(At this point Representative Bernard W. Kearney left the hearing room.)

MR. PARKS: It is no comfort whatsoever.

MR. TAVENNER: Do you know of any other person now whose name comes to your recollection?

MR. PARKS: No, I don't recall anyone else.

MR. TAVENNER: I think that is all, Mr. Chairman.

MR. POTTER: I would like to say, Mr. Chairman, that Mr. Parks's testimony has certainly been refreshing in comparison with the other witnesses that we have had today.

MR. WOOD: I am sure you reflect the sentiments of the entire Committee. We appreciate your cooperation. You are excused.

7

Kazan Explains Why
April 12, 1952

Between January and April 1952 the enormously talented stage and movie director Elia Kazan testified twice in executive session before the House Un-American Activities Committee and freely named names. Unlike Larry Parks he saved his career, and had little trouble dealing with the guilt. He explained his reasons in an open letter advertisement in *The New York Times*. His rationale is interesting: One may inform on friends and colleagues because the Communist Party was so authoritarian and manipulative!

In the past weeks intolerable rumors about my political position have been circulating in New York and Hollywood. I want to make my stand clear:

I believe that Communist activities confront the people of this country with an unprecedented and exceptionally tough problem. That is, how to protect ourselves from a dangerous and alien conspiracy and still keep the free, open, healthy way of life that gives us self-respect.

I believe that the American people can solve this problem wisely only if they have the facts about communism. All the facts.

Now, I believe that any American who is in possession of such facts has the obligation to make them known, either to the public or to the appropriate Government agency.

Whatever hysteria exists—and there is some, particularly in Hollywood—is inflamed by mystery, suspicion and secrecy. Hard and exact facts will cool it.

The facts I have are sixteen years out of date, but they supply a small piece of background to the graver picture of communism today.

I have placed these facts before the House Committee on Un-American Activities without reserve and I now place them before the public and before my co-workers in motion pictures and in the theatre.

Seventeen and a half years ago I was a twenty-four-year-old stage manager and bit actor, making $40 a week, when I worked.

At that time nearly all of us felt menaced by two things: the depression and the ever growing power of Hitler. The streets were full of unemployed and shaken men. I was taken in by the Hard Times version of what might be called the Communists' advertising or recruiting technique. They claimed to have a cure for depressions and a cure for Naziism and Fascism.

I joined the Communist Party late in the summer of 1934. I got out a year and a half later.

The New York Times, April 12, 1952.

I have no spy stories to tell, because I saw no spies. Nor did I understand, at that time, any opposition between American and Russian national interest. It was not even clear to me in 1936 that the American Communist Party was abjectly taking its orders from the Kremlin.

What I learned was the minimum that anyone must learn who puts his head into the noose of party "discipline." The Communists automatically violated the daily practices of democracy to which I was accustomed. They attempted to control thought and to suppress personal opinion. They tried to dictate personal conduct. They habitually distorted and disregarded and violated the truth. All this was crudely opposite to their claims of "democracy" and "the scientific approach."

To be a member of the Communist Party is to have a taste of the police state. It is a diluted taste but it is bitter and unforgettable. It is diluted because you can walk out.

I got out in the spring of 1936.

The question will be asked why I did not tell this story sooner. I was held back, primarily, by concern for the reputations and employment of people who may, like myself, have left the party many years ago.

I was also held back by a piece of specious reasoning which has silenced many liberals. It goes like this: "You may hate the Communists, but you must not attack them or expose them, because if you do you are attacking the right to hold unpopular opinions and you are joining the people who attack civil liberties."

I have thought soberly about this. It is, simply, a lie.

Secrecy serves the Communists. At the other pole, it serves those who are interested in silencing liberal voices. The employment of a lot of good liberals is threatened because they have allowed themselves to become associated with or silenced by the Communists.

Liberals must speak out.

I think it is useful that certain of us had this kind of experience with the Communists, for if we had not we should not know them so well. Today, when all the world fears war and they scream peace, we know how much their professions are worth. We know tomorrow they will have a new slogan.

Firsthand experience of dictatorship and thought control left me with an abiding hatred of these. It left me with an abiding hatred of Communist philosophy and methods and the conviction that these must be resisted always.

It also left me with the passionate conviction that we must never let the Communists get away with the pretense that they stand for the very things which they kill in their own countries.

I am talking about free speech, a free press, the rights of property, the rights of labor, racial equality and, above all, individual rights. I value these things. I take them seriously. I value peace, too, when it is not bought at the price of fundamental decencies.

I believe these things must be fought for wherever they are not fully honored and protected whenever they are threatened.

The motion pictures I have made and the plays I have chosen to direct represent my convictions.

I expect to continue to make the same kinds of pictures and to direct the same kinds of plays.

8

Hellman's Cry of Conscience
May 19, 1952

In *Scoundrel Time,* her memoir about the monstrous effects of Mc-Carthyism on her life and profession, Lillian Hellman tells of the arrangement she managed to work out with HUAC. It is explained in her famous letter, addressed to chairman John Wood. She nevertheless remained on the blacklist for years, reduced to being a salesgirl for a while in Bloomingdale's.

As you know, I am under subpoena to appear before your committee on May 21, 1952.

I am most willing to answer all questions about myself. I have nothing to hide from your committee and there is nothing in my life of which I am ashamed. I have been advised by counsel that under the fifth amendment I have a constitutional privilege to decline to answer any questions about my political opinions, activities, and associations, on the grounds of self-incrimination. I do not wish to claim this privilege. I am ready and willing to testify before the representatives of our Government as to my own opinions and my own actions, regardless of any risks or consequences to myself.

But I am advised by counsel that if I answer the committee's questions about myself, I must also answer questions about other people and that if I refuse to do so, I can be cited for contempt. My counsel tells me that if I answer questions about myself, I will have waived my rights under the fifth amendment and could be forced legally to answer questions about others. This is very difficult for a layman to understand. But there is one principle that I do understand: I am not willing, now or in the future, to bring bad trouble to people who, in my past association with them, were completely innocent of any talk or any action that was disloyal or subversive. I do not like subversion or disloyalty in any form and if I had ever seen any I would have considered it my duty to have reported it to the proper authorities. But to hurt innocent people whom I knew many years ago in order to save myself is, to me, inhuman and indecent and dishonorable. I cannot and will not cut my conscience to fit this year's fashions, even though I long ago came to the conclusion that I was not a political person and could have no comfortable place in any political group.

I was raised in an old-fashioned American tradition and there were certain homely things that were taught to me: To try to tell the truth, not to bear false witness, not to harm my neighbor, to be loyal to my country, and so on. In general, I respected these ideals of Christian honor and did as well with them as I knew how. It is my belief that you will agree with these

United States House of Representatives, 82nd Congress, 2nd Session, Committee on Un-American Activities, *Hearings,* May 19, 1952.

simple rules of human decency and will not expect me to violate the good American tradition from which they spring. I would, therefore, like to come before you and speak of myself.

I am prepared to waive the privilege against self-incrimination and to tell you everything you wish to know about my views or actions if your committee will agree to refrain from asking me to name other people. If the committee is unwilling to give me this assurance, I will be forced to plead the privilege of the fifth amendment at the hearing.

9

The Rights and Responsibilities of Universities and Their Faculties
March 1953

> The leaders of the academic community could no longer avoid the
> curse of McCarthyism. Sooner or later they had to spell out what
> academic freedom meant and how far they should go in its defense. So
> it was that early in 1953 thirty-seven presidents of the top private and
> public universities, members of the Association of American Univer-
> sities, met at Princeton to work out a position paper. This excerpt from
> the published text reveals just how weak and platitudinous it was, how
> much it conceded to repressive political authority.

We must recognize the fact that honest men hold differing opinions.
This fundamental truth underlies the assertion and definition of individual
rights and freedom in our Bill of Rights. How does it apply to universities?
In the eyes of the law, the university scholar has no more and no less
freedom than his fellow citizens outside a university. Nonetheless, because
of the vital importance of the university to civilization, membership in its
society of scholars enhances the prestige of persons admitted to its fellow-
ship after probation and upon the basis of achievement in research and
teaching. The university supplies a distinctive forum and, in so doing,
strengthens the scholar's voice. When his opinions challenge the existing
orthodox points of view, his freedom may be more in need of defense than
that of men in other professions. The guarantee of tenure to professors of
mature and proven scholarship is one such defense. As in the case of
judges, tenure protects the scholar against undue economic or political
pressures and ensures the continuity of the scholarly process.

This is the line at which "freedom" or "privilege" begins to be qualified
by legal "duty" and "obligation." The determination of the line is the
function of the legislature and the courts. The ultimate interpretation and
application of the First and Fourteenth Amendments are the function of
the United States Supreme Court; but every public official is bound by his
oath of office to respect and preserve the liberties guaranteed therein.
These are not to be determined arbitrarily or by public outcry. The line
thus drawn can be changed by legislative and judicial action; it has varied in
the past because of prevailing anxieties as well as by reason of "clear and
present" danger. Its location is subject to, and should receive, criticism
both popular and judicial. However much the location of the line may be
criticized, it cannot be disregarded with impunity. Any member of a uni-
versity who crosses the duly established line is not excused by the fact that
he believes the line ill-drawn. When the speech, writing, or other actions of

Excerpt from *The Rights and Responsibilities of Universities and Their Faculties* (Princeton:
Association of American University Professors, March, 1953).

a member of a faculty exceed lawful limits, he is subject to the same penalties as other persons. In addition, he may lose his university status. . . .

As in all acts of association, the professor accepts conventions which become morally binding. Above all, he owes his colleagues in the university complete candor and perfect integrity, precluding any kind of clandestine or conspiratorial activities. He owes equal candor to the public. If he is called upon to answer for his convictions it is his duty as a citizen to speak out. It is even more definitely his duty as a professor. Refusal to do so, on whatever legal grounds, cannot fail to reflect upon a profession that claims for itself the fullest freedom to speak and the maximum protection of that freedom available in our society. In this respect, invocation of the Fifth Amendment places upon a professor a heavy burden of proof of his fitness to hold a teaching position and lays upon his university an obligation to reexamine his qualifications for membership in its society.

In all universities faculties exercise wide authority in internal affairs. The greater their autonomy, the greater their share of responsibility to the public. They must maintain the highest standards and exercise the utmost wisdom in appointments and promotions. They must accept their share of responsibility for the discipline of those who fall short in the discharge of their academic trust.

The universities owe their existence to legislative acts and public charters. A state university exists by constitutional and legislative acts, an endowed university enjoys its independence by franchise from the state and by custom. The state university is supported by public funds. The privately sustained university is benefited by tax exemptions. Such benefits are conferred upon universities not as favors but in furtherance of the public interest. They carry with them the public obligation of direct concern to the faculties of the universities as well as to the governing boards.

Legislative bodies from time to time may scrutinize these benefits and privileges. It is clearly the duty of the universities and their members to cooperate in official inquiries directed to those ends. When the powers of legislative inquiry are abused, the remedy does not lie in non-cooperation or defiance; it is to be sought through the normal channels of informed public opinion.

. . . Appointment to a university position and retention after appointment require not only professional competence but involve the affirmative obligation of being diligent and loyal in citizenship. This renders impossible adherence to such a regime as that of Russia and its satellites. No person who accepts or advocates such principles and methods has any place in the university. Since present membership in the Communist Party requires the acceptance of these principles and methods, such membership extinguishes the right to a university position. Moreover, if an instructor follows communistic practice by becoming a propagandist for one opinion, adopting a "party line", silencing criticism or impairing freedom of

thought and expression in his classroom, he forfeits not only all university support by his right to membership in the university.

"Academic freedom" is not a shield for those who break the law. Universities must cooperate fully with the law-enforcement officers whose duty requires them to prosecute those charged with offenses. . . .

10

Stander Confounds HUAC
May 6, 1953

No testimony before HUAC was more hilariously defiant than Lionel Stander's. He was a gravelly voiced character actor who, until the blacklist engulfed him, had appeared in many films and TV programs. He found work again—in his late sixties.

. . . MR. STANDER: I know of some subversion, and I can help the Committee if it is really interested.

MR. VELDE: Mr. Stander—

MR. STANDER: I know of a group of fanatics who are desperately trying to undermine the Constitution of the United States by depriving artists and others of life, liberty, and pursuit of happiness without due process of law. If you are interested in that, I would like to tell you about it. I can tell names, and I can cite instances, and I am one of the first victims of it, and if you are interested in that—and also a group of ex-Bundists, America Firsters, and anti-Semites, people who hate everybody, including Negroes, minority groups, and most likely themselves—

MR. VELDE: No, Mr. Stander, let me—

MR. STANDER: And these people are engaged in the conspiracy, outside all the legal processes, to undermine our very fundamental American concepts upon which our entire system of jurisprudence exists—

MR. VELDE: Now, Mr. Stander—

MR. STANDER: —and who also—

MR. VELDE: Let me tell you this: You are a witness before this Committee—

MR. STANDER: Well, if you are interested—

MR. VELDE: —a Committee of the Congress of the United States—

MR. STANDER: —I am willing to tell you—

MR. VELDE: —and you are in the same position as any other witness before this Committee—

MR. STANDER: —I am willing to tell you about these activities—

MR. VELDE: —regardless of your standing in the motion-picture world—

MR. STANDER: —which I think are subversive.

MR. VELDE: —or for any other reason. No witness can come before this Committee and insult the Committee—

MR. STANDER: Is this an insult to the Committee?

MR. VELDE: —and continue to—

MR. STANDER: —when I inform the Committee I know of subversive activities which are contrary to the Constitution?

United States House of Representatives, 83d Congress, 1st Session, Committee on Un-American Activities, *Hearings,* May 6, 1953.

MR. VELDE: Now, Mr. Stander, unless you begin to answer these questions and act like a witness in a reasonable, dignified manner, under the rules of the Committee, I will be forced to have you removed from this room.

MR. STANDER: I am deeply shocked, Mr. Chairman.

MR. CLARDY: Mr. Stander, let me—

MR. STANDER: Let me explain myself. I don't mean to be contemptuous of this Committee at all.

MR. VELDE: Will you—

MR. STANDER: I want to cooperate with it. You said you would like me to cooperate with you in your attempt to unearth subversive activities. I know of such subversive activities. I began to tell you about them, and I am shocked by your cutting me off. You don't seem to be interested in the sort of subversive activities I know about.

MR. VELDE: You will be asked questions relative to subversive activities by counsel.

MR. STANDER: Let him ask me, and I will be glad to answer. And I am not a dupe, or a dope, or a moe, or a schmoe, and everything I did—I was absolutely conscious of what I was doing, and I am not ashamed of everything [anything?] I said in public or private, and I am very proud of my war record, my private record as a citizen, and my public record as an entertainer.

MR. DOYLE: Mr. Stander, won't you be courteous enough to let our general counsel ask you the questions?

MR. STANDER: But there was an inference of the Chairman that deeply irritated me.

MR. DOYLE: Well—

MR. STANDER: And that is I was out of order. I thought—

MR. DOYLE: You have made your record, and it is very glorious and very fine.

MR. STANDER: I am glad the Committee—

MR. DOYLE: Now, won't you go ahead and cooperate—

MR. STANDER: —thinks that is a very fine record.

MR. DOYLE: —and let somebody else do some talking? . . .

MR. STANDER: I would like the record to show I am not charged with being a member of the Communist Party; I am not charged with lying under oath, because I have made continuous oaths to various governmental agencies. You are not charging me with being a Communist, right?

MR. CLARDY: Will you subside until the Chairman finishes?

MR. VELDE: You are brought here as a witness.

MR. STANDER: I am a witness—

MR. VELDE: Please don't—

MR. STANDER: —not a defendant. I haven't been accused of anything. I want that very straight, because through newspaper headlines people get peculiar attitudes. Mere appearance here is tantamount—not just appearance, the mere fact, in my case, I was subpoenaed, is tanta-

mount—to being blacklisted, because people say, "What is an actor doing in front of the Un-American Activities Committee?"

MR. CLARDY: Why did you want to appear before the Committee so badly, then, if that is the case?

MR. STANDER: Because I was told by my agent if I appeared before the Committee, and the Committee was a fair Committee, and allowed me to refute Lawrence's testimony, that I would be able to get back in television and motion pictures. I had made eleven television shows in a row, and one of the biggest TV agencies and producers had told my agent that if I went before the Committee and could again swear under oath that I wasn't [a Communist], I would have my own TV program, which meant one hundred fifty thousand dollars a year to me.

MR. CLARDY: Mr. Stander—

MR. STANDER: So, I had a hundred-and-fifty-thousand-buck motive—

MR. CLARDY: Mr. Stander, will you subside?

MR. STANDER: —for coming before the Committee.

MR. CLARDY: If you will just subside and answer the questions, I am sure you will accomplish your purpose.

MR. STANDER: Are you inferring—

MR. CLARDY: Now, just a minute, Mr. Stander.

MR. STANDER: —anything I said wasn't the truth?

MR. CLARDY: Unless you do that, your performance is not going to be regarded as funny.

MR. STANDER: I want to state right now I was not—

MR. CLARDY: Will you please subside?

MR. STANDER: —trying to be funny.

MR. CLARDY: If you continue with what you are doing, I am going to suggest to the Chairman that you are putting on a show, and I am going to ask him to turn on the lights and cameras so that your performance may be recorded for posterity. Now, if you will subside and go along, I am not going to make that request.

MR. STANDER: Mr. Chairman, may I state that, first, to clear up this misunderstanding, I have never been more deadly serious in my life.

MR. CLARDY: All right, then—

MR. STANDER: If anything I said seemed humorous or funny, I assure you it was purely coincidental and doesn't mirror what I deeply feel, because my entire career and the respect of my fellow artists and the American people is at stake, and I don't think that is very funny. . . .

MR. CLARDY: Mr. Stander, now, I suggested something to you a moment ago. You have been asked a straightforward question as to whether or not you were a Communist during a certain period. Now, answer that—

MR. STANDER: I swore under oath—

MR. CLARDY: —yes or no—

MR. STANDER: I swore—

MR. CLARDY: —or refuse to answer it on constitutional grounds.

MR. STANDER: I swore under oath in 1940, and that was covered by this same Committee.

MR. SCHERER: Why don't you swear under oath now whether you were?

MR. STANDER: You want me to give you the reason?

MR. SCHERER: Yes.

MR. STANDER: Because by using psychopaths—and I have the letter here giving the mental history of Marc Lawrence, who came from a mental sanitorium—he suffered a mental breakdown, and I gave you the names of the doctors—and you used that psychopath and used previously this man Leech, who the district attorney and the grand jury of Los Angeles didn't believe, throughout his charges, and they cleared me—so, I don't want to be responsible for a whole stable of informers, stool pigeons, and psychopaths and ex-political heretics, who come in here beating their breast and say, "I am awfully sorry, I didn't know what I was doing. Please, I want absolution, get me back into pictures," and they will do anything—they will name anybody—they will go to any extent necessary to get back into pictures, they will mention names and name anybody.

MR. VELDE: Now, will you answer the question?

MR. STANDER: Therefore, I decline to answer that question. It clearly is not relevant to the purpose of this Committee, and it violates my rights under the First and Fifth Amendments of the Constitution of the United States. And, incidentally, don't give me the routine about hiding, because the only people, witnesses, who hide here are witnesse like—

MR. VELDE: Mr. Stander—

MR. STANDER: —these people named here, who hide behind the cloak of legal responsibility, and I know, because I tried to get somewhere in the courts of New York, and I find the only people who hide behind immunity are the witnesses, the stool pigeons, used here, and that you are using, arrogating—

MR. TAVENNER: Have you finished?

MR. STANDER: No, this Committee arrogates judicial and punitive powers which it does not possess. . . .

MR. TAVENNER: Are you acquainted with Martin Berkeley?

MR. STANDER: I told you any question along those lines by stool pigeons, informers, psychopathic liars, or anybody—for instance, Mr. Berkeley. I read in the minutes that, first, he said he was not a member of the Communist Party, then, when he realized you had the goods on him, he came here and rattled off one hundred fifty names. This is, in my idea, an incredible witness.

MR. VELDE: Do you decline to answer that question?

MR. STANDER: And I decline to answer under my constitutional rights, which I am proud of, and I resent the inference here that anyone who uses it, which our forefathers fought for, is guilty of anything. . . .

MR. TAVENNER: Was Martin Berkeley—

Mr. VELDE: Just a minute, counsel. It is very apparent that the witness is excited and nervous, as he stated.

Mr. STANDER: Not as nervous as Marc Lawrence, who came out of a mental institution.

Mr. VELDE: You said you would cooperate with the Committee and give it the benefit of your knowledge.

Mr. STANDER: Against the blacklisting. Pardon me, I am sorry.

Mr. VELDE: It is the order of the Chair and this Committee that you be continued under subpoena, and the investigation and hearing be continued in your case until a future date, at which time you will be notified by our counsel.

Mr. STANDER: May I make one statement now?

Mr. CLARDY: No.

11

Dr. Oppenheimer's Disgrace
April 12–June 29, 1954

It was no secret during World War II that physicist J. Robert Oppenheimer and members of his family had been, to say the least, Communist fellow travelers. That did not prevent the Army from appointing him head of the Los Alamos laboratory, part of the Manhattan Project. Having been instrumental in making the atomic bomb, he was honored by the powers that be. Like so many atomic scientists Oppenheimer during the Cold War had misgivings about government policy, especially the decision to build the hydrogen bomb. Not that he was by any stretch of incredulity sympathetic to the Soviet Union or Communism, but now, in the heat of the McCarthy era, his attitude raised suspicions; his past returned to haunt him. In 1953 he was, as consultant to the Atomic Energy Commission, denied security clearance. Instead of resigning from that position—he was, after all, director of the very prestigious Institute of Advanced Studies at Princeton—he decided to fight for his security clearance. The AEC accordingly set up a special three-man commission to look into the matter. It recommended two to one against him and the AEC then turned him down. The extent to which he was publicly raked over the coals, McCarthy style, is obvious from the excerpts below. Ten years later, in an act of contrition, the government officially honored Oppenheimer for his contributions to America.

CHARGES

. . . "As a result of additional investigation as to your character, associations, and loyalty, and review of your personnel security file in the light of the requirements of the Atomic Energy Act and the requirements of Executive Order 10450, there has developed considerable question whether your continued employment on Atomic Energy Commission work will endanger the common defense and security and whether such continued employment is clearly consistent with the interests of the national security. This letter is to advise you of the steps which you may take to assist in the resolution of this question.

"The substance of the information which raises the question concerning your eligibility for employment on Atomic Energy Commission work is as follows. . . .

Excerpts from *In the Matter of J. Robert Oppenheimer* (Washington, D.C.: United States Government Printing Office, 1954), 3–4, 1019–20, 1049, 1064–5.

"It was reported that in 1943 and previously you were intimately associated with Dr. Jean Tatlock, a member of the Communist Party in San Francisco, and that Dr. Tatlock was partially responsible for your association with Communist-front groups.

"It was reported that your wife, Katherine Puening Oppenheimer, was formerly the wife of Joseph Dallet, a member of the Communist Party, who was killed in Spain in 1937 fighting for the Spanish Republican Army. It was further reported that during the period of her association with Joseph Dallet, your wife became a member of the Communist Party. The Communist Party has been designated by the Attorney General as a subversive organization which seeks to alter the form of Government of the United States by unconstitutional means, within the purview of Executive Order 9835 and Executive Order 10450.

"It was reported that your brother, Frank Friedman Oppenheimer, became a member of the Communist Party in 1936 and has served as a party organizer and as educational director of the professional section of the Communist Party in Los Angeles County. It was further reported that your brother's wife, Jackie Oppenheimer, was a member of the Communist Party in 1938; and that in August 1944, Jackie Oppenheimer assisted in the organization of the East Bay branch of the California Labor School. It was further reported that in 1945 Frank and Jackie Oppenheimer were invited to an informal reception at the Russian consulate, that this invitation was extended by the American-Russian Institute of San Francisco and was for the purpose of introducing famous American scientists to Russian scientists who were delegates to the United Nations Conference on International Organization being held at San Francisco at that time, and that Frank Oppenheimer accepted this invitation. It was further reported that Frank Oppenheimer agreed to give a 6 weeks course on The Social Implications of Modern Scientific Development at the California Labor School, beginning May 9, 1946. The American-Russian Institute of San Francisco and the California Labor School have been cited by the Attorney General as Communist organizations within the purview of Executive Order 9835 and Executive Order 10450.

"It was reported that you have associated with members and officials of the Communist Party including Isaac Folkoff, Steve Nelson, Rudy Lambert, Kenneth May, Jack Manley, and Thomas Addis.

"It was reported that you were a subscriber to the Daily People's World, a west coast Communist newspaper, in 1941 and 1942. . . .

"It was reported that you stated to an agent of the Federal Bureau of Investigation in 1950, that you attended a meeting in 1940 or 1941, which may have taken place at the home of Haakon Chevalier, which was addressed by William Schneiderman, whom you knew to be a leading functionary of the Communist Party. In testimony in 1950 before the California State Senate Committee on Un-American Activities, Haakon Chevalier was identified as a member of the Communist Party in the San Francisco area in the early 1940's." . . .

RECOMMENDATION

In arriving at our recommendation we have sought to address ourselves to the whole question before us and not to consider the problem as a fragmented one either in terms of specific criteria or in terms of any period in Dr. Oppenheimer's life, or to consider loyalty, character, and associations separately.

However, of course, the most serious finding which this Board could make as a result of these proceedings would be that of disloyalty on the part of Dr. Oppenheimer to his country. For that reason, we have given particular attention to the question of his loyalty, and we have come to a clear conclusion, which should be reassuring to the people of this country, that he is a loyal citizen. If this were the only consideration, therefore, we would recommend that the reinstatement of his clearance would not be a danger to the common defense and security.

We have, however, been unable to arrive at the conlusion that it would be clearly consistent with the security interests of the United States to reinstate Dr. Oppenheimer's clearance and, therefore, do not so recommend.

The following considerations have been controlling in leading us to our conclusion:

1. We find that Dr. Oppenheimer's *continuing conduct and associations* have reflected a serious disregard for the requirements of the security system.

2. We have found *a susceptibility to influence* which could have serious implications for the security interests of the country.

3. We find his conduct in the hydrogen-bomb program sufficiently disturbing as to raise a doubt as to whether his future participation, if characterized by the same attitudes in a Government program relating to the national defense, would be clearly consistent with the best interests of security.

4. We have regretfully concluded that Dr. Oppenheimer has been *less than candid* in several instances in his testimony before this Board.

Respectfully submitted.

GORDON GRAY, *Chairman.*
THOMAS A. MORGAN.

MINORITY REPORT OF DR. WARD V. EVANS

. . . *Most of this derogatory information was in the hands of the Commission when Dr. Oppenheimer was cleared in 1947.* They apparently were aware

of his associations and his left-wing policies; yet they cleared him. They took a chance on him because of his special talents and he continued to do a good job. Now when the job is done, we are asked to investigate him for practically the same derogatory information. He did his job in a thorough and painstaking manner. There is not the slightest vestige of information before this Board that would indicate that Dr. Oppenheimer is not a loyal citizen of his country. . . .

We don't have to go out of our way and invent something to prove that the principle of "double jeopardy" does not apply here. This is not our function, and it is not our function to rewrite any clearance rules. The fact remains he is being investigated twice for the same things. Furthermore, we don't have to dig deeply to find other ways that he may be a security risk outside of loyalty, character, and association. He is loyal, we agree on that. There is, in my estimation, nothing wrong with his character. During the early years of his life, Dr. Oppenheimer devoted himself to study and did not vote or become interested in political matters until he was almost 30. Then, in his ignorance, he embraced many subversive organizations.

His judgment was bad in some cases, and most excellent in others but, in my estimation, it is better now than it was in 1947 and to damn him now and ruin his career and his service, I cannot do it. . . .

STATEMENT BY THE ATOMIC ENERGY COMMISSION

The Atomic Energy Act of 1946 lays upon the Commissioners the duty to reach a determination as to "the character, associations, and loyalty" of the individuals engaged in the work of the Commission. Thus, disloyalty would be one basis for disqualification, but it is only one. *Substantial defects of character and imprudent and dangerous associations,* particularly with known subversives who place the interests of foreign powers above those of the United States, are also reasons for disqualification.

On the basis of the record before the Commission, comprising the transcript of the hearing before the Gray Board as well as reports of Military Intelligence and the Federal Bureau of Investigation, we find Dr. Oppenheimer is not entitled to the continued confidence of the Government and of this Commission because of the proof of fundamental defects in his "character."

In respect to the criterion of "associations," we find that his associations with persons known to him to be Communists have extended far beyond the tolerable limits of prudence and self-restraint which are to be expected of one holding the high positions that the Government has continuously entrusted to him since 1942. These associations have lasted too long to be justified as merely the intermittent and accidental revival of earlier friendships. . . .

DISSENTING OPINION BY DR. HENRY DeWOLFE SMYTH

The instances that I have described constitute the whole of the evidence extracted from a lengthy record to support the severe conclusions of the majority that Dr. Oppenheimer has "given proof of fundamental defects in his character" and of "persistent continuing associations." Any implication that these are illustrations only and that further substantial evidence exists in the investigative files to support these charges is unfounded.

With the single exception of the Chevalier incident, the evidence relied upon is thin, whether individual instances are considered separately or in combination. All added together, with the Chevalier incident included, the evidence is singularly unimpressive when viewed in the perspective of the 15 years of active life from which it is drawn. Few men could survive such a period of investigation and interrogation without having many of their actions misinterpreted or misunderstood. . . .

With respect to the alleged disregard of the security system, I would suggest that the system itself is nothing to worship. It is a necessary means to an end. Its sole purpose, apart from the prevention of sabotage, is to protect secrets. *If a man protects the secrets he has in his hands and his head, he has shown essential regard for the security system.*

In addition, cooperation with security officials in their legitimate activities is to be expected of private citizens and Government employees. The security system has, however, neither the responsibility nor the right to dictate every detail of a man's life. I frankly do not understand the charge made by the majority that Dr. Oppenheimer has shown a persistent and willful disregard for the obligations of security, and that therefore he should be declared a security risk. No gymnastics of rationalization allow me to accept this argument. *If in any recent instances, Dr. Oppenheimer has misunderstood his obligation to security, the error is occasion for reproof but not for a finding that he should be debarred from serving his country. Such a finding extends the concept of "security risk" beyond its legitimate justification and constitutes a dangerous precedent.*

In these times, failure to employ a man of great talents may impair the strength and power of this country. Yet I would accept this loss if I doubted the loyalty of Dr. Oppenheimer or his ability to hold his tongue. I have no such doubts.

I conclude that Dr. Oppenheimer's employment "will not endanger the common defense and security" and will be "clearly consistent with the interests of the national security." I prefer the positive statement that Dr. Oppenheimer's further employment will continue to strengthen the United States.

I therefore have voted to reinstate Dr. Oppenheimer's clearance.

12

The Butterfly and the Committee
October 14, 1955

Samuel "Zero" Mostel, a prodigious comic actor, made a notable appearance before HUAC, part of which is presented below. Blacklisted for years, he came back in 1959 with a smashing performance in an Off Broadway hit, *Ulysses in Nighttown*. There was no stopping him after that.

. . . MR. JACKSON: Mr. Chairman, may I say that I can think of no greater way to parade one's political beliefs than to appear under the auspices of *Mainstream,* a Communist publication, on the same program, the same platform, as it is alleged here—you have refused to state whether or not you did so appear—with Dalton Trumbo, Hanns Eisler, John Howard Lawson, W. E. B. DuBois, Dorothy Parker, Howard Fast, and Zero Mostel. That program to me speaks volumes as to why you are here. Communist propaganda cannot exist without the funds that are derived from programs of this kind, and I daresay that your name on these many things for which Communist funds were being raised for Communist purposes bolstered and furthered these purposes whether or not you appeared.

MR. MOSTEL: I appreciate your opinion very much, but I do want to say that—I don't know, you know—I still stand on my grounds, and maybe it is unwise and impolitic for me to say this. If I appeared there, what if I did an imitation of a butterfly at rest? There is no crime in making anybody laugh. I don't care if *you* laugh at me.

MR. JACKSON: If your interpretation of a butterfly at rest brought money into the coffers of the Communist Party, you contributed directly to the propaganda effort of the Communist Party.

MR. MOSTEL: Suppose I had the urge to do the butterfly at rest somewhere?

MR. DOYLE: Yes, but please. When you have the urge, don't have such an urge to put the butterfly at rest by putting some money in Communist Party coffers as a result of the urge to put the butterfly to rest. Put the bug to rest somewhere else next time.

MR. JACKSON: I suggest we put this butterfly hearing to rest. . . .

MR. DOYLE: The witness is excused. Thank you, Mr. Mostel. Remember what I said to you.

MR. MOSTEL: You remember what I said to you.

United States House of Representatives, 84th Congress, 1st Session, Committee on Un-American Activities, *Hearings,* October 14, 1955.

13

Paul Robeson Takes on the Committee
June 12, 1956

No individual (who avoided jail) suffered from the effects of Mc-
Carthyism more than Paul Robeson did. Long before he gave this
defiant testimony before the HUAC his flourishing career as a singer
and actor lay in ruins. Nor was he allowed to leave the country and
travel abroad, where he was very popular. In 1959 he got back his
passport, thanks to the Supreme Court (Chapter 10, Document 7),
and he did promptly go abroad, but he became too ill to resume his
career.

. . . MR. ARENS: Are you now a member of the Communist Party?

MR. ROBESON: Oh please, please, please.

MR. SCHERER: Please answer, will you, Mr. Robeson?

MR. ROBESON: What is the Communist Party? What do you mean by
that?

MR. SCHERER: I ask that you direct the witness to answer the ques-
tion.

MR. ROBESON: What do you mean the Communist Party? As far as I
know it is a legal party like the Republican Party and the Democratic Party.
Do you mean a party of people who have sacrificed for my people, and for
all Americans and workers, that they can live in dignity? Do you mean that
party?

MR. ARENS: Are you now a member of the Communist Party?

MR. ROBESON: Would you like to come to the ballot box when I vote
and take out the ballot and see?

MR. ARENS: Mr. Chairman, I respectfully suggest that the witness be
ordered and directed to answer the question.

THE CHAIRMAN: You are directed to answer the question.

(*The witness consulted with his counsel.*)

MR. ROBESON: I stand on the Fifth Amendment of the American
Constitution.

MR. ARENS: Do you mean you invoke the Fifth Amendment?

MR. ROBESON: I invoke the Fifth Amendment.

MR. ARENS: Do you honestly apprehend that if you told this Com-
mittee truthfully—

MR. ROBESON: I have no desire to consider anything. I invoke the
Fifth Amendment, and it is none of your business what I would like to do,
and I invoke the Fifth Amendment. And forget it.

THE CHAIRMAN: You are directed to answer the question.

United States House of Representatives, 84th Congress, 2nd Session, Committee on
Un-American Activities, *Hearings,* June 12, 1956.

MR. ROBESON: I invoke the Fifth Amendment, and so I am answering it, am I not?

MR. ARENS: I respectfully suggest the witness be ordered and directed to answer the question as to whether or not he honestly apprehends, that if he gave us a truthful answer to this last principal question, he would be supplying information which might be used against him in a criminal proceeding.

(The witness consulted with his counsel.)

THE CHAIRMAN: You are directed to answer that question, Mr. Robeson.

MR. ROBESON: Gentlemen, in the first place, wherever I have been in the world, Scandinavia, England, and many places, the first to die in the struggle against Fascism were the Communists and I laid many wreaths upon graves of Communists. It is not criminal, and the Fifth Amendment has nothing to do with criminality. The Chief Justice of the Supreme Court, Warren, has been very clear on that in many speeches, that the Fifth Amendment does not have anything to do with the inference of criminality. I invoke the Fifth Amendment. . . .

MR. ROBESON: To whom am I talking?

THE CHAIRMAN: You are speaking to the Chairman of this Committee.

MR. ROBESON: Mr. Walter?

THE CHAIRMAN: Yes.

MR. ROBESON: The Pennsylvania Walter?

THE CHAIRMAN: That is right.

MR. ROBESON: Representative of the steelworkers?

THE CHAIRMAN: That is right.

MR. ROBESON: Of the coal-mining workers and not United States Steel, by any chance? A great patriot.

THE CHAIRMAN: That is right.

MR. ROBESON: You are the author of all the bills that are going to keep all kinds of decent people out of the country.

THE CHAIRMAN: No, only your kind.

MR. ROBESON: Colored people like myself, from the West Indies and all kinds. And just the Teutonic Anglo-Saxon stock that you would let come in.

THE CHAIRMAN: We are trying to make it easier to get rid of your kind, too.

MR. ROBESON: You do not want any colored people to come in?

THE CHAIRMAN: Proceed. . . .

MR. ARENS: And while you were in Paris, did you tell an audience there that the American Negro would never go to war against the Soviet government?

MR. ROBESON: May I say that is slightly out of context? May I explain to you what I did say? I remember the speech very well, and the night before, in London, and do not take the newspaper, take me: I made the

speech gentlemen, Mr. So-and-So. It happened that the night before, in London, before I went to Paris . . . and will you please listen?

MR. ARENS: We are listening.

MR. ROBESON: Two thousand students from various parts of the colonial world, students who since have become very important in their governments, in places like Indonesia and India, and in many parts of Africa, two thousand students asked me and Mr. [Dr. Y. M.] Dadoo, a leader of the Indian people in South Africa, when we addressed this conference, and remember I was speaking to a peace conference, they asked me and Mr. Dadoo to say there that they were struggling for peace, that they did not want war against anybody. Two thousand students who came from populations that would range to six or seven hundred million people.

MR. KEARNEY: Do you know anybody who wants war?

MR. ROBESON: They asked me to say in their name that they did not want war. That is what I said. No part of my speech made in Paris says fifteen million American Negroes would do anything. I said it was my feeling that the American people would struggle for peace, and that has since been underscored by the President of these United States. Now, in passing I said—

MR. KEARNEY: Do you know of any people who want war?

MR. ROBESON: Listen to me. I said it was unthinkable to me that any people would take up arms, in the name of an Eastland, to go against anybody. Gentlemen, I still say that. This United States Government should go down to Mississippi and protect my people. That is what should happen.

THE CHAIRMAN: Did you say what was attributed to you?

MR. ROBESON: I did not say it in that context.

MR. ARENS: I lay before you a document containing an article, "I Am Looking for Full Freedom," by Paul Robeson, in a publication called the *Worker,* dated July 3, 1949.

> At the Paris Conference I said it was unthinkable that the Negro people of America or elsewhere in the world could be drawn into war with the Soviet Union.

MR. ROBESON: Is that saying the Negro people would *do* Anything? I said it is unthinkable. I did not say that there [in Paris]: I said that in the *Worker.*

MR. ARENS:

> I repeat it with hundred fold emphasis: they will not.

Did you say that?

MR. ROBESON: I did not say that in Paris, I said that in America. And, gentlemen, they have not yet done so, and it is quite clear that no Americans, no people in the world probably, are going to war with the Soviet Union. So I was rather prophetic, was I not? . . .

8

Expulsions and Imprisonments

I have refrained from writing an introduction to this chapter since such an introduction would add little to its contents—the testimony is a sampling culled from a huge literature, provided by victims of McCarthyism.

1

Adler's Lament
1948–1949

> Harmonica virtuoso Larry Adler wrote an article for the June 15, 1975, edition of *The New York Times*, "My Life on the Blacklist," from which this is taken. The occasion was his first appearance on the New York stage in twenty-seven years with dancer and fellow blacklistee Paul Draper.

As I was saying before I was so rudely interrupted. There we were, Paul Draper and me, doing our annual Christmas show at the New York City Center in 1948. We took in $52,000 that week—not bad for a tap-dancer and a mouth-organist—but within the next few months we became America's arch-subversives. We were believed to have overthrown more of the government with our combined talents than the entire Communist party had been able to do—plus which they had Moscow's backing and we hadn't. A splendid team of journalistic talents worked devotedly to expose our villainy, a team including Westbrook Pegler, George Sokolsky, Fulton Lewis, Jr., Walter Winchell, Hedda Hopper, Igor Cassini—where are they now, the old familiar faces?

We were also the bandwagon easiest to jump off of. The first leaper was the City Center management, which not only refused us our usual Christmas–New Year booking in 1949, but from then on acted as if they'd never heard of us. . . .

Signed contracts were repudiated; bookings were cancelled. What was so special about us anyway? Well, for one thing, we had supported Henry Wallace for President in 1948, which was a pretty subversive act right there. We were, and always had been against the House Committee on Un-American Activities (what in hell did that title ever mean?). When, in 1947, they investigated the Hollywood writers, we joined the Committee for the First Amendment to protest the activities of the House committee which we considered pretty un-American for a start.

This caught the attention of a lady in Greenwich, Conn., who wrote to her local paper protesting against a forthcoming recital by Draper and me in her home town. She thoughtfully sent a copy to the *New York Journal-American*. She considered us pro-Communist, thought that money paid to us would go directly to Moscow, somehow by-passing Internal Revenue en route, and would finance the campaign against the American Way of Life.

I thought the letter silly then and think so now, but all those cancellations stemmed from that letter, taken up by the Hearst press, which made the Greenwich lady the greatest patriot since Barbara Fritchie. We had to act. We could make a voluntary appearance before the Committee on Un-

The Sunday New York Times, June 15, 1975.

American Activities, selling out a few friends in the process, and thus "clear" ourselves, which struck us a nauseating idea, or we could sue for libel, which is what we did. The case, tried in Hartford, ended in a hung jury, and that was that—except that we ended up guilty as hell. Of what I have never been sure, but guilty of *something*. The blacklist was total.

So I went to England (can you even imagine a Parliamentary Committee on un-British Activities?) and Paul Draper went to Switzerland. He later returned and became a professor of liberal arts at Carnegie Tech. I didn't want to (and don't want to) return. I have a very good life in England. High taxes but a good life. . . .

Incidentally, people say to me, "But surely all that stuff was over long ago?" Not so. I can appear on American TV, but not on any sponsored show. My last offer was for the Andy Williams show, suddenly withdrawn, phone calls refused. . . . Remember the film "Genevieve"? I composed and played the music for that. Six weeks before it opened at the Sutton in New York a print was requested without my name. My music was nominated for an Oscar. As no composer's name was on the credits they nominated Muir Mathieson, who conducted the orchestra. I made the facts known to the Academy but no correction was made and my name never restored. . . .

Years ago, at a London party for James Thurber, Hugh Gaitskell asked me why I chose to live in England after the sybarite comforts of Beverly Hills.

"I once got into a lot of trouble in the U.S.," I told him, "and if I ever do again, I'd rather get into trouble here in England than anywhere else because you simply get a better shake here. The individual still matters, and the pressure to conform isn't stifling—not yet, anyway."

And for me, that still holds true.

2

The Fruits of Defiance: Lardner
1947–1950

Ring Lardner, Jr., one of the most successful of the Hollywood Ten writers, recounted his dreadful experience at the hands of HUAC, the House of Representatives, and the courts (all of which worked together to send him and the others to jail), many years later in an article, "My Life on the Blacklist," for the October 14, 1961, issue of *Saturday Evening Post*. It should be noted that when he wrote it Lardner was still on the blacklist.

. . . Long before going to jail I had lost my job. A scant month after my 1947 appearance there was a top-level meeting of the industry that had previously awarded me one of its Academy Oscars—for the picture *Woman of the Year* with Katharine Hepburn and Spencer Tracy—and a salary of $2000 a week at the age of thirty-one. It ended with a joint public statement declaring my colleagues and me unemployable.

This blacklisted status, expanded to cover more than 400 people from various crafts in movies, television and radio, has persisted ever since. A few of the writers among these outcasts have been able to operate under other names in the "black market." Others have had to find new occupations entirely, among them carpentry, selling women's clothing, bartending, driving a school bus, and waiting on tables in a restaurant.

For actors, of course, pseudonyms were out of the question, and the only branch of the entertainment world remaining more or less open to them has been the ailing Broadway theater.

While I didn't anticipate, during my Danbury sojourn, how long and how zealously my former employers would maintain their decree of exile, I could see, in the ample time for reflection provided by my Government, that the prospects were tougher than anything I had faced in a rather sheltered life.

I could assume that the newspaper and publicity businesses, in which I had been briefly employed before becoming a screen writer at the age of twenty-one, were not likely to welcome me back. I had no experience whatsoever as a novelist or playwright, and even these relatively open fields were somewhat restricted by the knowledge that my work could not be sold to the movies.

Writing for any of the major magazines was a highly dubious proposition and remained so up to the time of my present assignment. The only two blacklisted writers I know of who have sold their work profitably to magazines in recent years have had to do so under assumed names, despite

the fact that both had previously been in considerable demand under their real ones.

The situation clearly demanded a readjustment for which my background had done nothing to equip me. When you are descended from a Lardner who sat on the Governor's Council in colonial Pennsylvania, and an Abbott who fought with the minutemen at Lexington and Bunker Hill, you find it hard to accept the "un-American" designation. And the fact that I bore, through no fault or merit of my own, a well-known name in American letters simply made it the most easily remembered among the "Hollywood Ten" by people who read about the case in the newspapers.

As a complicating detail, in the summer of 1947 my wife and I had bought a large house with a tennis court in Santa Monica, on the strength of a new contract with Twentieth Century-Fox. We had just begun the process of moving in when my subpoena from Mr. Thomas was delivered in September by the local United States marshal.

My employer's reaction to my Washington debut the following month was provocatively erratic. A week after I returned to work, I was asked to waive a contractual provision limiting the studio's use of my services to two pictures annually and to undertake a third screenplay for the current year. Then, after the industry heads had convened at the Waldorf Astoria in New York in November, I was directed to quit the premises on approximately two hours' notice.

I held out in the new house while the case against us progressed slowly from citation by the House of Representatives to indictment, arraignment, trial, conviction and appeal. My tennis game improved; my wife conceived and bore another child, making five for whose rearing and education I was financially responsible; what insecurity I felt was tempered by the general sentiment in Hollywood that the whole thing would blow over like other periodic tempests in the movie business. Among liberals at least, including those who considered my conduct unwise or quixotic, it was widely conceded that I had a clear legal right to take the stand I had.

Reflecting this attitude, the blacklist was not as rigid during this interim as its formal announcement had seemed to indicate. True, the doors of all the major studios were closed to me. But independent and semi-independent producers and the stars and directors who were beginning the now-prevalent practice of forming their own corporations were not nearly so timid as they later became about making furtive arrangements with the proscribed ten.

On completing one piece of work for a prominent star, I met him at his bank, where he drew and paid over my compensation in cash. The amount, while considerably more than I was accustomed to carry about, was much less formidable than it would have been before the blacklist, since even the most friendly of such secret employers were motivated in part by the opportunity to hire our services at cut rates.

There was also for some of us the chance to work abroad, where we encountered the almost unanimous opinion that what had happened to us

was a piece of temporary American insanity. A European producer who came to Hollywood to employ me and to borrow one of Twentieth Century–Fox's leading stars found himself in negotiation with the same executive who had signed my dismissal notice. Before he was permitted to sublet the actor, for a fee of $200,000, he was asked who was doing the script. Given my name, the studio executive said, "Good man," and O.K.'d the deal.

These and other clandestine movie jobs enabled me to keep the food supply moving into hungry young mouths until April 10, 1950, when the Supreme Court announced its refusal to consider the issues in the two pilot cases on which the other eight of us had agreed to stand. This meant the imminent end of my precarious liberty and a distinctly reduced standard of living for my family. The first step was to finance their upkeep during my absence by selling the house, into which all my savings had gone, and moving them to rented quarters.

Quick sales of property were common amid the sudden changes of fortune in Hollywood, and the local trade papers often carred advertisements with such eye-catching captions as OWNER GOING ABROAD or OWNER RETURNING TO BROADWAY. I composed a notice featuring the line OWNER GOING TO JAIL and inserted it in one of these publications. A national news magazine, whose space rates I could scarcely have afforded, picked it up as a news story, reprinting the entire ad, and a Beverly Hills physician who was doing research in emotional stress at the gaming tables of Las Vegas, read it there, mounted his Cadillac before dawn and concluded by midday a deal that left me with a net loss of $9000. . . .

3
The Fruits of Defiance: Bessie
1950

Alvah Bessie, a writer with ten films to his credit, went to jail in 1950 along with the rest of the Hollywood Ten. In this segment of his 1965 book, *Inquisition in Eden* (New York: Macmillan), he describes the beginning of his prison experience.

. . . Judge Pine smiled at me after he had pronounced me guilty as charged and asked whether I had anything I would like to say.

This is, of course *pro forma,* and while I was strongly tempted to say nothing, the obligation of a man who saw himself in the position of opposing the government when he thinks the government is wrong dictated that something should be said.

My wife could not afford to make the trip from Los Angeles to Washington to witness this relatively unimportant moment. I thought briefly of Nazim Hikmet, the fine Turkish poet and revolutionary, who was doing thirty years in prison, of thousands of others who had been tortured to death in Nazi Germany for lesser crimes, and I hoped I did not sound too pretentious. Judge Pine smiled several times during the three minutes I spoke and nodded in agreement (?) once or twice, and then he pronounced sentence: ". . . twelve months in a common jail and that he pay a fine of $1,000."

It was a small courtroom, but it was impressive, as all American Federal courtrooms are impressive. It was paneled in oak and marble; the American flag stood behind the judge and to his right; the atmosphere was solemn, if not oppressive; the officers of the court—judges, attorneys, attendants—were soft-spoken, courteous, correct; the small audience was attentive; the place was clean and well lighted.

After all three of us had been convicted and sentenced, we were handcuffed and led by the U.S. marshal out of the courtroom and down the marble corridor to the elevator; and within the space of two minutes and two stories of a building, the dialectical opposite of the decorous judicial process was revealed: the bullpen was filthy and crowded with men; the paint was peeling off the walls; the open latrine in the corner stank; the men—mostly Negroes—sat on battered wooden benches around the walls, for the most part apathetic, depressed, and disinclined even to ask each other, "What're *you* in for?"

The gears began to mesh, to roll. The fingerprints were taken (again); the papers were filled out; the minutes dragged as we waited for a sandwich, which one of the cops eventually supplied, drank warm water from

Excerpts from *Inquisition in Eden,* Alvah Bessie (New York: Macmillan, 1965), 242–4. Copyright 1965 by Macmillan. Reprinted by permission.

the fountain in the other corner, waited for transport to the Washington District Jail.

Some Negro prisoners who were being booked shouted through the screening at us, "Hiya, Hollywood kids!" Our attorneys made brief appearances on the other side of the wire, their faces distraught. Biberman and Dmytryk were brought in to be booked and held up their hands with six fingers extended, to indicate that they had each drawn six months instead of twelve.

We waited about two hours, then we were led, handcuffed two by two, through a narrow corridor and out into the brilliant Washington sunlight, made more brilliant momentarily by the flashbulbs of a battery of newspaper photographers.

We rode through the streets of our capital city in a van, screened with heavy wire, to the District Jail, where the van was admitted through double doors and the process of fingerprinting and mugging (with a number hung around your neck) began again, followed by stripping, showering, and the issuance, temporarily, of prison clothing. We were shaken down on our entrance into the central well of the prison, and what cigarettes we had managed to secrete were confiscated, with stern words of admonition not to try *that* again.

The strangest moment of all came shortly thereafter. We were directed to individual cells on various tiers of the prison; the doors of these cells opened, apparently automatically; we entered and the doors clanged shut.

In my cell there were two cots, double-deck; a toilet without a wooden seat; a washbasin; steel walls painted a dull green—nothing else. Later, a cellmate came in from a court hearing, but we could not make contact because he spoke a foreign language that I did not understand.

I stood at the entrance to the cell and automatically grasped the bars. It was almost instinctive behavior, although there is no doubt that it originated in my memory of countless prison films.

A trusty came to the cell and slipped me two packs of cigarettes. "Lawson and Trumbo bought these for you," he said.

"Where are they?"

"Shipped out—a couple days ago."

I tore open the pack and lit one with trembling hands. Can I *do* this? I thought; can I do this for a whole *year*?

4

The Travails of a Communist
1948–1955

In his 1969 autobiography, *Dangerous Scot,* John Williamson re-
counted his harrowing experience as a member of the first group of top
Communists to be arrested, tried, and jailed. He was doubly punished
as an alien even though he had lived here for decades. He was shipped
back to Great Britain, after serving his five-year term, and there he
remained until his death in 1978.

. . . On July 20, 1948, I stepped off a plane from Los Angeles, very
tired. It was a hot, sultry humid New York day with the temperature in the
90's. The plane had run into trouble over Oklahoma and we were late in
arriving. When I got home, I phoned the office to say I was going to get
some sleep. In a couple of hours the office phoned me to say I must come at
once—an emergency.

I went reluctantly, without shaving and in shirt sleeves, thinking I
would be back in an hour. The following story had been leaked to us: It
seemed that a grand jury which had been in session for months trying to
hang a Red label on several prominent New Dealers had failed in the
attempt. In desperation, on the last day of the jury's legal existence, it was
now about to indict the Communist Party's national leaders, in order to
help Truman rebut the Republicans' charge of "20 years of Democratic
treason."

A group of us—Foster, Dennis, Winston, Davis, Stachel, Thompson
and myself—were discussing this in Dennis's office when the door burst
open and a dozen men rushed in. They identified themselves as FBI men,
and then identified each of us officially. We were handcuffed and taken
outside, where the street had been barricaded off. Separate cars were pro-
vided for each of us, with an intricate system of inter-car communication.

At FBI headquarters we were each stripped and interrogated sepa-
rately. I refused to answer to any questions except my name and address.
They kept up their barrage of questions till I lost my temper. After being
mugged and placarded with numbers, we were locked up till they could get
a judge to come from home to convene court. (A picture of me unshaven
and looking like a desperado was used by the Hearst press for years.) Then
we were all charged under the Smith Act on two counts: first, a conspiracy
indictment alleging we organized to advocate and teach the violent over-
throw of the United States government by force and violence at some
unknown time in the future; and second, a membership indictment alleg-
ing that we belonged to an organization, the Communist Party, that

taught and advocated the overthrow of the government by force and violence. . . .

While still in Lewisburg I was ordered to appear before an immigration department hearing dealing with the order of deportation issued against me on February 10, 1948. After several weeks of controversy, during which I refused to answer questions because my lawyer was not present, the hearing finally took place on November 19, 1952.

The reasons outlined for my deportation were crouched in very lengthy and repetitious legal language. Briefly, it was charged that I was an alien who believed in the overthrow of the government by force and violence; that I belong to an organization that held the same belief; that I wrote and caused to be distributed articles that so advocated; and so on, *ad infinitum*. The second series of reasons covered my membership in the Communist Party. . . .

When we were finally released from prison on March 1, 1955, the three non-citizens—myself, Stachel and Potash—were put under bail in connection with the deportation order, as well as the second Smith Act indictment. This involved, from the outset, daily reports from Britain and, after much legal maneuvering, the second indictment was dropped to allow me to be deported. The aim of the American Committee for the Protection of Foreign Born, which was handling the end of my case, was to get agreement for Mae and the two boys to accompany me. They felt this was necessary to avoid any vindicative move that might prevent them from leaving the country later (they were all United States citizens).

The government refused any such commitment and told me I could be deported at any time. During these weeks I always had a bag packed in case I was forcibly taken to a ship by myself. While my first letters to the British ambassador had received a polite brush-off, later on I received unsolicited visits from British consular officials offering me help. They also interceded with Washington demanding the entire family travel to Britain together. This reflected mass pressure, especially in Scotland and in parliament. . . .

When May 4 arrived, I was practically encircled by FBI men until we got on the *Queen Elizabeth*. Our tourist cabin was on the bottom deck and the steward told me later that FBI men had come and counted all my baggage and watched the cabin, and that some of them had stayed on the ship and only gone off with the pilot.

On the ship was a flock of reporters, photographers and TV men. Our departure was front-page news, with pictures in the papers the next day. That night, our departure on the ship and an interview with me on the deck of the *Queen Elizabeth* appeared on TV. In my statement to the press and on TV, I said:

"I am being deported for the same reasons I have been jailed and persecuted these last years—for my working-class activities and ideas. My ideas are simple: I hold that the interests of Americans demand co-existence—not war, cold or hot. I hold that McCarthyite reaction endangers the liberties of all Americans and that the majority must unite to

restore the Bill of Rights for all. I hold that true Americanism call for a relentless struggle for the unconditional equality of the Negro people. I favor a society where production is for use, not for profit—namely, socialism.

"These are my ideas. These are Communist ideas. These are American ideas. I didn't bring them with me from Scotland as a child of ten. I brought no foreign ideology except perhaps the democratic heritage represented by the immortal Robert Burns."

Between 50 and 60 comrades had come to the ship to see us off. We took over one of the public rooms and had a farewell party. My closest co-workers, who had been released from prison at the same time, could not take a chance and attend either of these affairs, because one of the regulations prohibited any association with ex-prisoners during conditional release. However, we found appropriate means of saying good-bye to each other. We were accompanied to the ship by one of Mae's brothers and his wife.

The full meaning of being torn up by the roots and isolated from your adopted country, its people, your comrades, friends and family does not strike you till weeks, even months later. But, as we stood on the deck of the *Queen Elizabeth,* my eyes instinctively turned to Bedloe's Island. Passing the Statue of Liberty I no longer saw the historic symbol of democracy that greeted each new immigrant with the words: "Give me your tired, your poor, your huddled masses, yearning to be free." . . .

5

Getting Dashiell Hammett, et al.
1951

Along with Dashiell Hammett, the famous writer, and black activist W. Alpaeus Hunton, Frederick Vanderbilt Field (a Vanderbilt and a Field), a longtime friend of the Communist Party, was a trustee of the special bail fund for the Communist leaders who were convicted in 1949. That fund had come from the Civil Rights Congress, which ranked high on the attorney general's list of "subversive" organizations. In his memoir, *From Right to Left,* Field tells what happened to him and Hammett and Hunton when some of the convicted Communists broke bail and fled.

Shortly after the Supreme Court ruled that their conviction under the Smith Act had been constitutional, those top functionaries of the Communist Party were ordered to surrender in order to begin serving their sentences. Four of the eleven, Henry Winston, Gus Hall, Robert Thompson and Gilbert Green, failed to show up and thereby forfeited their bail. And all hell broke loose.

I was not privy to the decision that four of the eleven were to jump bail and "go underground." The later explanation was that the Party anticipated a widespread seizure of functionaries, down to the local level, thereby wiping out the entire leadership. A few experienced officials had to disappear in order to prevent the complete success of such a wholesale raid. The survival of the organization demanded such a move.

As expected, I was immediately subpoenaed to appear in a federal court. Presiding over the case that July 5, 1951, was Judge Sylvester J. Ryan, and prosecuting was Irving Saypol. I had encountered my inquisitor once before. In the late forties, we had both attended a function at Fieldston Academy just north of Manhattan. I was there because my oldest daughter was then a student at Fieldston and I suppose that Saypol attended for a similar reason. I remember very clearly being in conversation with Lila and a group of her friends when Saypol came over and interrupted. He said nothing more nor less than, "Field, I just want to take this opportunity to tell you that someday we're going to get you." I was therefore not too pleased to meet this patriot again under circumstances that were clearly unfavorable. From the first instant, it did indeed look as though his prediction was about to come true.

Believing that discovery of the whereabouts of the fugitives was the purpose of the hearing and its only legitimate purpose, I answered questions directed to that point. No, I had nothing to do with their disappearance. No, I had no idea where they were. Yes, I remembered having

Excerpted from *From Right to Left,* Frederick Vanderbilt Field (Westport: Lawrence Hill, 1983), 225–7, 298–9. Copyright 1983 by Lawrence Hill. Reprinted by permission.

seen Gus Hall a few days before and Winston "some time last week." I said I had expressed "great concern and amazement" when I first learned the four were missing. Judge Ryan then informed me that by answering those questions I had denied myself the privilege of claiming the Fifth Amendment on other questions. (This was a very doubtful legal point, but in those days its validity was never questioned.) The hearing then moved on to its real objective.

Judge Ryan explained to me and the rest of his audience that he wanted the names of the contributors of the $80,000 that I had put up for those four fugitives—bail which had now been forfeited—because the names might lead to their whereabouts. It soon became apparent that extracting from me and my colleagues the list of contributors to the Bail Fund was the hearing's real purpose. Getting their names would not help discover the fugitives, but it certainly would expose the contributors. In the prevailing atmosphere of hysteria, that exposure surely would have caused the donors to lose their jobs and to suffer a multitude of other problems.

I answered certain questions about the contributors, thinking I could show the futility of further pursuing this line of questioning. I explained that we had received over three-quarters of a million dollars from several thousand contributors. Some had lent cash, others bonds. Several times I said that even if I divulged the names it could in no way help the court's effort to find the four. All the money and securities had gone into a general fund with which we had bought U.S. government bonds; there was no way to trace whose money was used to post that particular $80,000. . . .

I refused to produce the fund's checkbook, certificates of deposit and the list of contributors. I refused to tell the court where the fund kept its records, when I had last seen them, whether Henry Winston was one of the contributors and whether I was.

For me the whole hearing had an air of unreality. When I agreed to become the secretary and main functionary of the Bail Fund, I had done so under certain conditions that were agreed to and strictly observed by all concerned. I was not only not to be the guardian of the list of contributors, but I was never to see it or to be told about it. I was not to have access in any form or manner to the checkbook or the accounts. I was not myself to contribute any money or certificates. Nor was I to have anything to do with raising the funds we required. My responsibilities were to attend and participate at meetings to decide when and how and for whom we were to post bail and then to do the posting myself. . . .

The upshot of my lengthy and exhausting questioning that July 5 in Judge Ryan's court was that His Honor turned to me, and made some remarks to the effect that I had conducted myself courteously. Then he pronounced, "You are guilty in contempt of court and hereby committed to the custody of the Attorney General for ninety days, or until such time as you purge yourself." He gave me until next morning to see if I could either get somewhere with an appeal to a higher court or change my mind and

confess all. Because my hopes and his were not fulfilled within the twenty-four hours, I was escorted the next day directly from the witness chair to the basement of the building. There a Black Maria was conveniently waiting to take me to the federal detention facility on West Street. On July 6 I spent my first night in jail. . . .

By that time Hammett and Hunton had also been jailed, and Green, the remaining member of the Bail Fund trustees, was about to join us. But before his arrival, Hammett, Hunton and I were taken several times before a grand jury which asked us exactly the same questions that we had already refused to answer and for which refusal had been jailed. . . .

Instead of reaching Lewisburg, Pennsylvania, in the early afternoon as scheduled, we got there well after dark. Our stopover began with an unpleasant incident. We had been herded into a room with two chairs and a desk for the prison officials and no benches. We sat on the floor as roll was called, alphabetically. In our group of three, my name was called first. "Field?" "Yes, sir." Then, "Hammett?" "Yes, sir." Next, "Alphaeus." Dead silence. A little louder, "Alphaeus?" Not a sound. A shout, "ALPHAEUS." A quiet voice next to me said, "My name is Hunton." Alphaeus, if I haven't mentioned it earlier, was the only black among us. He won that battle hands down, for the official then said, "Alphaeus Hunton?" and my friend answered, "Present." The bastards we thought, the goddamn sons of bitches. And this is way up in Pennsylvania.

Hunton, Hammett and I were variations on a thin-man theme. Hammett, who had obviosuly modeled his famous fictional character after himself, was about my height but considerably sparer, if that was possible without becoming transparent. He was the oldest at 57, Hunton was 48, and I was 46 when we entered prison.

If Dash was physically conspicuous for his slimness, Alphaeus was notable for his enormous height. He was built like one of those basketball players who reach an arm up and flip the ball into the basket. His life, however, had not been that of an athlete. A graduate of Howard University, he had gone on to take an M.A. at Harvard and a Ph.D. at New York University. Then followed a long period of teaching at Howard before he came to work for the Council on African Affairs in New York. That was where I first met him and began to work closely with him on some of his organization's interests.

The Council on African Affairs pioneered the study of African struggles for freedom in the United States. Hunton came to it first as educational director and later became its executive secretary. In the preface to *Decision in Africa,* a book which Alphaeus wrote in the middle 1950s, Dr. W. E. B. Du Bois said of him, "He knows and appreciates the rise of socialism and sees in it the coming emancipation of the darker world from the exploitation of the white world." He was an admired friend, and I was dismayed that evening when I discovered that Alphaeus was not coming with us to Ashland. Instead, he was sent to an all-Negro prison. But on arriving at Ashland, I was glad we had parted company. The place was Jim-

Crowed. The blacks were housed in separate cell blocks and sat at segregated tables in the mess hall. . . .

We were standing in line for lunch one day shortly after we had arrived when Dash suddenly turned white as a sheet and staggered to a nearby bench. Concerned, I broke ranks and rushed after him. (For doing this I was sharply reprimanded.) He was simply dead-tired; his small store of energy was exhausted. He told me he suffered from low blood pressure, and that may have been true, but as I learned later, he had a long history of tuberculosis, and he did not talk about that. In his last years, he developed emphysema and, at the end, cancer. At Ashland, it seemed to me, he had no illusions that he had much longer to live. Though he did live until 1961, the authorities should not have been permitted to take five months (Dash got about a month off for good behavior) out of the life of a sick man.

I was aware that Dash had done very little, if any, creative writing after 1934, when he was forty years old. It was hard for me to understand how such an enormous talent could have simply ceased. He had had, as a matter of fact, only twelve years of productive writing; his first stories had been published in 1922. I asked him what had happened. Had he lost interest in writing? No, that was not it. From time to time he had tried to write again, but nothing had come of it. What was it then? I never got an adequate answer. Not that Dash didn't talk about it. He left the impression that he simply didn't know the answer. But maybe I was wrong; maybe he did not want to tell me or anyone else. Perhaps it was something very private to him. I suspect that he was so ravaged by ill health and too much drinking that his talent ebbed with his energy.

Hammett got along well with his fellow inmates. They were not strangers to him. He had been a Pinkerton agent and in his writing had brought a hard-boiled realism about crime to an enormous public. He knew what the bad ones were all about. He kidded the inmates unmercifully and sometimes, I thought, dangerously, for they were not a stable lot. But I was wrong. They took everything he dished out. He knew the men he was talking to. I am sure that living for a month or so with Hammett was the high point of their lives. . . .

6

"Sedition" in Pittsburgh
1950–1952

On August 31, 1950, Pennsylvania authorities arrested Steve Nelson, a major Communist Party official (among other things he led the Abraham Lincoln Brigade in the Spanish civil war), for violating the state's sedition law. Nelson was living in Pittsburgh, where the trial took place the following summer. (It would have taken place sooner had he not been recovering from a serious auto accident.) In his 1981 memoir, *Steve Nelson, American Radical* from which this is excerpted, he tells the whole bitter experience. Years later, the Supreme Court, it should be noted, in a landmark case, threw out his conviction. (See Chapter 10, Document 2.)

. . . We were charged with attempting to overthrow by force and violence the government of Pennsylvania and the United States under the 1919 Pennsylvania Sedition Act. Initially designed to deter labor organizing, the act had been a dead letter since the 1926 prosecution of a handful of workers from Jones and Laughlin's Aliquippa works. Why then were we suddenly arrested and charged with violation of it?

In the first place, the federal government was not the force that came after us. There had not been any prosecutions under the federal Smith Act since July 1948 arrests of the National Board members of the Party, and there were not to be any more until June 1951. The federal government was waiting for the U.S. Supreme Court to dispose of the appeals from the 1948 National Board cases before proceeding with any more Smith Act prosecutions. Ours was a state charge all the way and it was the result of local conditions and personalities. . . .

All our efforts to get a lawyer failed. Margaret and various friends saw over eighty in Pittsburgh who said they were too busy or that they didn't practice criminal law. Some frankly admitted that they didn't want to become another Schlesinger, the local progressive attorney who had been, at one time or another in 1950 and 1951, arrested, brought up for disbarment, and held in contempt of court, all because of his politics and whom he defended. Upon my return to Pittsburgh, I visited more than twenty-five lawyers myself and wrote to fifty others out of town. Some are willing but unable to go to court without a delay of several months. Most simply refused.

December 3 arrived, and the trial was scheduled to start. I was still without counsel and was in pain as I hobbled into the courtroom. I told all this to Judge Harry Montgomery and asked for a postponement. He re-

Excerpted from *Steve Nelson: American Radical,* Steve Nelson, James Barrett and Bob Ruck (Pittsburgh: University of Pittsburgh Press, 1981), 180–3. Copyright 1983 by University of Pittsburgh Press. Reprinted by permission.

plied that there had already been too many delays, and that the trial would start. I pointed out to him that every racketeer could and did get postponements. But there would be no more "dilly-dallying," as the judge told me. I demanded that doctors be appointed to examine me, and he complied, appointing them himself. . . .

I tried my last card. "Your Honor, since you apparently don't believe that I cannot get an attorney in this city, I request that you appoint a panel of attorneys with whom I can discuss the case and see if I can get one to defend me."

He hesitated but gave me the names of four lawyers who I could try to see, "but I should be prepared to go to trial tomorrow morning." I protested that no attorney could be ready to go to trial in one day. He must have other clients, whom he could not drop, and he must have time to become familiar with the case. The judge, however, refused to reconsider.

Still, I thought any lawyer was better than none. That night was a busy one. I interviewed three of the attorneys on the list, but they were unacceptable. The fourth, whom I located fifteen minutes before court opened, was only interested in his fee of fifty dollars a day.

Court then began, and Judge Montgomery asked me if I was ready to proceed. I explained that I had no attorney, but that there were three willing to represent me if they could get thirty to sixty days' time. The judge pointed out that he had done his duty by suggesting a panel, and that I was actually refusing everybody he had recommended. He denied me any more time. The trial would proceed the next day, and I was to be my own lawyer.

That night I sat up looking over old cases, trying to become a lawyer. I knew that I could begin by filing certain motions, and I asked the judge for time to do so. He gave me fifteen minutes to write them up and present them. Margaret and I scribbled furiously and handed them over, but he hardly glanced at them. My final motion stunned the judge. I demanded that he disqualify himself because of his deep participation with those who had been behind my arrest and trial. I pointed out that among other actions showing his prejudice was the sentence he gave Nate Albert for attempting to break down Jim Crow at the Highland Park pool. I asked him if it wasn't a fact that he was one of the founders of Americans Battling Communism, which had demanded my arrest and circulated propaganda against me. He admitted that he was one of the officers, but "at the present time, inactive," and he refused to disqualify himself. . . .

The trial ended in late January 1952. For a few months we all remained free on bail and motions for appeals to both trials were filed. On June 26, 1952, our motion for a new trial was denied, and we were placed in the Allegheny county jail. On July 10, we appeared before Judge Montgomery and he pronounced sentence of twenty years imprisonment, court costs and $10,000 in fines—the maximum.

I was pretty upset when I heard him say twenty years, even though I knew it was coming. I think I was ready to cry. I recall looking back over

my shoulder as I was led away and seeing Margaret and a few others crying. I felt very helpless. When I was put in a cell, the other men asked what I got. When I said "twenty years," one of them remarked "Holy shit!" and the others just shook their heads. Then one guy said, "You're not going to serve it, Nelson." I don't know why he said it, but it did me a lot of good. . . .

7

Harrassing a Labor Radical
1954

Len DeCaux, a talented journalist, had played a significant role in the CIO as editor of its hard-hitting newspaper. After being purged as a Communist and knocking about, with the FBI never far behind, he found a factory job and a measure of anonymity. But then came the inevitable call from HUAC. In this excerpt from his interesting memoir, *Labor Radical,* DeCaux describes what followed.

. . . When the knock on the door came—after months of this rehabilitation—our family agitation was extreme. It was a subpoena to appear before the House Un-American Activities Committee in Washington, for a hearing on *March of Labor.* I hadn't been connected with the magazine for nearly a year. It had long since moved back from Chicago to New York, where its dying gasps were less and less frequent.

Could I somehow come through without losing my job? I thought there was a fighting chance and began to plot the seemingly impossible—an undiscovered public appearance before HUAC.

Had the hearing been in Chicago, I'd have given up. Exposure, discharge, blacklist, would have been inevitable. If HUAC came to one's city, the only out was to dodge the subpoena. For years after, I had no telephone in my name, left no forwarding address when I moved. Each place of employment was a closely guarded secret—mentioned not even in family or among friends. At first I thought to dodge the FBI also, then concluded that was asking trouble from an outfit concerned chiefly with knowing my whereabouts. HUAC was the menace to my job, and I figured a local subpoena-server couldn't count on earning his pay by no more than calling the FBI.

In this 1954 case, however, the HUAC hearing was in Washington, and I was working in Chicago. Local hearings got a big splash. But a hearing in Washington, about a near-defunct labor magazine in New York, should rate no more than a routine wireservice squib in Chicago papers, I thought. Mention of my name might escape my employer's attention, or be passed off as error or coincidence, provided all evidence pointed to my being on the job continuously in Chicago at the time. Could I make the trip to Washington and back without being missed from the job?

It was fortunate I worked the night shift. By split-second timing I could work my shift Wednesday night, catch a plane to Washington, and return by afternoon plane after the hearing, to start my Thursday shift in Chicago at 4:30 P.M. Schooled in detective fiction, I gave close attention to every detail. Nothing about my clothes, habits, manner, must lead anyone

to suspect I was not going home from work Wednesday night and coming from home Thursday afternoon exactly as I always did.

Every detail clicked, I thought—but one. If I quit work at the regular 1 A.M. time, I might miss my plane by minutes. Moreover, in leaving the shop with the rest of the shift, I might be seen heading for a taxi rather than the Elevated I normally took. I therefore fixed it with a foreman to punch me out at the regular time while I slipped out ten minutes early. It was a small and not unusual favor, but if anything came up, the strawboss mightn't confess his delinquency; whereas, if I begged off and punched out early, it could be a giveaway to the office.

It was a possible weak link. I agonized over it as I fidgeted sleeplessly on the plane. Everything else had seemed to work out perfectly.

In Washington, I had breakfast with my lawyer, who discussed my constitutional rights. Besides citing the First Amendment on press freedom, I'd have to claim protection of the Fifth and answer no anticommunist questions, or I'd be required, under pain of jail and fine, to answer all related questions, inevitably designed to make me an informer against associates and friends. My chief concern was to protect my job, but the lawyer said they'd certainly ask about it and I'd have to answer.

Sure enough, committee counsel soon asked the question that could mean discharge and blacklist. I stalled, asking to keep my employer's name from the record—lest he be embarrassed, I said. Congressman Harold Velde (R., Ill.) was presiding inattentively, when not peacocking before some lady friends. At my feeble evasion he sprang to life with the look of a hunter out for the kill. He insisted I give full name, business, address of my employer, spell it out and repeat it. Velde's eagerness surprised me. Charitably I speculated he might have thought I was holding back on some juicy connection. Less charitably I concluded that anyone engaged in HUAC's persecution of individuals must have a strong streak of sadism.

With my job and employer's name in the record, I could only hope now that Chicago papers wouldn't print them—so I could keep my job long enought to quit voluntarily with a good reference. In this hope I was encouraged by the dullness of the hearing and the dearth of reporters. I was the only witness all morning and into a brief afternoon session. Some reporters spoke to chairman and counsel before the hearing, then disappeared. At the press table was only one man, bored, doodling, and lightly snoozing. . . .

HUAC was arrogant, hectoring, deliberately rude, and inconsiderate. Each time I started to snap back, I felt the cautioning glance of my lawyer, who had advised self-control under provocation, lest I risk extended persecution. When my anger tempted me to disregard him, my fear of publicity bringing job loss stopped me. The sure way to make a news story was to clash with the committee.

Once released from the hearing, I sped to the Washington airport with but minutes to spare. I congratulated myself on my self-control. The story shouldn't rate more than a squib in Chicago papers. All went smoothly on

my return. At 4:30 P.M. I began my shift at the shop, in every detail exactly as I'd always done.

During the lunch break, I got a copy of the Chicago *Daily News*. On an inside page was an inconspicuous United Press story headed, "Chicagoan Defies Red Quiz." That much I had expected and, blessed break, it didn't give the name of my employer. With this I might be able to cope. It might escape attention in the shop, where last names were never used and only payroll clerks paid them attention. I had been continuously on the job, and if confronted with the item, might plausibly deny it referred to me.

Across the table from me, as I ate my lunch, was a printer who always read the *Daily News* as he ate. He read it page by page and column by column. By the time he came to the page where my item was, I was in a sweat. I followed his eyes going down column by column to the spot where my story was. His eyes ran right past the item. He turned the page.

At end of shift, I left the shop with great relief. No one had mentioned the news item. Others would likely pay it as little attention as had my lunch mate. At the El station, I bought the other papers, to hunt through them on the way home for further squibs. I started with the *Chicago Tribune*.

I didn't have to hunt; it was no squib. On the second page, with my picture and sprawling over four columns, was a story exclusively about me, my life story and all. It was from Washington by the *Tribune*'s redbait specialist, Willard Edwards, who had evidently been the doodling, dozing reporter. It gave my home address, the name, description, and address of my employer, and all possible identification of myself and my job.

That was that. I saw no point in going to work for the next shift— thought I'd call the shop, let the boss speak first, then ask him to mail my final paycheck. . . .

The superintendent had come in after the foreman, to hear my story. Before I left, he came back and said I was a good worker, the shop needed me, he'd do all he could to keep me. The big boss would have the last word, and he was away, but I could keep on working till he returned.

It turned out to be a great night.

The next day was Saturday, and with a night's sleep to make up, I slept in till the afternoon. The super called. He sounded genuinely distressed.

"Can't tell you how sorry I am," he said, "but I've got to let you go. You can have it any way you like—quit, call it a layoff, a discharge, whatever's best for you. I can't wait till the boss returns. Customers have been calling in all day, and the salesmen are raising hell. They say I've got to fire you at once." . . .

9

McCarthy's Fall

1

To his cost McCarthy discovered that what Providence suddenly bestows with one hand it just as suddenly removes with the other, the other hand of Providence being again the Cold War and its influence on domestic politics. As we saw, McCarthy's fantastic rise coincided with the national trauma that had set in by the time he delivered his Wheeling speech. But when he was at the height of his power during the Korean War, when, chairing his own investigative subcommittee, he still made headlines at will and when the Eisenhower administration bent over backward to appease him—it was then, in the spring and summer of 1953, the the Cold War took another major turn. Stalin died in March and five months later the Korean War ended. No longer were American boys dying in battle and soon after they would no longer be drafted. Eisenhower was making good on his implied Republican promise to bring the nation peace and quiet after twenty years of depression and wars and high taxes and government controls under Democratic rule.

It was a situation hardly conducive to McCarthy's political well-being. The endemic sense of crisis guaranteed him his public, and to the degree that the sense of crisis gave way to peace and quiet so his public was bound to diminish. But he was hardly the kind of man who, perceiving the change, would draw back, restrain himself, bide his time. One can only conclude that his fame had intoxicated him, that he depended on it more and more to keep his psychic balance. His biographers tell us of the toll his

fame exacted from him. A heavy drinker before he became responsible for the image that Providence thrust on him, he had by now become a hope-less alcoholic and begun experiencing other infirmities too. That he found it increasingly difficult to handle the demands of his fame is luminously clear in retrospect, and those demands rose as Cold War anxieties fell.

It was apparent to McCarthy and the far right that Eisenhower dif-fered little from Truman, that indeed Eisenhower might be worse than Truman. (Before long, the extremely far right—for example, the recently founded John Birch Society)—would regard Eisenhower as part of the international Communist conspiracy.) As 1953 wore on, then, McCarthy turned his crusading zeal against his fellow Republicans in the Eisenhower administration. He continued to be good copy, of course, and the adminis-tration refused, publicly, to take him on, but he was not having the effect he once did. His criticisms of the administration, if not yet of Eisenhower himself, whose popularity remained high, became more strident. By the end of the year McCarthy was referring to "21 years of treason."

2

He thought he found the issue he was looking for, the equivalent perhaps of the Communist-in-State Department issue that had launched him four years earlier. His subcommittee operatives, while investigating the top secret Army research facility at Fort Monmouth, New Jersey, discovered that an Army dentist names Irving Peress, suspected for some time of being a "security risk" (having questionable relatives and friends), had nonethe-less been promoted from captain to major. This was the very facility at which Julius Rosenberg, recently electrocuted for spying, had worked during the war. The paranoid implications could not be more vivid: the promotion of dentist Peress proved that something was rotten not only at Fort Monmouth but somewhere in the U.S. Army itself.

For Eisenhower, ex-general and war hero, this was the last straw. He was determined to bring McCarthy down, and he shrewdly assigned the task to Vice President Richard Nixon, whose whole political career had been a continuous exercise in McCarthysim. And thanks to McCarthy's deputy, subcommittee chief counsel Roy Cohn, the administration found the issue *it* was looking for. Cohn's personal friend, one G. David Schine, also worked for the subcommittee, the two of them having traveled the year before through the American zone of Germany investigating the In-ternational Information Agency for subversives ("junketeering gumshoes" was how critics described them) and finding literature in agency-financed libraries written by such American Communists as Dashiell Hammett and Howard Fast. Soon after their return, Schine was drafted into the Army. Cohn tried desperately to get his bosom friend taken off the onerous duties to which all privates are subject so that he could be free on evenings and weekends. So desperate was Cohn that he repeatedly called up and yelled at the base commander and, that unavailing, the commander's Pentagon su-

periors, including, incredibly enough, the Secretary of the Army. The administration case against McCarthy, then, was that subcommittee staff members, acting in his name, went to inordinate lengths to seek favors and special privileges for Private Schine. Here was where hubris caught up with McCarthy. Instead of distancing himself from Cohn, letting Cohn take the blame, he accepted responsibility for what Cohn did. That proved his undoing.

The fury of charges and countercharges, leaks and counterleaks, forced McCarthy's subcommittee to hold hearings on the whole matter; being himself a subject of the inquiry, McCarthy stepped down as chairman. And so it was McCarthy versus the U.S. Army, with the nation watching on television, week after week, through the spring of 1954. What the nation saw bore out, in extremis, everything his enemies had been saying about him for years—his incivility, his cruelty, his recklessness. Cohn came across as his scheming, duplicitous, oily, partner in vice. They more than met their match in the Army Secretary's attorney, Boston lawyer Joseph P. Welch, whose soft-spoken, grandfatherly demeanor, wily intelligence, and acerbic wit incensed McCarthy and brought out his worst qualities. Naturally, he investigated Welch and Welch's assistants to see what he could find. And find something he did (see pages 185–187), which he then made public; it was a vicious smear. Nothing McCarthy did was more self-destructive. By the time the hearings had run their totally inconclusive course, he was finished. The public had definitely turned against him. No longer was he in any position to trouble the Eisenhower administration.

He was now in free fall. Fellow Senators whose enmity he had incurred attacked him pitilessly. Responding in his accustomed style, he only deepened the enmity. A censure motion having been offered, the Senate formed a special committee, chaired by an impeccable conservative (Utah's Arthur Watkins) who had never raised his voice in protest against McCarthy or McCarthyism, to decide what measures it should take, if any. The Committee at last recommended that he be condemned for insulting members of the august body, not for any of the heinous things he did to ordinary citizens. On the surface it was a rather moderate rebuke because it carried no penalties. Yet it was severe given the fact that for the Senate to agree on even the mildest rebuke of an errant member is such a rarity. On December 2, 1954, the Senate voted overwhelmingly for the recommendation. McCarthy soon departed from the stage of history. Illness and inebriation hastened his exit, though marriage and fatherhood was his solace before he died in 1957.

<div align="center">3</div>

While the Senate debated his fate it was also passing a bill that must have appealed to his sense of irony. A has-been he might be, but what he stood for—McCarthyism—was obviously alive and well. The bill, drawn up by liberal Democrats who denounced him and McCarthyism loudest, in effect

outlawed the Communist Party by ordering its registration under the Internal Security Act. The move was a transparent attempt to assure the American people, what with Congressional elections coming up, that no one hated Communists more than liberal Democrats. It was the kind of cynical move which, again, McCarthy must have appreciated. They could not help knowing that the Communists Control Act, as they named it, would never stand up legally (and has ever since remained a dead letter). It may have been a shrewd move after all, for the Democrats went on to recapture both the House and Senate.

1

Assailing Eisenhower
November 23, 1953

> In the fall of 1953 Attorney General Brownell accused former President Truman of having appointed a Soviet spy (a high official in his administration) to the International Monetary Fund. In a televised speech Truman accused his accuser of basest McCarthyism. McCarthy was no part of the controversy, but because his name was used he demanded equal time to answer Truman. The broadcasters gave in. He used the occasion, before the vast audience, to link the Eisenhower administration to Truman's treasonous one.

Well, my good friends, this gives you some of the picture why the Communists, the fellow-travelers, the Truman-type Democrats, who place party above country, scream so loudly about McCarthyism, why their hatred and venom knows no bounds.

Now, a few days ago—a few days ago, I read that President Eisenhower expressed the hope that by election time in 1954 the subject of Communism would be a dead and forgotten issue. The raw, harsh, unpleasant fact is that Communism is an issue and will be an issue in 1954. . . .

But now, now let's take a look at the Republican party. Unfortunately, in some cases, our batting average has not been too good. Before looking at some of the cases in which our batting average is zero, let me make it clear that I think that the new Administration is doing a job so infinitely better than the Truman-Acheson regime that there is absolutely no comparison.

For example, the new Administration in the first ten months in office has gotten rid of 1,456 Truman holdovers who were all security risks. And over 90 per cent of the 1,456 security risks were gotten rid of because of Communist connections and activities or perversion. Fourteen hundred and fifty-six, I would say: an excellent record for the time President Eisenhower has been in office.

However, let us glance at a few cases where we struck out. For example, we still have John Paton Davies on the payroll after eleven months of the Eisenhower Administration.

And who is John Paton Davies? John Paton Davies was (1) part and parcel of the old Acheson-Lattimore-Vincent-White-Hiss group which did so much toward delivering our Chinese friends into Communist hands; (2) he was unanimously referred by the McCarran Committee to the Justice Department in connection with a proposed indictment because he lied

Excerpted from *The New York Times,* November 24, 1953.

under oath about his activities in trying to put—listen to this—in trying to put Communists and espionage agents in key spots in the Central Intelligence Agency.

A question which we ask is: Why is this man still a high official in our department after eleven months of Republican Administration?

Now let us examine the failure of my party, if we may, to liquidate the foulest bankruptcy of the Democrat Administration.

On September 12, 1953, the Chinese Communists announced that they would not treat as prisoners of war American fliers who were shot down during the Korean war over Manchuria. On September 10, 1953, the Army announced that some 100 American young men known to have been prisoners of the Communists in Korea were still unaccounted for. Unaccounted for as of tonight, my good friends.

Well, why do I bring this situation up tonight in telling about the Republican party? The Republican party did not create the situation, I admit. We inherited it. But we are responsible for the proper handling of the situation as of tonight. Now what are we going to do about it? Are we going to continue to send perfumed notes, following the style of the Truman-Acheson regime? . . .

I realize, of course, the low ebb to which our honor has sunk over the past twenty years. But it is time that we, the Republican party, liquidate this blood-stained blunder of the Acheson-Truman regime. We promised the American people something different. It is up to us now to deliver—not next year, next month—let us deliver now, my good friends.

How are we going to do it? Once a nation has allowed itself to be reduced to a state of whining, whimpering appeasement, the cost of regaining national honor may be very high. But we must regain our national honor regardless of what it costs. Now I know it is easy to talk in general terms about what can be done. Let us be specific.

As you know, we have been voting billions of dollars each year to help our allies build up their military and economic strength, so that they can help in this day-to-day struggle between the free half of the world and the Communist slave half. If that money we give them is being used for that purpose, then it is well spent. If not, then those allies are defrauding us.

How does that affect you? As of today, some money was taken out of your paycheck and sent to Britain. As of today, Britain used that money from your paycheck to pay for the shipment of the sinews of war to Red China.

What can we do about that? We can deal a death blow to the war-making power of Communist China. We can, without firing a single shot, force the Communists in China to open their filthy Communist dungeons and release every American. We can blockade the coast of China, without using a single ship, a single sailor or a single gun.

In this connection I want to point out that Lloyds of London, the outfit that keeps track of shipping, according to their records the shipments

to Red China for this year have increased over 1,500 per cent over what they were last year.

Now what can we do about it? We can handle this by saying this to our Allies: If you continue to ship to Red China, while they are imprisoning and torturing American men, you will get not one cent of American money. . . .

2

McCarthy and His Nemesis
April 29, 1954

The passage below represents the climactic moment of the Army-McCarthy hearings, which daily played before the nation throughout the spring of 1954. McCarthy received his coup de gras from Joseph Welch, the secretary of the Army's puckishly adroit lawyer. Out of uncontrollable irritation with Welch, McCarthy smeared one of Welch's assistants, who had nothing to do with the hearings, and by inference Welch himself. From this point on it was all downhill for McCarthy, Welch's plaintive, beautifully cadenced words, "Have you no sense of decency sir, at long last? Have you left no sense of decency?," ringing in his ears for the rest of his life.

SENATOR MUNDT: Have you a point of order?

SENATOR MCCARTHY: Not exactly, Mr. Chairman, but in view of Mr. Welch's request that the information be given once we know of anyone who might be performing any work for the Communist Party, I think we should tell him that he has in his law firm a young man named Fisher whom he recommended, incidentally, to do work on this committee, who has been for a number of years a member of an organization which was named, oh, years and years ago, as the legal bulwark of the Communist Party, an organization which always swings to the defense of anyone who dares to expose Communists. I certainly assume that Mr. Welch did not know of this young man at the time he recommended him as the assistant counsel for this committee, but he has such terror and such a great desire to know where anyone is located who may be serving the Communist cause, Mr. Welch, that I thought we should just call to your attention the fact that your Mr. Fisher, who is still in your law firm today, whom you asked to have down here looking over the secret and classified material, is a member of an organization, not named by me but named by various committees, named by the Attorney General, as I recall, and I think I quote this verbatim, as "the legal bulwark of the Communist Party." He belonged to that for a sizable number of years, according to his own admission, and he belonged to it long after it had been exposed as the legal arm of the Communist Party.

Knowing that, Mr. Welch, I just felt that I had a duty to respond to your urgent request that before sundown, when we know of anyone serving the Communist cause, we let the agency know. We are now letting you know that your man did belong to this organization for either 3 or 4 years, belonged to it long after he was out of law school.

I don't think you can find anyplace, anywhere, an organization which

United States Senate, 83d Congress, 2nd Session, Permanent Subcommittee on Investigations of Committee on Government Operations, *Special Investigation, Hearings,* 2428–8.

has done more to defend Communists—I am again quoting the report—to defend Communists, to defend espionage agents, and to aid the Communist cause, than the man whom you originally wanted down here at your right hand instead of Mr. St. Clair.

I have hesitated bringing that up, but I have been rather bored with your phony requests to Mr. Cohn here that he personally get every Communist out of government before sundown. Therefore, we will give you information about the young man in your own organization.

I am not asking you at this time to explain why you tried to foist him on this committee. Whether you knew he was a member of that Communist organization or not, I don't know. I assume you did not, Mr. Welch, because I get the impression that, while you are quite an actor, you play for a laugh, I don't think you have any conception of the danger of the Communist Party. I don't think you yourself would ever knowingly aid the Communist cause. I think you are unknowingly aiding it when you try to burlesque this hearing in which we are attempting to bring out the facts, however.

MR. WELCH: Mr. Chairman.

SENATOR MUNDT: Mr. Welch, the Chair should say he has no recognition or no memory of Mr. Welch's recommending either Mr. Fisher or anybody else as counsel for this committee.

I will recognize Mr. Welch.

SENATOR MCCARTHY: Mr. Chairman, I will give you the news story on that.

MR. WELCH: Mr. Chairman, under these circumstances I must have something approaching a personal privilege.

SENATOR MUNDT: You may have it, sir. It will not be taken out of your time.

MR. WELCH: Senator McCarthy, I did not know—Senator, sometimes you say "May I have your attention?"

SENATOR MCCARTHY: I am listening to you. I can listen with one ear.

MR. WELCH: This time I want you to listen with both.

SENATOR MCCARTHY: Yes.

MR. WELCH: Senator McCarthy, I think until this moment—

SENATOR MCCARTHY: Jim, will you get the news story to the effect that this man belonged to this Communist-front organization? Will you get the citations showing that this was the legal arm of the Communist Party, and the length of time that he belonged, and the fact that he was recommended by Mr. Welch? I think that should be in the record.

MR. WELCH: You won't need anything in the record when I have finished telling you this.

Until this moment, Senator, I think I never really gaged your cruelty or your recklessness. Fred Fisher is a young man who went to the Harvard Law School and came into my firm and is starting what looks to be a brilliant career with us.

When I decided to work for this committee I asked Jim St. Clair, who sits on my right, to be my first assistant. I said to Jim, "Pick somebody in the firm who works under you that you would like." He chose Fred Fisher and they came down on an afternoon plane. That night, when he had taken a little stab at trying to see what the case was about, Fred Fisher and Jim St. Clair and I went to dinner together. I then said to these two young men, "Boys, I don't know anything about you except I have always liked you, but if there is anything funny in the life of either one of you that would hurt anybody in this case you speak up quick."

Fred Fisher said, "Mr. Welch, when I was in law school and for a period of months after, I belonged to the Lawyers Guild," as you have suggested, Senator. He went on to say, "I am secretary of the Young Republicans League in Newton with the son of Massachusetts' Governor, and I have the respect and admiration of my community and I am sure I have the respect and admiration of the 25 lawyers or so in Hale & Dorr."

I said, "Fred, I just don't think I am going to ask you to work on the case. If I do, one of these days that will come out and go over national television and it will just hurt like the dickens."

So, Senator, I asked him to go back to Boston.

Little did I dream you could be so reckless and so cruel as to do an injury to that lad. It is true he is still with Hale & Dorr. It is true that he will continue to be with Hale & Dorr. It is, I regret to say, equally true that I fear he shall always bear a scar needlessly inflicted by you. If it were in my power to forgive you for your reckless cruelty, I will do so. I like to think I am a gentleman, but your forgiveness will have to come from someone other than me.

SENATOR McCARTHY: Mr. Chairman.

SENATOR MUNDT: Senator McCarthy?

SENATOR McCARTHY: May I say the Mr. Welch talks about this being cruel and reckless. He was just baiting; he has been baiting Mr. Cohn here for hours, requesting the Mr. Cohn, before sundown, get out of any department of Government anyone who is serving the Communist cause.

I just give this man's record, and I want to say, Mr. Welch, that it has been labeled long before he became a member as early as 1944—

MR. WELCH: Senator, may we not drop this? We know he belonged to the Lawyers Guild, and Mr. Cohn nods his head at me. I did you, I think, no personal injury, Mr. Cohn.

MR. COHN: No, sir.

MR. WELCH: I meant to do you no personal injury, and if I did, I beg your pardon.

Let us not assassinate this lad further, Senator. You have done enough. Have you no sense of decency, sir, at long last? Have you left no sense of decency? . . .

3

Defiance to the Bitter End
November 10, 1954

> Vermont Senator Ralph Flanders, an inveterate foe of McCarthy, on July 30, 1954 introduced a resolution to censure McCarthy for numerous acts of improper conduct. The Senate was by then in the mood to take up the matter—the Army-McCarthy hearings were fresh in everyone's mind—and appointed a select committee. On November 8th it recommended that he be censured. But most Republicans favored making a deal with McCarthy: no censure, only a mild chastisement for his methods coupled with an appreciation for his dedicated anti-Communism, if he apologized to the senator whom he had called "the only man in the world who has lived so long with neither brains nor guts." Below is his response.

This week the United States Senate convened in special session to debate Senator Flanders' resolution to censure me. I take it, judging from declarations of individual Senators—made in most cases without bothering to study the Watkins committee record—that the resolution will be approved. I will be censured.

Today I want to discuss with you the implications, as I see them, of the censure vote.

There are two things about censure that the American people should understand. There is one thing that censure unquestionably does mean. It does mean that those who are leading the fight against subversion have been slowed down, and that others who might otherwise have been enlisted in the fight will be discouraged from joining us by the now-established hazards of such a course. It thus does mean that the Communist Party has achieved a major victory. . . .

My colleagues are perfectly well aware that they would not be in Washington this month were it not for the fact that I have been prominently involved in the fight against Communist subversion. That being the case, let us not pretend otherwise.

If I lose on the censure vote, it follows, of course, that someone else wins. Now, I ask the American people to consider carefully: Who is it that wins? And then, having answered that question, I ask them to contemplate the shocking truth revealed by the fact that the victors have been able to win.

There is one group that is pretty sure about who has won.

When the Watkins committee announced its recommendation of censure, the Communists made no attempt to conceal their joy. The *Daily Worker's* headline that day read, "Throw the Bum Out" (that's me). And the story beneath said, and I quote: "America is catching up with McCar-

United States Congress, 83d Congress, 2nd Session, *Congressional Record*, 15952–4.

thy. . . . It is good news for America—for its free speech, its right to speak out for peace, co-existence, and the abolition of H-bomb war."

Now, the *Daily Worker* was not just applauding a committee of the United States Senate. Its cry was primarily one of self-congratulation, of smug jubilation over the success of the Communists' own efforts to rebuke me. The Communists could point with justifiable pride to the campaign they have waged vigorously and unceasingly long before Senator Flanders was taken out of mothballs and persuaded to advance his censure motion last July.

No sooner had the Flanders resolution been moved than the *Daily Worker* called to party members in flaming headlines, "Aid Senate Fight on McCarthy." The *Daily Worker's* story that day read, and I quote it: "We urge all New Yorkers to write to Ives insisting he support the Flanders resolution. We urge New Yorkers to write to Senator Herbert Lehman suggesting he put the heat on the Democrat Senate leadership to line up behind the resolution. We urge readers everywhere to line up behind the resolution. We urge readers everywhere to take similar action in connection with their Senators." In this vein the campaign continued, gaining momentum day by day; and even as I speak to you now a new story denouncing me is rolling off the *Daily Worker* presses.

There is, of course, nothing remarkable in the fact that the Communists have mobilized their strength behind the Flanders resolution. This was to be expected. From the moment I entered the fight against subversion back in 1950 at Wheeling, West Virginia, the Communists have said that the destruction of me and what I stand for is their No. 1 objective in this country. . . .

The real strength of the Communist Party is measured by the extent to which Communist objectives have been embraced by loyal Americans. It is measured by the Communists' ability to influence the American mind—to persuade large numbers of otherwise sound-thinking Americans that our Government is wise to let up in its efforts to clean out the subversives and to attack, instead, those who have hurt the Communists. I would have the American people recognize, and contemplate in dread, the fact that the Communist Party—a relatively small group of deadly conspirators—has now extended its tentacles to that most respected of American bodies, the United States Senate; that it has made a committee of the Senate its unwitting handmaiden.

Let me be very clear about this. I am not saying, as I am confident the opposition press will have me saying tomorrow, that the Watkins committee knowingly did thw work of the Communist Party. I am saying it was the victim of a Communist campaign; and having been victimized, it became the Communist Party's involuntary agent.

I am aware that many of you listening to me regard this as an unpalatable proposition. I have made similar statements before, in other contexts. Such statements never fail to exasperate a good number of loyal Americans. But said they must be if we are to survive, and said they will be.

I regard as the most disturbing phenomenon in America today the fact that so many Americans still refuse to acknowledge the ability of Communists to persuade loyal Americans to do their work for them. In the course of the Senate debate I shall demonstrate that the Watkins committee has done the work of the Communist Party, that it not only cooperated in the achievement of Communist goals, but that in writing its report it imitated Communist methods—that it distorted, misrepresented, and omitted in its effort to manufacture a plausible rationalization for advising the Senate to accede to the clamor for my scalp.

In view of this pattern of Communist success—in view of the Communists' uncanny ability to strike back just when it would appear that their strength has dissipated—can anyone doubt that the security of this country is still in great danger?

But while I would never have you underestimate the Communist threat, neither would I have you believe that this thing is unbeatable. I haven't the slightest doubt that one day, and perhaps soon, the American people will rise up in righteous fury and, once and for all, extinguish the Communist menace. As for me, I will be around for sometime, and I will continue to serve the cause in which I have dedicated my life. . . .

4
Condemned!
December 2, 1954

Having been told by McCarthy what it could do with the select committee's recommendations or with any attempt to reach a compromise with him, the Senate voted by more than three to one to *condemn* him, something of a reduction perhaps (it is unclear) compared to censure. Following is the gist of the resolution.

Resolved, That the Senator from Wisconsin, Mr. McCarthy, failed to cooperate with the Subcommittee on Privileges and Elections of the Senate Committee on Rules and Administration in clearing up matters referred to that subcommittee which concerned his conduct as a Senator and affected the honor of the Senate and, instead, repeatedly abused the subcommittee and its members who were trying to carry out assigned duties, thereby obstructing the constitutional processes of the Senate, and that this conduct of the Senator from Wisconsin, Mr. McCarthy, is contrary to senatorial traditions and is hereby condemned. . . .

SEC. 2. The Senator from Wisconsin, Mr. McCarthy, in writing to the chairman of the Select Committee to Study Censure Charges (Mr. Watkins) after the Select Committee had issued its report and before the report was presented to the Senate charging three members of the Select Committee with "deliberate deception" and "fraud" for failure to disqualify themselves; in stating to the press on November 4, 1954, that the special Senate session that was to begin November 8, 1954, was a "lynch party"; in repeatedly describing this special Senate session as a "lynch bee" in a nationwide television and radio show on November 7, 1954; in stating to the public press on November 13, 1954, that the chairman of the Select Committee (Mr. Watkins) was guilty of "the most unusual, most cowardly things I've heard of" and stating further: "I expected he would be afraid to answer the questions, but didn't think he'd be stupid enough to make a public statement"; and in characterizing the said committee as the "unwitting handmaiden," "involuntary agent" and "attorneys-in-fact" of the Communist Party and in charging that the said committee in writing its report "imitated Communist methods—that it distorted, misrepresented, and omitted in its effort to manufacture a plausible rationalization" in support of its recommendations to the Senate, which characterizations and charges were contained in a statement released to the press and inserted in the *Congressional Record* of November 10, 1954, acted contrary to senatorial ethics and tended to bring the Senate into dishonor and disrepute, to obstruct the constitutional processes of the Senate, and to impair its dignity; and such conduct is hereby condemned.

United States Congress, 83d Congress, 2nd Session, *Congressional Record,* 16392.

5

Liberals Seek Cover:
The Communist Control Act
August 24, 1954

> This act in effect declared the Communist Party a criminal conspiracy. It went beyond the McCarran Act, which at least called for hearings. Here Senate liberals disgraced themselves; it was they who drew it up. Of course hardly anyone dared vote against it: only one senator and a handful of representatives.

. . . SEC. 2. The Congress hereby finds and declares that the Communist Party of the United States, although purportedly a political party, is in fact an instrumentality of a conspiracy to overthrow the Government of the United States. It constitutes an authoritarian dictatorship within a republic, demanding for itself the rights and privileges accorded to political parties, but denying to all others the liberties guaranteed by the Constitution. Unlike politcal parties, which evolve their policies and programs through public means, by the reconciliation of a wide variety of individual views, and submit those policies and programs to the electorate at large for approval or disapproval, the policies and programs of the Communist Party are secretly prescribed for it by the foreign leaders of the world Communist movement. Its members have no part in determining its goals, and are not permitted to voice dissent to party objectives. Unlike members of political parties, members of the Communist Party are recruited for indoctrination with respect to its objectives and methods, and are organized, instructed, and disciplined to carry into action slavishly the assignments given them by their hierarchical chieftains. Unlike political parties, the Communist Party acknowledges no constitutional or statutory limitations upon its conduct or upon that of its members. The Communist Party is relatively small numerically, and give scant indication of capacity ever to attain its ends by lawful political means. The peril inherent in its operation arises not from its numbers, but from its failure to acknowledge any limitation as to the nature of its activities, and its dedication to the proposition that the present constitutional Government of the United States ultimately must be brought to ruin by any available means, including resort to force and violence. Holding that doctrine, its role as the agency of a hostile foreign power renders its existence a clear present and continuing danger to the security of the United States. It is the means whereby individuals are seduced into the service of the world Communist movement, trained to do its bidding, and directed and controlled in the conspiratorial performance of their revolutionary services. Therefore, the Communist Party should be outlawed. . . .

83d Congress, 2nd Session, Public Law 673.

Sec 4. Whoever knowingly and willfully becomes or remains a member of (1) the Communist Party, or (2) any other organization having for one of its purposes or objectives the establishment, control, conduct, seizure, or overthrow of the Government of the United States, or the government of any State or political subdivision thereof, by the use of force or violence, with knowledge of the purpose or objective of such organization, shall be subject to all the provisions and penalties of the Internal Security Act of 1950, as amended, as a member of a "Communist-action" organization. . . .

10

A Measure of Redress

1

Slowly, almost imperceptibly, resistance to McCarthyism began picking up momentum in the mid-1950s. How much McCarthy's disgrace figured in the resistance it would be impossible to say; the effect may have been subliminal. But one can also argue that his disgrace, by enabling America to smugly convince itself that it could discipline a political bully and lout, may actually have legitimated the deeper institutional expressions of McCarthyism and therefore made it even harder to resist.

Be that as it may, resistance did emerge, especially from the Supreme Court. How this happened is a study in unintended consequences, in the fortuitousness of history.

In his first year in office President Eisenhower appointed California Governor Earl Warren as Chief Justice; without Warren he might not have gotten the nomination. He regarded the appointment as a cut and dry affair; Warren was the sort of moderately conservative politician he admired. There certainly was nothing in Warren's long record as a middle-of-the-road Republican to give him pause. The same could be said for another of Eisenhower's Supreme Court appointees three years later. His subordinates led him to believe that William J. Brennan, Jr., a New Jersey judge and a Democrat, could also be counted on to uphold the status quo. By Eisenhower's reckoning, Brennan proved to be the second biggest mistake he made as President, Warren having been the first. For both men promptly joined the inveterate dissenters, Black and Douglas, to

comprise a solid liberal phalanx, which, in time, came to dominate the court.

In its decade and a half the Warren Court made itself the most activist in American history. And by activist is meant the assertion of judicial prerogatives over and against the other branches of the federal government and the states. What interests us here is the prerogative relating to civil liberties, the one most antithetical to McCarthyism. The Warren Court was thus continuing the revolution that the Roosevelt court had initiated. As we saw, it was the Roosevelt court that had begun the shift of judicial review away from protection of propertied minorities—the historical role of the judiciary—and toward protection of political and social minorities. But then came World War II and the Cold War and the Truman court's subordination to Congress and the president. By extending its hand to beleaguered minorities—i.e., the victims of McCarthyism—the Warren court in the process also restored the judiciary's status as co-equal branch and as the guardian of national supremacy over the states.

The Warren Court lifted or imposed the following government restrictions, nearly all of which coincided with the advent of the Cold War. Loyalty review boards had to strictly observe the canons of due process, in other words, allow accused employees to confront the evidence against them, this on the premise that they could not be fired at the mere discretion or whim of the government. The State Department could no longer withhold a citizen's passport simply on its say-so; it had to justify the ban, present evidence, etc. Nor could the Post Office separate out and retain mail from abroad to persons it deemed security risks. Most of the punitive provisions of the Internal Security, or McCarran, Act were invalidated, including the registration of the Communist Party and other so-called subversive organizations. Thrown out too were the non-Communist affidavits required of union leaders under the Taft-Hartley Act. The House Un-American Activities Committee, along with its imitators could no longer cite witnesses for contempt because they refused to cooperate on political grounds, i.e., took the First or Fifth Amendments, or for that matter on any grounds. And the Smith Act was rendered practically inoperative, the government thereupon dropping further indictments of Communist Party leaders.

The Warren Court came down even harder on the states, effectively nationalizing the Bill of Rights in general, the civil liberties portion of it in particular. State and local laws against sedition, some dating back to the turn of the century, were declared null and void; only Congress could legislate in these areas. State investigative committees were subject to the same limitations that HUAC and the other Congressional committees were. State civil service agencies had to abide by the same canons of due process that applied to federal loyalty review boards, and the statutes that authorized those agencies to fire employees without accountability were outlawed as well. Nor could states penalize anyone who refused to sign oaths or affidavits of loyalty.

Justice Hugo Black lived long enough to see come true the hope he expressed so powerfully in the 1951 Dennis case, during the darkest days of McCarthyism. In "Calmer times," he then predicted, "when present pressures and fears subside, this or some later court will restore the First Amendment liberties to the high preferred place where they belong in a free society." Not only the First Amendment, he might have added, but the Fifth and Fourteenth and the bill of attainder and ex post facto clauses too.

2

Meanwhile, the assault on McCarthyism was going on apace on other fronts. In 1955, even before the Warren Court took shape, a lower court federal appeals judge, Luther Youngdahl, struck a significant blow for civil liberties when he threw out the perjury conviction of Owen Lattimore, the ill-stared Johns Hopkins professor. McCarthy and his friends had tortured no one more than Lattimore, whom McCarthy had accused of being the State Department traitor he had in mind when he was throwing his numbers around. Nothing came of that charge except Lattimore's public humiliation. Two years later he was grilled for days by a Senate investigative subcommittee that was clearly out to get him. A minor contradiction in his interminably long testimony led to the perjury indictment (drawn up by the Truman Justice Department) and the guilty verdict. Judge Youngdahl threw out the indictment as a subcommittee violation of Lattimore's First Amendment rights. The howl of protest sent up by Lattimore's foes can be imagined; he had by now taken on enormous symbolic importance, identified as he was by his unique relationship with their fallen hero. But Lattimore had suffered too much to gloat. He settled in England, and there he remained, teaching and writing, for the rest of his long life.

The same year that Judge Youngdahl handed down his decison, a book titled *False Witness* was published. The title could not be more apt, the author, Harvey Matusow, having confessed in a fit of conscience to repeatedly lying as a paid government witness against Communists. He was an effective witness, as were so many others, because he, like them, had belonged to the party and, like them seemed to know whereof he spoke, down to the arcane details and the coterie language. And, like so many of them, Matusow was a rather unsavory character—unsavory in his new life as in his previous ones. Coming clean, at any rate, he corroborated those who had been complaining all along about the corrupt use of professional witnesses. Juries, loyalty review boards, investigative committees, and intelligence agencies had reason to be more skeptical of their testimony now.

But the Matusow book and the notoriety he received—he personally suffered for his expiation—had little adverse effect on the sordid practice to which he called attention. The same witnesses continued to show up at the trials and hearings of alleged subversives and security risks. The practice died out slowly, just as McCarthyism itself did. History has been unkind to the anti-Communist witnesses, to the extent even of forgetting their names. Harvey Matusow's name is the one it remembers.

And there was John Henry Faulk who dealt another sharp blow to McCarthyism by the central role he played in ending the blacklist. Faulk was one of the numerous entertainers who lost their jobs, and usually their careers, because industry giants, in this instance the Columbia Broadcast System, caved in to anti-Communist blackmailers.

Faulk had an afternoon program on CBS radio, which featured his down-home Texas sagacity and humor. He kept his politics off the air, but his liberalism was no secret. Active in the left faction of the American Federation of Television and Radio Artists (AFTRA) that bested the pro-McCarthy faction in a leadership struggle, he was a marked man. Enter AWARE, one of the private outfits, which, for a price, cleared or publicly exposed suspects about whom they, the outfits in question, had dredged up derogatory information. Behind the entrepreneur who ran AWARE, Vincent Hartnett, stood the proprietor of a small grocery chain in Syracuse who felt very keenly that not enough was being done about the Communist menace. This proprietor, Lawrence Johnson, supplied the muscle for Hartnett by threatening to remove from his shelves the products that advertised on offending programs and networks and to get the rest of the retailing world to do likewise. CBS let Faulk go after AWARE complained about him, much as the industry in general, Hollywood included, let so many others go without ever admitting why. He was persona non grata in broadcasting, and that, presumably, would be the end of it; no one would hear of him again.

Faulk's place in the history of McCarthyism rests on the fact that instead of going quietly he sued Hartnett and Johnson, having gotten a famous trial lawyer, Louis Nizer, to take his case. It was the magnitude of Faulk's (and Nizer's) triumph in 1962, the astronomical total of three and a half million dollars the jury awarded him (later reduced to 550,000 dollars, still a vast sum), that made it so notable. The message could not be louder and clearer. Now blacklisting was liable. Moreover, the blacklisters, more accurately the extortioners, themselves faced the prospect of full disclosure in open court, along with the sizable penalties. The informal blacklisting continued, to be sure, but the inquisitors who ran such agencies as AWARE, who terrorized industries, stole away, never again to be seen.

Eventually, the blacklist became a thing of the past. This was meager satisfaction for its victims. To most of them, the precious lost years were irrecoverable. Some landed on their feet: actor-comic Zero Mostel, screenwriter Dalton Trumbo, folk-singer Pete Seeger, novelist Howard Fast, film directors Jules Dassin and Joseph Losey (but only after they became ex-patriates), and others. But the overwhelming majority dropped out of their professions for good, or, like Paul Robeson, would certainly have come back but for illness and debilitaton and old age. Faulk himself returned to Texas and soldiered on until his death in 1989, as an engaging liberal wag among the local conservatives. He never received more than a tiny fraction of his award.

1

End of the Lattimore Affair
January 18, 1955

> With this excellent opinion in *United States v. Lattimore,* federal judge Luther W. Youngdahl closed a reprehensible chapter in the history of McCarthyism, the five-year ordeal of Professor Owen Lattimore.

Owen Lattimore was indicted October 7, 1954, on two counts of perjury allegedly committed before the Senate Internal Security Subcommittee on or about February 27, 1952.

The first count charges that Lattimore perjured himself when he denied that he was a "follower of the Communist line." It avers that in his positions and policies as to political, diplomatic, military, economic and social matters, there can be found expressed in his statements and writings from 1935 to 1950, several hundred instances in which he followed the Communist line, meaning that he:

> ". . . followed in time, conformed to, complied with and paralleled the positions taken, the policies expressed and propaganda issued on the same matters by the Government of the Soviet Union, the Communist Party of the Soviet Union, the Comintern and its successors, the various Communist governments, parties and persons adhering to Communism and accepting the leadership of the Soviet Communist Party." (Count I, paragraph 5).

The second count charges that Lattimore perjured himself when he testified he had never been a "promoter of Communist interests." Such a person is defined as one who:

> ". . . knowingly and intentionally contributed to the growth, enlargement and prosperity of Communism by acting to further, encourage and advance those objectives of political, diplomatic, military, economic and social interest to the Government of the Soviet Union, the Communist party of the Soviet Union, the Comintern and its successors, the various Communist governments, parties and persons adhering to Communism and accepting the leadership of the Soviet Communist party." (Count II, paragraph 5). . . .

The Court cannot escape the conclusion that "follower of the Communist line" is not a phrase with a meaning about which men of ordinary intellect could agree, nor one which could be used with mutual understanding by a questioner and answerer unless it were defined at the time it were sought and offered as testimony. This count, even with its apparent definition, is an open invitation to the jury to substitute, by conjecture, their understanding of the phrase for that of the defendant. The meaning of such a phrase varies according to a particular individual's political philosophy. To ask twelve jurors to agree and then decide that the definition of the Communist line found in the indictment is the definiton that defen-

127 Federal Supplement 405–9.

dant had in mind and denied believing in, is to ask the jury to aspire to levels of insight to which the ordinary person is incapable, and upon which speculation no criminal indictment should hinge. We cannot debase the principle that:

> "The accused is entitled under the Constitution to be advised as to every element in respect to which it is necessary for him to prepare a defense."

When elements in an indictment are so easily subject to divergent interpretation, the accused is not adequately apprised of the charges as to enable him to prepare a defense. It therefore fails to conform to the requirements of the Sixth Amendment and Federal Rules. It cannot be cured by a bill of particulars.

The second count charges that Lattimore perjured himself when he testified he had never been a "promoter of Communist interest."

This entire perjury indictment arises out of, and is essentially founded upon, the statements, correspondence, and editorial comments of defendant. It does not rest upon alleged acts of espionage or such an act as membership in the Communist party. . . .

Count II, thus dependent upon Count I, cannot stand, being anchored to, partaking of, and plagued by, all its vagueness and indefiniteness. While some paragraphs of Count II specifically refer to Count I, either for the definition of the Communist line or for topical references wherein defendant promoted Communist interests, all of the paragraphs, realistically appraised, are rooted in, and presume a prior finding of, the meaning of the phrase "follower of the Communist line." . . .

Jury inquiries would be limitless. No charge by the Court could embody objective standards to circumscribe and guide the jury in its determination of what the witness maight have meant regarding words he used. With so sweeping an indictment with its many vague charges, and with the existing atmosphere of assumed and expected loathing for Communism, it would be neither surprising nor unreasonable were the jury subconsciously impelled to substitute its own understanding for that of defendant.

To require defendant to go to trial for perjury under charges so formless and obscure as those before the Court would be unprecedented and would make a sham of the Sixth Amendment and the Federal Rule requiring specificity of charges.

The indictment will therefore be dismissed.

2

Freedom for Steve Nelson
April 2, 1956

Pennsylvania v. Nelson, delivered by Warren, was a landmark decision because it went beyond the personal fate of a single man. By a bare majority the Court used the Nelson case (see Chapter Eight, Document Six) to throw out all state sedition laws. Pennsylvania's highest court had laid the groundwork for the argument, that in matters of sedition federal laws overrrode local ones. Nelson's travails thus gave civil liberties a boost.

. . . We examine these Acts only to determine the congressional plan. Looking to all of them in the aggregate, the conclusion is inescapable that Congress has intended to occupy the field of sedition. Taken as a whole, they evince a congressional plan which makes it reasonable to determine that no room has been left for the States to supplement it. Therefore a state sedition statute is superseded regardless of whether it purports to supplement the federal law. . . .

Since we find that Congress has occupied the field to the exclusion of parallel state legislation, that the dominant interest of the Federal Government precludes state intervention, and that administration of state Acts would conflict with the operation of the federal plan, we are convinced that the decision of the Supreme Court of Pennsylvania is unassailable. . . .

350 U.S., 504, 509.

3

Matusow Confesses
1955

Harvey Matusow was a useful government witness in Communist trials: He helped get convictions. So he caused quite a bit of consternation when, without warning, he recanted in his 1955 book, *False Witness,* a snippet from which follows. Suffice it that the affidavit he mentions brought no results, that the defendants against whom he had falsely testified—the second tier of Communist leaders—served out their terms.

HARVEY M. MATUSOW, being duly sworn, deposes and says:

1. I make this affidavit in support of the motion by the defendants for a new trial and to do what I can to remedy the harm I have done to the defendants in the case of *United States of America v. Elizabeth Gurley Flynn, et al.*

2. I appeared as a witness for the Government against the defendants in the course of the trial in the above-entitled case in this Court in July, 1952, on an indictment charging the defendants with conspiring to violate the teaching and advocacy and organizing sections of the Smith Act.

3. The testimony I gave in the course of the trial appears in the typewritten transcript of the record at page 6565 and thereafter.

4. The matters I testified to were either false or not entirely true and were known to me to be either false or not entirely true, at the time I so testified, in that: . . .

F. I testified that in December, 1945, I attended a meeting of the Communist Party in Philadelphia at which Henry Winston, Organizational Secretary of the Communist Party, spoke (Tr. 6622–24). I further testified that I returned from Philadelphia together with Henry Winston and that on this return trip Winston said:

> . . . that his article in the fourteenth convention issue of Political Affairs, which was September of 1948, should be read and studied more fully by the members of the Communist Party. He said that it was important for the young members of the Communist Party in New York, members of the Yough (sic) clubs, to get out of New York and to get out into the midwest into basic industries, out in Ohio, Illinois, Indiana, Western Pennsylvania, and upstate New York near Buffalo. He said that it was important to go there so that the young Communists could form a nucleus of workers on the side of the Communist Party, to recruit and get young people into the Communist Party, so

Excerpted from *False Witness,* Harvey Matusow (New York: Cameron and Kahn, 1955), 242, 249–50.

that in the event of any imperialistic war, as he put it, we could help the side of the Soviet Union, as he stated it, and slow down production, and in some places call strikes, and in general see that the war production, in the event of a war, would not carry forward to its fullest capacity. (Tr. 6625–6)

My testimony relating to my conversation with Henry Winston in December, 1948, was true only so far as I did have a conversation with Henry Winston, but my testimony that Henry Winston said ". . . so that in the event of any imperialistic war, as he put it, we could help the side of the Soviet Union, as he stated it, and slow down production, and in some places call strikes, and in general see that the war production, in the event of a war, would not carry forward to its fullest capacity" (Tr. 6626) was false.

G. The foregoing does not exhaust the matters concerning which I testified falsely at the trial of these defendants. Nor do the incidents related in paragraphs 4B and 4C exhaust the matters concerning which I testified falsely with the knowledge of the United States Attorneys. For, on other occasions in connection with other portions of my testimony, the United States Attorneys participated in formulating statements which I attributed to the defendants and other persons named in my testimony which was not based on what was actually said, but which was created for the purposes of the trial.

The reason I have not described in this affidavit other testimony which I gave which was false and other testimony which the United States Attorneys knew to be false is that there has been insufficient time since I first spoke to any defense counsel concerning this motion and the making of this affidavit to read the entire record of my testimony and to locate all of the matters concerning which I testified to falsely and/or which was known to be false by the United States Attorneys. . . .

4
The Fifth Vindicated
April 9, 1956

Like most communities in the McCarthyism era, New York City dismissed anyone in its employ who failed to cooperate with any official investigation (this under Section 903 of the city charter). And state courts agreed with the city that those taking the Fifth Amendment fell under the ban. So it was that Harry Slochower, venerable professor of philosophy and literature at Brooklyn College, was summarily fired because he refused to discuss past membership in the Communist Party before McCarthy's committee in 1953. *Slochower v. Board of Education,* written by Warren, gave a huge lift to Fifth Amendment protection.

. . . At the outset we must condemn the practice of imputing a sinister meaning to the exercise of a person's constitutional right under the Fifth Amendment. The right of an accused person to refuse to testify, which had been in England merely a rule of evidence, was so important to our forefathers that they raised it to the dignity of a constitutional enactment, and it has been recognized as "one of the most valuable prerogatives of the citizen.". . .

The privilege against self-incrimination would be reduced to a hollow mockery if its exercise could be taken as equivalent either to a confession of guilt or a conclusive presumption of perjury. As we pointed out in *Ullmann,* a witness may have a reasonable fear of prosecution and yet be innocent of any wrongdoing. The privilege serves to protect the innocent who otherwise might be ensnared by ambiguous circumstances. See Griswold, The Fifth Amendment Today (1955).

With this in mind, we consider the application of § 903. As interpreted and applied by the state courts, it operates to discharge every city employee who invokes the Fifth Amendment. In practical effect the questions asked are taken as confessed and made the basis of the discharge. No consideration is given to such factors as the subject matter of the questions, remoteness of the period to which they are directed, or justification for exercise of the privilege. It matters not whether the plea resulted from mistake, inadvertence or legal advice conscientiously given, whether wisely or unwisely. The heavy hand of the statute falls alike on all who exercise their constitutional privilege, the full enjoyment of which every person is entitled to receive. Such action falls squarely within the prohibition of *Wieman v Updegraff, supra.* . . .

Without attacking Professor Slochower's qualification for his position in any manner, and apparently with full knowledge of the testimony he had given some 12 years before at the state committee hearing, the Board

350 U.S., 557–9.

seized upon his claim of privilege before the federal committee and converted it through the use of § 903 into a conclusive presumption of guilt. Since no inference of guilt was possible from the claim before the federal committee, the discharge falls of its own weight as wholly without support. There has not been the "protection of the individual against arbitrary action" which Mr. Justice Cardozo characterized as the very essence of due process. . . .

5
The Smith Act Disabled
June 17, 1957

Dorothy Healey and the other convicted California Communists appealed of course. The case, *Yates v. United States,* came before a different Supreme Court than the one that had adjudicated the Dennis case six years earlier. It now held that the government must provide a much more precise definition of advocacy in trying Communists under the Smith Act. So Yates et al. went free, and the government not only did not try them but dropped charges against all the others it was going to prosecute. In truth, the Smith Act was a dead letter (scant satisfaction to those it sent to jail). Nevertheless, Justice Black's opinion, excerpted below, went further than the rest of the majority in reaffirming the principles he had held from the start.

I would reverse every one of these convictions and direct that all the defendants be acquitted. In my judgment the statutory provisions on which these prosecutions are based abridge freedom of speech, press, and assembly in violation of the First Amendment to the United States Constitution. . . .

The kind of trials conducted here are wholly dissimilar to normal criminal trials. Ordinarily these "Smith Act" trials are prolonged affairs lasting for months. In part this is attributable to the routine introduction in evidence of massive collections of books, tracts, pamphlets, newspapers, and manifestoes discussing communism, socialism, capitalism, feudalism and governmental institutions in general, which, it is not too much to say, are turgid, diffuse, abstruse, and just plain dull. Of course, no juror can or is expected to plow his way through this jungle of verbiage. The testimony of witnesses is comparatively insignificant. Guilt or innocence may turn on what Marx or Engels or someone else wrote or advocated as much as a hundred or more years ago. Elaborate, refined distinctions are drawn between "communism," "Marxism," "Leninism," "Trotskyism," and "Stalinism." When the propriety of obnoxious or unorthodox views about government is in reality made the crucial issue, as it must be in cases of this kind, prejudice makes conviction inevitable except in the rarest circumstances.

Since the Court proceeds on the assumption that the statutory provisions involved are valid, however, I feel free to express my views about the issues it considers. . . .

I agree with the Court insofar as it holds that the trial judge erred in instructing that persons could be punished under the Smith Act for teaching and advocating forceful overthrow as an abstract principle. But on the other hand, I cannot agree that the instruction which the Court indicates it

354 U.S., 339–40, 343–4.

might approve is constitutionally permissible. The Court says that persons can be punished for advocating action to overthrow the Government by force and violence, where those to whom the advocacy is addressed are urged "to *do* something, now or in the future, rather than merely to *believe* in something." Under the Court's approach, defendants could still be convicted simply for agreeing to talk as distinguished from agreeing to act. I believe that the First Amendment forbids Congress to punish people for talking about public affairs, whether or not such discussion incites to action, legal or illegal. As the Virginia Assembly said in 1785, in its "Statute for Religious Liberty," written by Thomas Jefferson, "it is time enough for the rightful purposes of civil government, for its officers to interfere when principles break out into overt acts against peace and good order." . . .

In essence, petitioners were tried upon the charge that they believe in and want to foist upon this country a different and to us a despicable form of authoritarian government in which voices criticizing the existing order are summarily silenced. I fear that the present type of prosecutions are more in line with the philosophy of authoritarian government than with that expressed by our First Amendment.

Doubtlessly, dictators have to stamp out causes and beliefs which they deem subversive to their evil regimes.

But governmental suppression of causes and beliefs seems to me to be the very antithesis of what our Constitution stands for. The choice expressed in the First Amendment in fovor of free expression was made against a turbulent background by men such as Jefferson, Madison, and Mason—men who believed that loyalty to the provisions of this Amendment was the best way to assure a long life for this new nation and its Government. Unless there is complete freedom for expression of all ideas, whether we like them or not, concerning the way government should be run and who shall run it, I doubt if any views in the long run can be secured against the censor. The First Amendment provides the only kind of security system that can preserve a free government—one that leaves the way wide open for people to favor, discuss, advocate, or incite causes and doctrines however obnoxious and antagonistic such views may be to the rest of us.

6

HUAC's Wings Clipped
June 17, 1957

The Court finally got around to taking up the abuse of power by investigative committees in general, HUAC in particular. *Watkins v. United States,* written by Warren, was a groundbreaking decision, curtailing as it did the committee's punitive authority—the threat of contempt, hence jail, it held over the heads of witnesses who refused to talk on Constitutional grounds other than the Fifth Amendment. Congress of course sent up a loud cry of protest against what it regarded as the Court's usurpation, and further demands for the impeachment of Warren could be heard. Two years later a majority of the Court retreated in *Barenblatt v. United States* when it upheld a HUAC contempt citation. But the larger point held fast: From now on Congressional investigative committees would have to obey limits defined by the Court. And in another decision, *Sweezy v. New Hampshire,* it extended those same limits to state investigative committees.

It is unquestionably the duty of all citizens to cooperate with the Congress in its efforts to obtain the facts needed for intelligent legislative action. It is their unremitting obligation to respond to subpoenas, to respect the dignity of the Congress and its committees and to testify fully with respect to matters within the province of proper investigation. This, of course, assumes that the constitutional rights of witnesses will be respected by the Congress as they are in a court of justice.

In the decade following World War II, there appeared a new kind of congressional inquiry unknown in prior periods of American history. Principally this was the result of the various investigations into the threat of subversion of the United States Government, but other subjects of congressional interest also contributed to the changed scene. This new phase of legislative inquiry involved a broad-scale intrusion into the lives and affairs of private citizens. It brought before the courts novel questions of the appropriate limits of congressional inquiry. Prior cases, like *Kilbourn, McGrain* and *Sinclair,* had defined the scope of investigative power in terms of the inherent limitations of the sources of that power. In the more recent cases, the emphasis shifted to problems of accommodation the interest of the Government with the rights and privileges of individuals. The central theme was the application of the Bill of Rights as a restraint upon the assertion of governmental power in this form.

It was during this period that the Fifth Amendment privilege against self-incrimination was frequently invoked and recognized as a legal limit upon the authority of a committee to require that a witness answer its questions. Some early doubts as to the applicability of that privilege before

354 U.S., 187–8, 195–8, 200–2, 205, 207–8, 215–6.

a legislative committee never matured. When the matter reached this Court, the Government did not challenge in any way that the Fifth Amendment protection was available to the witness, and such a challenge could not have prevailed. It confined its argument to the character of the answers sought and to the adequacy of the claim of privilege. . . .

A far more difficult task evolved from the claim by witnesses that the committees' interrogations were infringements upon the freedoms of the First Amendment. Clearly, an investigaton is subject to the command that the Congress shall make no law abridging freedom of speech or press or assembly. While it is true that there is no statute to be reviewed, and that an investigation is not a law, nevertheless an investigation is part of lawmaking. It is justified solely as an adjunct to the legislative process. The First Amendment may by invoked against infringement of the protected freedoms by law or by lawmaking.

Abuses of the investigative process may imperceptibly lead to abridgement of protected freedoms. The mere summoning of a witness and compelling him to testify, against his will, about his beliefs, expressions or associations is a measure of governmental interference. And when those forced revelations concern matters that are unorthodox, unpopular, or even hateful to the general public, the reaction in the life of the witness may be disastrous. This effect is even more harsh when it is past beliefs, expressins or associations that are disclosed and judged by current standards rather than those contemporary with the matters exposed. Nor does the witness alone suffer the consequences. Those who are identified by witnesses and thereby placed in the same glare of publicity are equally subject to public stigma, scorn and obloquy. Beyond that, there is the more subtle and immeasurable effect upon those who tend to adhere to the most orthodox and uncontroversial views and associations in order to avoid a similar fate at some future time. That this impact is partly the result of nongovernmental activity by private persons cannot relieve the investigators of their responsibility for initiating the reaction. . . .

We have no doubt that there is no congressional power to expose for the sake of exposure. The public is, of course, entitled to be informed concerning the workings of its government. That cannot be inflated into a general power to expose where the predominant result can only be an invasion of the private rights of individuals. But a solution to our problem is not to be found in testing the motives of committee members for this purpose. Such is not our function. Their motives alone would not vitiate an investigation which had been instituted by a House of Congress if that assembly's legislative purpose is being served.

. . . It is the responsibility of the Congress, in the first instance, to insure that compulsory process is used only in furtherance of a legislative purpose. That requires that the instructions to an investigating committee spell out that group's jurisdiction and purpose with sufficient particularity. Those instructions are embodied in the authorizing resolution. That document is the committee's charter. Broadly drafted and loosely worded, how-

ever, such resolutions can leave tremendous latitude to the discretion of the investigators. The more vague the committee's charter is, the greater becomes the possibility that the committee's specific actions are not in conformity with the will of the parent House of Congress.

The authorizing resolution of the Un-American Activities Committee was adopted in 1938 when a select committee, under the chairmanship of Representative Dies, was created. Several years later, the Committee was made a standing organ of the House with the same mandate. It defines the Committee's authority as follows:

> Rule XI
> The Committee on Un-American Activities, as a whole or by subcommittee, is authorized to make from time to time investigations of (i) the extent, character, and objects of un-American propaganda activities in the United States, (ii) the diffusion within the United States of subversive and un-American propaganda that is instigated from foreign countries or of a domestic origin and attacks the principle of the form of government as guaranteed by our Constitution, and (iii) all other questions in relation thereto that would aid Congress in any necessary remedial legislation.

It would be difficult to imagine a less explicit authorizing resolution. Who can define the meaning of "un-American"? What is that single, solitary "principle of the form of government as guaranteed by our Constitution"? There is no need to dwell upon the language, however. At one time, perhaps, the resolution might have been read narrowly to confine the Committee to the subject of propaganda. The events that have transpired in the fifteen years before the interrogation of petitioner makes such a construction impossible at this date. . . .

It is, of course, not the function of this Court to prescribe rigid rules for the Congress to follow in drafting resolutions establishing investigating committees. That is a matter peculiarly within the realm of the legislature, and its decisions will be accepted by the courts up to the point where their own duty to enforce the constitutionally protected rights of individuals is affected.

. . . Plainly these committees are restricted to the missions delegated to them, i.e., to acquire certain data to be used by the House or the Senate in coping with a problem that falls within its legislative sphere. No witness can be compelled to make disclosures on matters outside that area. This is a jurisdictional concept of pertinency drawn from the nature of a congressional committee's source of authority. It is not wholly different from nor unrelated to the element of pertinency embodied in the criminal statute under which petitioner was prosecuted. When the definition of jurisdictional pertinency is as uncertain and wavering as in the case of the Un-American Activities Committee, it becomes extremely difficult for the Committee to limit its inquiries to statutory pertinency.

In fulfillment of their obligation under this statute, the courts must accord to the defendants every right which is guaranteed to defendants in all other criminal cases. Among these is the right to have available, through

a sufficiently precise statute, information revealing the standard of criminality before the commission of the alleged offense. Applied to persons prosecuted under § 192, this raises a special problem in that the statute defines the crime as refusal to answer "any question pertinent to the queston under inquiry." Part of the standard of criminality, therefore, is the pertinency of the questions propounded to the witness.

The problem attains proportion when viewed from the standpoint of the witness who appears before a congressional committee. He must decide at the time the questions are propounded whether or not to answer. . . .

. . . The conclusions which we have reached in this case will not prevent the Congress, through its committees, from obtaining any information it needs for the proper fulfillment of its role in our scheme of government. The legislature is free to determine the kinds of data that should be collected. It is only those investigations that are conducted by use of compulsory process that give rise to a need to protect the rights of individuals against illegal encroachment. That protection can be readily achieved through procedures which prevent the separation of power from responsibility and which provide the constitutional requisites of fairness for witnesses. A measure of added care on the part of the House and the Senate in authorizing the use of compulsory process and by their committees in exercising that power would suffice. That is a small price to pay if it serves to uphold the principles of limited, constitutional government without constricting the power of the Congress to inform itself.

7

The Right to Travel Abroad Affirmed
June 16, 1958

With *Kent v. Dulles,* decided by five to four and written by Justice Douglas, the Court at last brought the State Department's Passport Office within the ambit of due process of law. (Rockwell Kent was a prominent artist and book illustrator.) Until then its authority to determine who could travel abroad and who not was arbitrary and absolute.

This case concerns two applications for passports denied by the Secretary of State. One was by Rockwell Kent who desired to visit England and attend a meeting of an organization know as the "World Council of Peace" in Helsinki, Finland. The Director of the Passport Office informed Kent that issuance of a passport precluded by 51.135 of the Regulations promulgated by the Secretary of State on two grounds: (1) that he was a Communist and (2) that he had had "a consistent and prolonged adherence to the Communist Party line." The letter of denial specified in some detail the facts on which those conclusions were based. Kent was also advised of his right to an informal hearing under 51.137 of the Regulations. But he was also told that whether or not a hearing was requested it would be necessary, before a passport would be issued, to submit an affidavit as to whether he was then or ever had been a Communist. Kent did not ask for a hearing but filed a new passport application listing several European countries he desired to visit. When advised that a hearing was still available to him, his attorney replied that Kent took the position that the requirement of an affidavit concerning Communist Party membership "is unlawful and that for that reason and as a matter of conscience," he would not supply one. He did, however, have a hearing at which the principal evidence against him was from his book, *It's Me O Lord,* which Kent agreed was accurate. He again refused to submit the affidavit, maintaining that any matters unrelated to the question of his citizenship were irrelevant to the department's consideration of his application. The Department advised him that no further consideration of his application would be given until he satisfied the requirements of the Regulations.

We deal with beliefs, with associations, with ideological matters. We must remember that we are dealing here with citizens who have neither been accused of crimes nor found guilty. They are being denied their freedom of movement solely because of their refusal to be subjected to inquiry into their beliefs and associations. They do not seek to escape the law nor to violate it. They may or may not be Communists. But assuming they are, the only law which Congress has passed expressly curtailing the movement of Communists across our borders has not yet become effective.

357 U.S., 117–119, 130

It would therefore be strange to infer that pending the effectiveness of the law, the Secretary has been silently granted by Congress the larger, the more pervasive power to curtail in his discretion the free movement of citizens in order to satisfy himself about their beliefs and associations.

To repeat, we deal here with a constitutional right of the citizen, a right which we must assume Congress will be faithful to respect. We would be faced with important constitutional questions were we to hold that Congress by 1185 and 211a had given the Secretary authority to withhold passports to citizens because of their beliefs or associations. Congress has made no such provision in explicit terms; and absent one, the Secretary may not employ that standard to restrict the citizens' right of free movement.

Reversed.

8

Faulk Breaks the Blacklist
1962

Little more need be said about the John Henry Faulk case—his suit against the blacklisters Vincent Hartnett, boss of AWARE Inc., and the Syracuse grocer who backed him. Here is an excerpt from lawyer Louis Nizer's summation to the jury, taken from Faulk's fine book on the subject, *Fear on Trail*.

NIZER: It is a case by John Henry Faulk against these defendants, but certain cases involve extraordinary principles. There are in the history of litigation just a few of these, sometimes only one in a generation, and I stand here with a very deep sense of responsibility because I have upon me the burden of presenting this case to you. . . . For six years we have waited for this day, six years. We have worked during those six years day and night. You see the exhibits, the documents, the unraveling of that which was very difficult to prove in a courtroom under oath; and so we too have been under strain. It has been a great responsibility, which we take very earnestly and you ought to have, I hope, the satisfaction that your work, whatever it be when this case is over, will have significance in the history of litigation nationally and, I think, internationally. . . .

The question is whether we will permit out government to protect us under proper judicial and other procedures, or whether we're going to permit private vigilantes like this gentleman seated here with the thin mouth and the blue suit [pointing at Hartnett], who sneaks into a restaurant, the Blue Ribbon Restaurant, when there is a meeting of some union people, with a hidden microphine in his lapel. That is the question, or are you going to permit private vigilantism for profit? If he was a real patriot and he dug up any evidence, he would have sent it to the F.B.I. like all of us should, against a Communist. . . .

If any citizen has any evidence of any kind and he is really a good-natured and proper and loyal citizen, he sends it to the governmental authorities, not to this gentleman; he charged $20 a throw.

The issue is not Communism at all. It is private vigilantism, and the only time that Mr. Bolan came near to touching the issue in this case is when he told you yesterday all about the Fifth Amendment fellows. He said, "If a fellow takes a Fifth Amendment, haven't we a right, when I want to employ the man, to take it into consideration?" Why, you don't need the Fifth Amendment. I as an individual employer can refuse to hire anybody because I don't like the color of his tie. I can refuse to hire anybody because I don't like his speech, I don't like the way he dresses. That is my privilege

as an American, but that isn't blacklisting. That doesn't mean that I send around a list to all the employers that this man will go to, and they all agree that they can't hire this man. That is what is evil about it. As an individual, cannot the electric company say, "I want to charge twice as much as my competitor?" They're fixing a price. That is legal. But what they can't do is get together willll all their people and fix prices among them. That is a crime under our law, not only an anti-trust violation, it's a crime under the criminal law. . . .

The real issue in this case, ladies and gentlemen, is that there are people who try to take the law into their hands. They try to, because they believe fanatically and in this case there was no fanaticism; it was malice. They didn't think Faulk, even fanatically, was a Communist. They struck at Faulk for another reason with I am going to give you. That is what makes it malicious. But when they struck at other people, they did it fanatically, and if people can take the law into their own hands that way, then the Ku Klux Klan is a good organization. They too, think that government isn't doing enough. Then the Silver Shirt organization, that is Pelly's group, that is a very good group if that's right, because they say, "We are impatient."

You heard Mr. Hartnett testify that is the philosophy of these people. Mr. Hartnett said it's unrealistic to depend on the government. I couldn't believe my ears. He actually said it from the witness stand. . . . And there you had an insight into the evil that we're striking at, private vigilantes taking the law into their own hands. . . .

When you and your neighbor are not safe from somebody who does not like you, and he tips off Mr. Milton or Mr. Johnson and Mr. Hartnett and he can, through these organizations, ruin you and your enterprise and your business by writing a letter behind your back to your employer, and you suddenly find yourself economically strangled, which is what happened to Mr. Faulk (he didn't earn one cent in his profession from 1958, 1959, 1960)—Mr. Bolan forgot all about that—When you are strangled because your neighbor or someone who is fanatical can take these measures against you without recourse, without your facing an accuser, without your showing you are innocent, then you have Communism under the guise of fighting Communism. . . .

That is the kind of action and conspiracy which operates here, and there are bones on these roads, of wonderful artists, men and women in their profession, crushed by this.

And we have had the courage—I say "we"; I mean Mr. John Henry Faulk—You rarely find them. The reason I'm spilling out my heart and feeling in this case is—well, when do you find that kind of American? Everybody rushes to shelter. Why put up the fight? Why should I starve with my children for the industry? I know Americanism is being violated, but why is it my duty to be a martyr?

But this man, from the first moment, said, "I am going to see this thing through if I have to drive a taxi." And, incidentally, he couldn't even do

that. He tried to sell the *Encyclopedia Britannica;* he failed. He went into mutual welfare funds; he failed.

And the thing that touched me most, I must admit to you I had to stop, I am sure you didn't notice, but I cried when he was on the stand and said, "I finally got to the point where I went over, . . . and said, 'Have you got any kind of a job for me in television?' and the fellow said, 'You know, let's be blunt about it. You are controversial. I can't take the chance.'" . . . And the result of that situation is that Faulk asked for a $10 sit-in job and the fellow said, "We haven't got a sit-in," and he can't earn $10 to sit in a chair because these people have crushed him. . . .

11

Afterword

In a sense, McCarthyism had been a smashing success. It had contributed mightily to the demise of the Communist movement and popular front liberalism. The liberalism that survived, or rather prevailed, embraced the Cold War and, in the name of aggressive anti-Communism, sought to promote both New Deal type social reforms and a steadily enlarged military-industrial complex. With John F. Kennedy's election Cold War liberalism came fully into its own, marked by a spirit of optimism and rejuvenation that Americans had not seen since the early days of the Roosevelt administration. But then something gigantic and wholly unanticipated arose that changed the course of history, and incidentally gave McCarthyism a new lease on life.

That "something" was the 1960s, an age of protests that America had never experienced. The protests went beyond the tremendous demonstrations that filled streets, campuses, and other public places. They included startling new lifestyles and modes of behavior, openly expressed and proudly affirmed. Never had sanctified norms and values—the family, private property, the work ethic, gender roles, and sexual practices—been so flouted, especially by middle-class youth. A new political left emerged whose attitude toward authority can be measured by the way its votaries treated the House Un-American Activities Committee, or rather mistreated it, making it a laughingstock and an object of ridicule. Thereafter, no one could take it or the other investigative committees seriously, and in a few years they all closed up shop. The old left, Communists and non-Communists alike, were by comparison straitlaced and proper and models of conformity.

The 1960s also saw the recrudescence of McCarthyism, but it was a McCarthyism very different from the one that had flowered during the great American red scare. No longer could the reds be conjured up and blamed for what was happening, because what was happening had little to do with them or spies or traitors; the reds had been vanquished for good. But neither could powerful Cold War institutions stand by and watch America succumb to barbarians who were challenging the prosectuion of the Vietnam War and indeed the government's foreign policy in general. The head of one powerful institution, J. Edgar Hoover, was particularly upset to see the America he idealized—nineteenth century, small town, safely homogeneous—turn into a charnel house of depravity. But what could they do, the FBI and the rest of the intelligence bureaucracies, the CIA, the NSA, and the Army, plus the local red squads, now that the Supreme Court threw so many constitutional roadblocks in their path, meaning that nothing they did that was not legally permissible could be allowed as evidence in any legal proceeding? Not that these institutions could be forbidden from carrying on covertly, surreptitiously, for their own purposes. And so they did. They conducted surveillances and kept dossiers on the defiant new radicals (and reopened those still defiant old ones), read their mail, overheard their calls, etc. The chief culprit in this was the National Security Agency, with its incredible array of supertechnical equipment for listening to and decoding Soviet messages around the world. The CIA, drawing on its enormous resources, interpreted its national security mandate broadly enough to include domestic groups; the public had no idea it was spying on Americans. As for local red squads, they returned to the fray, collecting fresh quantitites of data for future reference. And the FBI, hampered by a multitude of legal restraints, embarked on a course that was egregious even by its standards: not only unauthorized wiretaps but "black bag" operations—breaking and entering—against suspected radical groups and, most notoriously, its counterintelligence programs (COINTELPRO), which provoked dissension and retribution within and between those groups and harassed individuals without mercy, occasionally unto death. Not until these tawdry activities were exposed, those we know of, did J. Edgar Hoover stop them.

Such clandestine and outlaw forms of McCarthyism, however, lacked the bite of old; they were furtive, defensive, and unsupported by public opinion; there was no red scare to buttress them. Only right-wing fanatics, joined by Hoover, saw a connection between the young insurgents of the 1960s and international Communism. Their rebelliousness petered out for reasons mainly of its own and not because of anything the FBI, the CIA, the NSA, etc. had done.

McCarthyism drew its final gasp inside the Nixon administration, more precisely inside the Nixon White House. Hamstrung by court decisions and a populace distrustful of government, and goaded by the paranoia that had always informed his political life, President Nixon established a band of operatives out of his Oval Office whose task was to watch and

confound and trick his enemies, most of them Cold War liberals (the left being of no serious account) of the Kennedy stamp, and punish them if possible by turning various executive agencies against them, the Internal Revenue Service, for example. As if this were insufficient, Nixon tried to bring the major intelligence divisions—the FBI, the CIA, the Defense Intelligence Agency, etc.—under his roof; this was the so-called Huston Plan, named for the assistant who drew it up. The Huston Plan collapsed because Hoover would have none of it; he was not about to surrender the turf he had spent forty-four years cultivating and expanding. It was one of his last deeds, this inadvertent defense of civil liberties, this rich piece of irony.

The world learned about the Nixon White House as a result of the Watergate revelations and trials that led to his resignation and disgrace. He was among the few in his immediate entourage to escape jail. And thanks to the post-Watergate Congress (1975–77), specifically the committee headed by Idaho Senator Frank Church, we know something of how the intelligence agencies broke the law during the previous decade. Congress also passed the Freedom of Information Act, opening up many files for public scrutiny and allowing individuals to get a glimpse, hardly more, of their dossiers.

Scarcely more needs to be said. The struggle on behalf of civil liberties is endless, but this book is not about that struggle. It is about one astounding moment in its history, which officially came to a close with the end of the Cold War and the disappearance of the Soviet Union. One can detect the possibility of recurrent McCarthyism in this popular outcry or that—against the drug trade, against repeat criminals, against terrorists, etc.—but they have amounted to little. McCarthyism is a thing of the past, it is over and done with, though what it means, what legacy it has left posterity, how it has affected American democracy, will never cease to be debated.

1
COINTELPRO in the Flesh
July 17, 1968

Thanks to the Church committee's revelations we have a prime example, from J. Edgar Hoover himself, of the dirty tricks conducted by the FBI's counterintelligence program (COINTELPRO). This one was directed against New Left and campus troublemakers in general.

. . . [It] is felt that the following suggestions for counterintelligence action can be utilized by all offices:

1. Preparation of a leaflet designed to counteract that Students for a Democratic Society (SDS) and other minority groups speak for the majority of students at universities. The leaflet should contain photographs of New Left leadership at the respective universities. Naturally, the most obnoxious pictures should be used.

2. The instigating of or the taking advantage of personal conflicts or animosities existing between New Left leaders.

3. The creating of impressions that certain New Left leaders are informants for the Bureau or other law enforcement agencies.

4. The use of articles from student newspapers and/or the underground press to show the depravity of New Left leaders and members. In this connection, articles showing advocation of the use of narcotics and free sex are ideal to send to university officials, wealthy donors, members of the legislature and parents of students who are active in New Left matters.

5. Since the use of marijuana and other narcotics is widespread among members of the New Left, you should be alert to opportunities to have them arrested by local police authorities on drug charges. . . .

6. The drawing up of anonymous letters regarding individuals active in the New Left. These letters should set out their activities and should be sent to their parents, neighbors and the parents' employers. This could have the effect of forcing the parents to take action.

7. Anonymous letters and leaflets describing faculty members and graduate assistants in the various institutions of learning who are active in New Left matters. The activities and associations of the individual should be set out. Anonymous mailings should be made to university officials, members of the state legislature, Board of Regents, and to the press. Such letters should be signed "A Concerned Alumni" or "A Concerned Taxpayer." . . .

United States Senate, 94th Congress, 1st Session, Select Committee to Study Governmental Operations with Respect to Intelligence Activities, *Hearings,* vol. 6, 395.

11. Consider the use of cartoons, photographs, and anonymous letters, which will have the effect of ridiculing the New Left. Ridicule is one of the most potent weapons which we can use against it.

12. Be alert for opportunities to confuse and disrupt New Left activities by misinformation. For example, when events are planned, notification that the event has been cancelled or postponed could be sent to various individuals.

You are reminded that no counterintelligence action is to be taken without Bureau approval. Insure that this program is assigned to an Agent with an excellent knowledge of both New Left group and individuals. It must be approached with imagination and enthusiasm if it is to be successful.

2

Breaking and Entering
September 23, 1975

> Below is the FBI's admission of "black bag" operations over the years
> in response to the Church committee's demand for such data in 1975.
> Of special interest are the instances of surreptitious entry in the period
> after World War II and as late as April 1968.

With respect to this request, from 1942 to April, 1968, surreptitious
entry was utilized by the FBI on a highly selective basis in the conduct of
certain investigations. Available records and recollection of Special Agents
at FBI Headquarters (FBIHQ), who have knowledge of such activities,
identify the targets of surreptitious entries as domestic subversive and
white hate groups. Surreptitious entry was used to obtain secret and
closely guarded organizational and financial information, and membership
lists and monthly reports of target organizations.

When a Special Agent in Charge (SAC) of a field office considered
surreptitious entry necessary to the conduct of an investigation, he would
make his request to the appropriate Assistant Director at FBIHQ, justify-
ing the need for an entry and assuring it could be accomplished safely with
full security. In accordance with instructions of Director J. Edgar Hoover,
a memorandum outlining the facts of the request was prepared for ap-
proval of Mr. Hoover, or Mr. Tolson, the Associate Director. Subse-
quently, the memorandun was filed in the Assistant Director's office under
a "Do Not File" procedure, and thereafter destroyed. In the field office, the
SAC maintained a record of approval as a control device in his office safe.
At the next yearly field office inspection, a review of these records would be
made by the Inspector to insure that the SAC was not acting without prior
FBIHQ approval in conducting surreptitious entries. Upon completion of
this review, these records were destroyed.

There is no central index, file, or document listing surreptitious entries
conducted against domestic targets. To reconstruct these activities, it is
necessary to rely upon recollections of Special Agents who have knowledge
of such activities, and review of those files identified by recollection as
being targets of surreptitious entries. Since policies and procedures fol-
lowed in reporting of information resulting from a surreptitious entry were
designed to conceal the activity from persons not having a need to know,
information contained in FBI files relating to entries is in most instances
incomplete and difficult to identify.

Reconstruction of instances of surreptitious entry through review of
files and recollections of Special Agent personnel at FBIHQ who have

United States Senate, 94th Congress, 1st Session, Select Committee to Study Govern-
mental Operations with Respect to Intelligence Activities, *Hearing,* vol. 6, 387.

knowledge of such activities, show the following categories of targets and the approximate number of entries conducted against each:

At least fourteen domestic subversive targets were the subject of at least 238 entries from 1942 to April, 1968. In addition, at least three domestic subversive targets were the subject of numerous entries from October, 1952, to June, 1966. Since there exists no precise record of entries, we are unable to retrieve an accurate accounting of their number.

3

Tom Huston's Try
Early July 1970

Huston was a young lawyer who worked in the Nixon White House under Chief of Staff Bob Haldeman. He had the task of drawing up a proposal to bring the intelligence agencies under close presidential coordination and supervision and to suggest ways of improving and expanding intelligence activities, legal and illegal, particularly against New Left and campus activists. By July 14th Nixon had officially approved the final version of the "Huston Plan," which follows the recommendations laid out in the draft below. Interesting to note is that Huston regarded Hoover as his chief obstacle. This was prescient, for it was Hoover who eventually killed the plan.

OPERATIONAL RESTRAINTS ON INTELLIGENCE COLLECTION

A. Interpretive Restraints on Communications Intelligence

Recommendation
Present interpretation should be broadened to permit and program for coverage by NSA [National Security Agency] of the communications of U.S. citizens using international facilities.

Rationale
The FBI does not have the capability to monitor international communications. NSA is currently doing so on a restricted basis, and the information it has provided has been most helpful. Much of this information is particularly useful to the White House and it would be to our disadvantage to allow the FBI to determine what NSA should do in this area without regard to our own requirements. No appreciable risk is involved in this course of action.

B. Electronic Surveillances and Penetrations

Recommendation
Present procedures should be changed to permit intensification of coverage of individuals and groups in the United States who pose a major threat to internal security. . . .

United States Senate, 94th Congress, 1st Session, Select Committee to Study Governmental Operations with Respect to Intelligence Activities, *Hearings,* vol. 2, 193–7.

Rationale

At the present time, less than 65 electronic penetrations are operative. This includes coverage of the CPUSA [Communist Party of the United States of America] and organized crime targets. . . . Mr. Hoover's statement that the FBI would not oppose other agencies seeking approval for and operating electronic surveillance is gratuitous since no other ageincies have the capability.

Everyone knowledgeable in the field, with the exception of Mr. Hoover, concurs that the existing coverage is inadequate. CIA and NSA note that this is particularly true of diplomatic establishments, and we have learned at the White House that it is also true of New Left groups.

C. Mail Coverage

Recommendation

Restrictions on legal coverage should be removed. ALSO, present restrictions on covert coverage should be relaxed on selected targets. . . .

Rationale

There is no valid argument against use of legal mail covers except Mr. Hoover's concern that the civil liberties people may become upset. This risk is surely an acceptable one and hardly serious enough to justify denying ourselves a valuable and legal intelligence tool. Covert coverage is illegal and there are serious risks involved. However, the advantages to be derived from its use outweigh the risks. . . .

D. Surreptitious Entry

Recommendation

Present restrictions should be modified to permit procurement of vitally needed foreign cryptographic material. ALSO, present restrictions should be modified to permit selective use of this technique against other urgent and high priority internal security targets.

Rationale

Use of this technique is clearly illegal: it amounts to burglary. It is also highly risky and could result in great embarrassment if exposed. However, it is also the most fruitful tool and can produce the type of intelligence which cannot be obtained in any other fashion. The FBI, in Mr. Hoover's younger days, used to conduct such operations with great success and with no exposure. The information secured was invaluable. . . . Surreptitious entry of facilities occupied by subversive elements can turn up information about identities, methods of operation and other invaluable investigative information which is not otherwise obtainable. This technique would be particularly helpful if used against the Weathermen and Black Panthers. . . .

E. Development of Campus Sources

Recommendation

Present restrictions should be relaxed to permit expanded coverage of violence-prone campus and student-related groups. ALSO, CIA coverage of American students (and others) traveling or living abroad should be increased.

The FBI does not currently recruit any campus sources among individuals below 21 years of age. This dramatically reduces the pool from which sources may be drawn. Mr. Hoover is afraid of a young student surfacing in the press as an FBI source, although the reaction in the past to such events has been minimal. After all, everyone assumes the FBI has such sources.

The campus is the battleground of the revolutionary protest movement. It is impossible to gather effective intelligence about the movement unless we have campus sources. The risk of exposure is minimal, and where exposure occurs the adverse publicity is moderate and short-lived. It is a price we must be willing to pay for effective coverage of the campus scene. The intelligence community, with the exception of Mr. Hoover, feels strongly that it is imperative that we increase the number of campus sources this fall in order to forestall widespread violence. . . .

MEASURES TO IMPROVE DOMESTIC INTELLIGENCE OPERATIONS

Recommendation

A permanent committee consisting of the FBI, CIA, NSA, DIA [Defense Intelligence Agency], and the military counterintelligence agencies should be appointed to provide evaluations of domestic intelligence, prepare periodic domestic intelligence estimates, and carry out the other objectives specified in the report.

Rationale

The need for increased coordination, joint estimates, and responsiveness to the White House is obvious to the intelligence community. There are a number of operational problems which need to be worked out, since Mr. Hoover is fearful of any mechanism which might jeopardize his autonomy. CIA would prefer an ad hoc committee to see how the system works, but other members believe that this would merely delay the establishment of effective coordination and joint operations. The value of lifting intelligence collection restraints is proportional to the availability of joint operations. . . .

4

J. Edgar Hoover Still Sees Red
June 1971

The rebelliousness of the 1960s was petering out, but Hoover was as wary of the reds as ever, as he demonstrated in a fantastic article, "Mao's Red Shadows in America," for the *VFW* [Veterans of Foreign Wars] *Magazine*.

Mao Tse-tung, the Red Chinese dictator, is some 6,000 miles from the United States. But the shadows of pro-Peking subversion are daily becoming a more serious problem in this country. . . .

Red Chinese intelligence in the United States, as compared with Soviet Russia's, has a major handicap in that Peking is not recognized diplomatically by this country nor is it a member of the United Nations. This deprives the Red Chinese of a legal base from which to operate spies. A high percentage of Soviet espionage, for example, is carried out by Soviet diplomats assigned to either the Soviet embassy in Washington or the USSR's Mission to the United Nations in New York.

Peking is attempting espionage in a variety of ways, one is to endeavor to introduce deep cover intelligence agents into the United States, trained Peking agents who clandestinely enter this country using false identities and identifications and attempt under the cover of being an American to conduct spy operations.

Third countries are used as bases of attack against the United States. The New China News Agency, an agency of Communist China, has an office in Canada. Though claiming to be a legitimate news-gathering organization, it is obvious that the New China News Agency serves as Red China's chief propaganda outlet abroad and has the potential of supplying Peking with intelligence of all types.

Penetration of Chinese ethnic groups in the United States is also tried. The overwhelming majority of Chinese Americans are loyal to this country, and only a very small percentage are sympathetic to Peking. Yet, Mao leaders constantly seek to identify those Chinese Americans who might help them, especially among the younger elements who might have a sentimental pride in the so-called "accomplishments" of Mao in the ancestral homeland.

Recruiting of agents among indigenous pro-Maoist American groups, such as the Progressive Labor Party, Worker-Student Alliance and the Revolutionary Union, is yet another method. The indoctrination of members of these groups in Mao ideology makes them prime candidates for the carrying out of Red Chinese espionage assignments.

Spy couriers are developed. They are individuals who travel between the United States and other countries and can engage in spy activities. This

United States Congress, 92d Congress, 1st Session, *Congressional Record*, 5573.

also includes the development of mail drops in third countries whereby spy data can be transmitted.

We must be alert constantly to the possibility that, following an established espionage pattern, we may find the Red Chinese attempting to introduce "sleeper agents" into the United States among the thousands of Chinese refugees who immigrate annually. The same observation applies to hundreds of Hong Kong-based merchant seamen who desert in American ports, some of whom vanish into the American mainstream.

The shadow of Mao Tse-tung can be seen and felt in the United States today. We can expect the subversive danger to grow as time passes. The only way to meet it is to be prepared. This the FBI is doing through its investigations and the training of its personnel. For example, we are giving instruction to FBI agents in the various Chinese dialects. In this way, our agents are capable of conversing in the native tongue, and the FBI will be able to handle present and likely future contingencies. . . .

Bibliographical Essay

I see no need to replicate the excellent bibliographies on McCarthyism that scholars have provided in recent years. Three may be strongly recommended not only as sources for further inquiry, but as brief historiographical guides: Ellen Schrecker, *The Age of McCarthyism* (Boston: Bedford Books, 1994); Richard M. Fried, *Nightmare in Red* (New York: Oxford University Press, 1990); and the introduction to the second edition of Robert Griffith, *The Politics of Fear* (Amherst: University of Massachusetts Press, 1987). Instead, I will concentrate on the works that bear directly on the matters discussed and documented throughout this book, or that I would suggest as worth reading for their own sake. McCarthyism, as we have seen, cuts a broad swath through American history.

1 INTRODUCTION: DEFINITIONS, A PRÉCIS

The literature on America's aversion toward radicals, Communists in particular— McCarthyism having been its latest and most extreme form—is a good place to begin. For a sweeping cultural overview, see Michael J. Heale, *American Anticommunism: Controlling the Enemy Within, 1830–1970* (Baltimore: Johns Hopkins University Press, 1990). Sweeping too, but more sharply honed with its psychoanalytic emphasis, is Joel Kovel, *Red Hunting in the Promised Land: Anticommunism in the Making of America* (New York: Basic Books, 1994). Not to be overlooked is David Brion Davis's survey: *The Fear of Conspiracy* (Ithaca, N.Y.: Cornell University Press, 1971). Along similar lines, but with its focus on politics and law, is Robert J. Goldstein's excellent *Political Repression in Modern America* (Cambridge, Mass.: Schenkman Books, 1978). Still serviceable is William Preston, *Aliens and Dissenters* (Cambridge, Mass.: Harvard University Press, 1963).

As for the red scare, properly so called, there is always the classic account: Robert Murray, *Red Scare* (Minneapolis: University of Minnesota Press, 1955), to which should be added: Stanley Coben, "A Study in Nativism: The American Red Scare of 1919–1920," *Political Science Quarterly* 79 (March 1964), 52–75.

McCarthyism is unintelligible without a grasp of American foreign policy just before and during the Cold War. The number of books on foreign policy, even of a general sort, being prodigious beyond measure, I would recommend one out of the many that are first-rate for its readability and for the attention it pays to domestic affairs: Stephen E. Ambrose, *Rise to Globalism* (New York: Penguin Books, 1993).

There are precious few studies of McCarthyism in its totality, as a central feature of American life before and during its heyday and indeed down to the present. In Ellen Schrecker's book, cited previously, we have a quick documentary run-through, which gives too much of its very limited space to the travails of the Communist Party and to the Rosenberg and Hiss cases, important as these were. Richard M. Fried's history, cited previously, is a fine piece of scholarship that touches most of the bases; if only it probed some of the questions it took up more deeply than it did. And then

there is David Caute's massive compendium of horrors, *The Great Fear* (New York: Simon and Schuster, 1978), which, within its chronological limits—the period embracing the Truman and Eisenhower administrations—is indispensable, inaccuracies and all, with a dry, ironic style perfectly suited to its content. An entertaining glance, one full of interesting vignettes, of how McCarthyism affected American culture is Stephen J. Whitfield, *The Culture of the Cold War* (Baltimore: Johns Hopkins University Press, 1991). On the extent to which the legal and administrative systems succumbed to McCarthyism, Stanley I. Kutler, *The American Inquisition* (New York: Hill and Wang, 1982) is a must. For a shrewd political analysis of McCarthyism see Nelson Polsby, "Toward an Explanation of McCarthyism," *Political Studies* 13 (October 1960), 250–271. For an entirely different kind of analysis one should go to a back issue (June 7, 1958, 555–6) of the *National Review* for an article by Frank S. Meyer, "Principles and Heresies: The Meaning of McCarthyism." An up-to-date, but less well-argued, version of the Meyer thesis is Peter Collier and David Horowitz, "McCarthyism: The Last Refuge of the Left," *Commentary* 85 (January 1988), 36–41.

2 INTIMATIONS OF THINGS TO COME

The American Communist Party, its vicissitudes and successes, from its founding in 1919 through World War II has been well served: on the 1920s by Theodore Draper, *The Roots of American Communism* (New York: Viking Books, 1957) and his *American Communism and Soviet Russia* (New York: Viking Books, 1960); on the 1930s by Harvey Klehr, *The Heyday of American Communism* (New York: Basic Books, 1984), and Fraser M. Ottanelli, *The Communist Party of the United States* (New Brunswick, N.J.: Rutgers University Press, 1991); and on the war years by Maurice Isserman, *Which Side Were You On?* (Middletown, Conn.: Wesleyan University Press, 1982).

On the Dies and early House Un-American Activities Committee see Telford Taylor, *Grand Inquest* (New York: Simon and Schuster, 1955); Frank J. Donner, *The Un-Americans* (New York: Ballantine Books, 1961); and Michael Wreszin, "The Dies Committee," Arthur M. Schlesinger, Jr., and Roger Bruns, eds., *Congress Investigates, 1792–1974* (New York: Chelsea House, 1975).

J. Edgar Hoover's obsessive anti-Communism, his straining at the bit to get the reds even before the war ended, is abundantly detailed in two muckraking works: Athan G. Theoharis and John Stuart Cox, *J. Edgar Hoover and the Great American Inquisition* (Philadelphia: Temple University Press, 1988), and Kenneth O'Reilly, *Hoover and the Un-Americans* (Philadelphia: Temple University Press, 1983). The Justice Department's insistence on maintaining electronic surveillance of the ideologically suspect is amply brought out in Frank J. Donner, *The Age of Surveillance* (New York: Alfred A. Knopf, 1981).

Finally, on Jack B. Tenney and his committee see Michael J. Heale, "Red Scare Politics: California's Campaign Against Un-American Activities, 1940–1970," *Journal of American Studies* 20 (1986), and Edward Barrett, *The Tenney Committee* (Ithaca, N.Y.: Cornell University Press, 1951).

3 McCARTHYISM IN EARNEST

The fact that the Cold War and McCarthyism arose together soon after Truman became president has produced an enormous literature, thanks mostly to revisionist

historians. Biographies of Truman tend to give him the benefit of the doubt. A good example is the recent and highly praised one by a talented writer, David McCullough, *Truman* (New York: Simon and Schuster, 1992). A number of harsh criticisms of Truman deserve mention: Richard M. Freeland, *The Truman Doctrine and the Origins of McCarthyism* (New York: Knopf, 1972); Athan G. Theoharis, *Seeds of Repression* (Chicago: Quadrangle Books, 1971); and Theoharis and Robert Griffith, eds., *The Specter* (New York: Franklin Watts, 1974), especially Peter Irons's essay, "American Business and the Origins of McCarthyism." More indulgent toward Truman are two solid studies: Alonzo Hamby, *Beyond the New Deal: Harry S. Truman and American Liberalism* (New York: Columbia University Press, 1973), and Alan D. Harper, *The Politics of Loyalty* (Westport, Conn.: Greenwood Press, 1969). And on Truman's background and position in the Democratic Party see Richard Lawrence Miller, *Truman: The Rise to Power* (New York: McGraw-Hill, 1983).

Truman's loyalty review program has received a good deal of attention almost from the time it began. Along with the pioneer work that Adam Yarmolinsky did, *Case Studies in Personnel Security* (Washington, D.C.: Bureau of National Affairs, 1955), to which we owe one of our documents, there are: Eleanor Bontecou, *The Federal Loyalty-Security Program* (Ithaca, N.Y.: Cornell University Press, 1953); Ralph S. Brown, Jr., *Loyalty and Security* (New Haven, Conn.: Yale University Press, 1958); and Alan Harper's study, cited above, which examines the politics associated with the program. And still fresh are Alan Barth's essays of the early 1950s in defense of civil liberties, *The Loyalty of Free Men* (New York: Viking, 1952).

David Caute's *The Great Fear* is the best place to find a discussion of the McCarthyite aspects of the Taft-Hartley Act.

The Hollywood Ten and the ideological conflicts within the movie industry in general have not lacked scholarly attention either. One source, of course, are the works on HUAC cited above, plus the HUAC hearings that Eric Bentley gathered for his monumental *Thirty Years of Treason* (New York: Viking, 1971). A second is the relevant portions of Caute. And a third consists of two fine books: Victor S. Navasky, *Naming Names* (New York: Viking, 1980) and Larry Ceplair and Steven Englund, *The Inquisition in Hollywood* (Garden City, N.Y.: Anchor Books, 1980).

On few subjects have revisionist historians been more unsparing in their criticisms of the Truman administration than over its trial of the leading American Communists. Two books cover the ground exhaustively: Michael Belknap, *Cold War Political Justice* (Westport, Conn.: Greenwood, 1977), and Peter Steinberg, *The Great "Red Menace"* (Westport, Conn.: Greenwood, 1984).

The contretemps between Truman and Wallace, between Cold War and popular front liberalism, has called forth a spate of books that deserve notice, among them: Mary Sperling McAuliffe, *Crisis on the Left* (Amherst: University of Massachusetts Press, 1978); Norman Markowitz, *The Rise and Fall of the People's Century* (New York: Free Press, 1973); Richard J. Walton, *Henry Wallace, Harry Truman and the Cold War* (New York: Viking, 1976); Alan Yarnell, *Democrats and Progressives* (Berkeley: University of California Press, 1974); and Steven M. Gillam, *Politics and Vision* (New York: Oxford University Press, 1987).

4 LIBERAL RESPONSE AND COUNTERRESPONSE

For a reprise of the hostility between old enemies—anti-Communist and popular front liberals—see the last paragraph in the bibliography for chapter three, to

which may be added the view from the Cold War liberal side of the divide: William L. O'Neill, *A Better World* (New York: Knopf, 1982). Two acute analyses of Schlesinger's place in the history of the era are James A. Neuchterlein, "Arthur M. Schlesinger Jr. and the Discontents of Postwar American Liberalism," *Review of Politics* 39 (1977), and Michael Wreszin, "Arthur M. Schlesinger Jr., Scholar-Activist in Cold War America: 1946–1956," *Salmagundi* 63–64 (Spring–Summer, 1984). An eye-opening study, the thesis of which is implied in the title, is William Keller, *The Liberals and J. Edgar Hoover* (Princeton: Princeton University Press, 1989).

The struggle between anti-Communist and popular front liberals was played out among black Americans as well. On this in general see Manning Marable, *Race, Reform and Rebellion* (Jackson: University of Mississippi Press, 1984). Gerald Horne, *Communist Front? The Civil Rights Congress, 1946–1956* (Rutherford, N.J.: Farleigh Dickinson University Press, 1988) deals with a part of that struggle. So does Martin Bauml Duberman's biography of one of the poignant victims of McCarthyism: *Paul Robeson* (New York: Knopf, 1988).

The expulsion of Communist-led unions from the CIO is another subject that revisionist scholars keep revisiting. Their views contrast sharply with the book that dominated the subject for so long: Max M. Kampelman, *The Communist Party vs. the C.I.O.* (New York: Praeger, 1957). On the other hand, see Ronald Schatz, *The Electrical Workers* (Urbana: University of Illinois Press, 1983); the essays in Steve Russwurm, ed., *The CIO's Left-led Unions* (New Brunswick, N.J.: Rutgers University Press, 1992); Roger Keeran's exemplary study, *The Communist Party and the Auto Workers Union* (Bloomington: University of Indiana Press, 1980); and Harvey A. Levenstein, *Communism, Anticommunism and the CIO* (Westport, Conn.: Greenwood, 1981).

5 McCARTHY THE MAN; McCARTHYISM TRIUMPHANT

The Hiss case, or affair, has not ceased to generate passionate controversy. In support of the government side Allen Weinstein, *Perjury* (New York: Knopf, 1978) may have written the last word. No comparably good book supports Hiss's argument (for which see, for example, Hiss's own account: *In the Court of Public Opinion* [New York: Knopf, 1957]). But we do have strong criticisms of Weinstein in the essays that Athan G. Theoharis brought together: *Beyond the Hiss Case* (Philadelphia: Temple University Press, 1982), particularly those by Kenneth O'Reilly, "Liberal Values, the Cold War, and American Intellectuals," and Theoharis, "Unanswered Questions: Chambers, Nixon, the FBI and the Hiss Case." For a vivid sense of what the trial meant at the time it was held Alistair Cooke, *A Generation on Trial* (New York: Knopf, 1950) is still a splendid read.

On McCarthy the man, two heavy-duty biographies may be recommended; they certainly tell us what we need to know about him: Thomas C. Reeves, *The Life and Times of Joe McCarthy* (New York: Stein and Day, 1982), and David M. Oshinsky, *A Conspiracy So Immense* (New York: Free Press, 1983). There are also numerous specialized studies of his career—on his momentous Senate years: Robert Griffith, *The Politics of Fear* (Amherst: University of Massachusetts Press, 1987), and Richard Fried, *Men Against McCarthy* (New York: Columbia University Press, 1976); on his connection to the larger political and ideological forces that predated his emergence and shaped the issues he exploited: Michael Paul Rogin, *The Intellec-*

tuals and McCarthy (Cambridge, Mass.: MIT Press, 1967), George Nash, The Conservative Intellectual Movement in America Since 1945 (New York: Basic Book, 1976), Michael Miles, The Odyssey of the American Right (New York: Oxford University Press, 1980), and John P. Diggins, Up from Communism (New York: Columbia University Press, 1993); and on his relations with the press: Edwin R. Bayley, Joe McCarthy and the Press (Madison: University of Wisconsin Press, 1981), the pertinent sections in David Halberstam, The Powers That Be (New York: Knopf, 1979), and, drawing the big picture, James Aronson, The Press and the Cold War (Indianapolis: Bobbs-Merrill, 1970).

In defense of McCarthy there is the standard hagiographies: William F. Buckley, Jr., and L. Brent Bozell, McCarthy and His Enemies (Chicago: Henry R. Regnery, 1954), and, better yet, James Burnham, The Web of Subversion (New York: John Day and Co., 1954).

McCarthy's sidekick and anti-Communist warrior in his own right, Roy Cohn, needs a scholarly biographer. What we have are two journalistic assays: Sidney Zion, The Autobiography of Roy Cohn (Secaucus, N.J.: Lyle Stuart, 1988), and Nicholas von Hoffman, Citizen Cohn (New York: Doubleday, 1988).

McCarthy's war on the State Department is amply covered. Owen Lattimore is vindicated in a massive biography by Robert Newman, Owen Lattimore and the "Loss" of China (Berkeley: University of California Press, 1992). Quite good is Gary May's book on John Carter Vincent: China Scapegoat (Washington, D.C.: New Republic Books, 1979). For a general survey see E. J. Kahn, Jr., The China Hands (New York: Viking, 1975).

A detailed inquiry into the McCarran Act would be a contribution. We must settle for useful bits and pieces, to be found in Fried, Men Against McCarthy, cited above, William Tanner and Robert Griffith, "Legislative Politics and McCarthyism: The Internal Security Act of 1950," The Specter, cited above, and Richard Longaker, "Emergency Detention: the Generation Gap, 1950–1971," Western Political Quarterly 27 (September 1974), 395–408.

6 JUDICIAL ACQUIESCENCE

Another book would be very much in order on the courts' failure to sufficiently defend civil liberties from McCarthyism, its state and local as well as federal manifestations. We have a more than adequate literature from the legal side, in textbooks that take up specific cases. One of the better ones is Norman Dorsen, Paul Bendix, and Burt Neuborne, Emerson, Haber and Dorsen's Political and Civil Rights in the United States, 2 vols. (Boston: Little, Brown and Co., 1976–79). Still indispensable is C. Herman Pritchett, Civil Liberties in the Vincent Court (Chicago: University of Chicago Press, 1954). On Black and Douglas see Howard Ball, Of Power and Light (New York: Oxford University Press, 1992). The two dissenters can also be approached through their biographers, e.g.: Gerald T. Dunne, Hugo Black and the Judicial Revolution (New York: Simon and Schuster, 1977), and James F. Simon, Independent Journey (New York: Harper and Row, 1980).

7 INQUISITION TRIUMPHANT

America's obsession with loyalty reviews, oaths, affidavits, etc., and the tribunals set up to enforce them has been a boon to scholars. Some of their works on the federal loyalty program have already been cited, and the interested reader is again advised

to consult the Caute and Kutler volumes. So far as the states and localities are concerned, there is the valuable old standby (dated to be sure): Walter Gellhorn, ed., *The States and Subversion* (Ithaca, N.Y.: Cornell University Press, 1952). Three others of more recent vintage are first-rate: David P. Gardner, *The California Oath Crisis* (Berkeley: University of California Press, 1967); Don E. Carleton, *Red Scare! Right-Wing Hysteria, Fifties Fanaticisms and Their Legacy in Texas* (Austin: Texas Monthly Press, 1985); and James Truett Selcraig, *The Red Scare in the Middle West, 1945–1951* (Ann Arbor: University of Michigan Press, 1982).

As for anti-Communist "experts" of the *Counterattack* and AWARE ilk—a study of them and what they wrought is also in order. Nor is there much on the use of professional witnesses, though here too Caute is informative. Hebert L. Packer, *Ex-Communist Witnesses* (Palo Alto: Stanford University Press, 1962) needs to be updated. As we already know, Harvey Matusow, *False Witness* (New York: Cameron and Kahn, 1955) is a primary source. So for that matter is Herbert Phillbrick, *I Led Three Lives* (New York: McGraw-Hill, 1952)—Phillbrick parlayed his "expertise" into a career that was as brief as it was lucrative—and Elizabeth Bentley, *Out of Bondage* (New York: Devin-Adair, 1951).

On the great purge—the witch-hunting and blacklisting and public humiliations in general—there are, along with the Navasky, Ceplair, and Englund and Caute books cited above, the dated classic by John Cogley, *Report on Blacklisting*, 2 vols. (New York: Fund for the Republic, 1956); and, more recently, Stephen Kanfer, *A Journal of the Plague Years* (New York: Atheneum, 1973); and Robert Vaughn, *Only Victims* (New York: Putnam, 1972). Also see J. Fred MacDonald, *Television and the Red Menace* (New York: Praeger, 1988). Philip M. Stern, *The Oppenheimer Case* (New York: Harper and Row, 1969) is fine but could use a new edition. We have a better idea of what happened on campuses, thanks to a host of studies: David Holmes, *Stalking the Academic Communist* (Hanover: University Press of New England, 1989); Charles H. McCormick, *This Nest of Vipers* (Urbana: University of Illinois Press, 1989); Sigmund Diamond, *Compromised Campus* (New York: Oxford University Press, 1992); and, above all, Ellen Schrecker, *No Ivory Tower* (New York, Oxford University Press, 1986).

On group or constituency support for McCarthyism in its heyday there are, in addition to the biographies of McCarthy mentioned in the bibliography for chapter five, Donald Crosby's work on Catholic support for McCarthyism: "The Politics of Religion," *The Specter,* and *God, Church and Flag* (Chapel Hill: University of North Carolina Press, 1978); also Vincent P. DeSantis's tantalizingly brief, "American Catholicism and McCarthyism," *Catholic Historical Review* 51 (1965), 1–30, and Douglas P. Seaton, et al., *Catholics and Radicals: The Association of Catholic Trade Unionists and the American Labor Movement* (Lewisburg, Pa: Bucknell University Press, 1981). Peter Irons's essay, already cited ("American Business and the Origins of McCarthyism"), should be read along with Stanley D. Backrack, *The Committee of One Million: "China Lobby" Politics, 1953–1971* (New York: Columbia University Press, 1976).

8 EXPULSIONS AND IMPRISONMENTS

What follows is a partial list of books by and about some victims of McCarthyism, in addition to those from whose memoirs I have excerpted documents for this book. Carl Bernstein tells, movingly at times, what happened to his parents in *Loyalties: A Son's Memoir* (New York: Simon and Schuster, 1983). Junius Irving

Scales and Richard Nickson describe Scales's experience as an idealistic Communist in North Carolina in *Cause At Heart* (Athens: University of Georgia Press, 1987). Poignant is the story told by Penn Kimball, *The File* (New York: Harcourt Brace Jovanovich, 1983). Herbert Biberman (himself a purge victim) tells another poignant story about the making of a wonderful movie, *Salt of the Earth* (Boston: Beacon, 1965). The best of the ex-Communist memoirs, in my opinion, is John Gates (one of the top eleven), *The Story of an American Communist* (New York: Nelson, 1958). We have a solid biography of the redoubtable Elizabeth Gurley Flynn: Helen C. Camp, *Iron in Her Soul* (Pullman: Washington State University Press, 1995). Peggy Dennis gives a fascinating account of her life with husband Eugene and what they went through in *The Autobiography of an American Communist* (Westport, Conn.: Lawrence Hill, 1977). Sketchy yet valuable is Benjamin Davis (another of the top eleven), *Communist Councilman from Harlem* (New York: International Publishers, 1969).

9 McCARTHY'S FALL

The bibliography for chapter five suffices for this chapter too. And for a description of the skill with which Eisenhower undid McCarthy see Stephen E. Ambrose's encomiastic, *Eisenhower,* vol. 2 (New York: Simon and Schuster, 1984).

10 A MEASURE OF REDRESS

Along with the bibliography for chapter six there is a fine study of *Earl Warren, A Public Life,* by G. Edward White (New York: Oxford University Press, 1982).

An up-to-date book on professional witnesses, including the few who recanted, would be a contribution to the history of McCarthyism. So we must rely on Herbert Packer, cited above. For the withering away of the inquisition, especially in show business, see the usual suspects, Caute, Navasky, and Ceplair and Englund, plus, of course, John Henry Faulk, *Fear on Trial* (Austin: University of Texas Press, 1983).

11 AFTERWORD

On the reappearance of McCarthyism in new dress, this time against New Leftists and other assorted radicals of the 1960s, see Frank J. Donner, *The Age of Surveillance,* cited above; Morton Halperin, et al., *The Lawless State* (New York: Penguin Books, 1976); Richard E. Morgan, *Domestic Intelligence* (Austin: University of Texas Press, 1980); Cathy Perkus, ed., *COINTELPRO* (New York: Monad Press, 1975); and, again, Theoharis, *Spying on Americans,* and with John Stuart Cox, *J. Edgar Hoover and the Great American Inquisition,* both cited previously. For the Church committee, its background and achievements, see Loch K. Johnson, *A Season of Inquiry* (Lexington: University Press of Kentucky, 1985). For a rather sympathetic view of Nixon's Watergate debacle see Stephen E. Ambrose, *Nixon: Ruin and Recovery, 1973–1990* (New York: Simon and Schuster, 1991). For a much darker view see Stanley I. Kutler's exhaustive *Wars of Watergate* (New York: Knopf, 1990).